I AM INUIT

I AM INUIT

PHOTOGRAPHS BY BRIAN ADAMS

EDITED BY JULIE DECKER WITH KELLY ENINGOWUK, JAQUELINE CLEVELAND, AND VERNAE ANGNABOOGOK

A project by the Anchorage Museum and the Inuit Circumpolar Council-Alaska

BENTELI

ALAKANUK

Robert Stanislaus, Kobe Cook, Mason Cook, Latrell Alstrom, Joseph Agayar **10** Nathaniel Agathluk **11**

ANAKTUVUK PASS

Ben Hopson **14** Kayla Hopson **15** Rainey Hopson **16** Taktuk Hopson **17** Richard Ahgook **18** Jeremiah Ticket and Lloyd Hugo **19**

ANCHORAGE

Allison Akootchook Warden **22** Trina Landlord **23** Holly Nordlum **24** Drew Michael **25** Tiffany Tutiakoff **26** Carol Richards **27**

BETHEL

Logan Gusty **30** Byron Nicholai **31** Chanel Alice Tuunralek Simon **32** Chato Michael Moss Sr. and kids **33** Charlee Korthuis **34** Wassillie Isaac **35** Emma Daniel, Kristen Heakin, Katherin Evan **36** Gabriel Charlie **37** Martha Attie **38** James A. Charles **39** Ludwina Jones **40** Jackie Williams **41**

BUCKLAND

Andrew Hadley and Trayton Ballot **44** Audrey Thomas **45** Calvin Brown Sr. **46** Charles Foster **47** Minnie Foster **48** Timothy Gavin Jr. **49**

HOOPER BAY

Axel Joe **52** Jerry Moses **53** Don Tall Sr. **54** Marlene Hill and Arnoldine Hill **55** Mary Simon **56** Steven Stone **57** Preston Olson **58** Renee Green **59**

KAKTOVIK

Alicia Solomon **62** Kate Lambrecht **63** Darren Kayotuk **64** Issac Akootchook **65** Jonas Mackenzie **66** Bruce Inglangasak **67** Levi Rexford **68** Mary Ann Warden **69** Marie Rexford **70** Linda Soplu **71** Nora Jane Kaveolook Burns **72** Tori Inglangasak **73**

KOTZEBUE

Beulah Ballot **76** Trenton Nazuruk **77**

NOATAK

Enoch L. Mitchell **80** Lonnie Arnold **81** Eva Wesley **82** Fred Vestal, Edwin Vestal and Lester Vestal **83** Martha Burns **84** Peter Norton **85** Philip A. Booth with his adopted sons Philip Jr. and Brandon **86** Steven Booth **87** Whittier Burns **88** Eugene K. Monroe Sr. **89**

NOME

Blaire Okpealuk **92** Jessica Gologergen **93**

NOORVIK

Bradley Jackson **96** Sophie Georgine Cleveland **97** Diane Coffin **98** Helen Wells **99** Jennie Massaun **100** Kirk Sampson **101** Karen Jackson **102** William Jack and Adrian Brown **103** Lloyd Morris **104** Lonnie Tebbits Jr. **105**

POINT HOPE

Adela Lane **108** Jon Ipalook **109** Irma Hunnicutt **110** Jimmie Milligrock **111** Ricky George, Edna Nashookpuk, Caldon Sampson **112** Tariek Oviok **113** Shirley Ipalook **114** Scotty Ipalook **115**

QUINHAGAK

Adolph Smart **118** Annie Cleveland **119** Brittany Cleveland and Taryn Andrew **120** Emma Frances **121** Robert White, William Sharp, John Sharp **122** Karen Atseriak **123** Keri and Elton Cleveland and family **124** Kristy and Zoe Mark **125** Phillip Charlie **126** Joshua Cleveland **127**

I AM INUIT

The United States of America is an Arctic nation because Alaska has territory north of the Arctic Circle. For people residing in Alaska's Arctic, place is not a curiosity, nor is it an untouched wilderness. It is our home. Globally, four million people live in the Arctic today. I AM INUIT seeks to connect the world with Alaskan Inuit, and the Arctic, through common humanity. Inuit are the Indigenous Peoples, with the same language and culture, inhabiting the Arctic regions of Greenland, Canada, Alaska, and far-east Chukotka. In Alaska, Inuit include the Iñupiat, Yupiit, Cupiit and St. Lawrence Island Yupiget.

The Inuit Circumpolar Council Alaska began I AM INUIT to raise public awareness of the Arctic. The project highlights the human dimension of the Arctic and shows the world something authentic about Alaskan Inuit at a time when reality television, instead of true understanding, often prevails.

Often, people living outside the Arctic do not realize that people, Inuit in particular, have lived and thrived in the Arctic for thousands of years. Initially developed as a social media project, I AM INUIT has been a way to break through stereotypes and an opportunity for Inuit to speak, with a distinct voice.

Beginning in 2015, Iñupiaq photographer Brian Adams traveled to sixteen Alaskan villages to document life, culture, and society through portraits and life stories of real people, as well as the landscape. His photographs and the stories shared highlight the rich and vibrant culture of Alaskan Inuit, and connect people outside the region to the Arctic. Places visited include Quinhagak, Teller, Shungnak, Utqiaġvik, Point Hope, Wainwright, Anaktuvuk Pass, Kaktovik, Kotzebue, Buckland, Noorvik, Noatak, Nome, Shishmaref, Shaktoolik, White Mountain, Bethel, Hooper Bay, Alakanuk, Tuluksak, and Anchorage.

The people of the Arctic are resilient and continuously adapting. Language, feasts, dancing, drumming, sharing foods, art, and ingenuity have kept Inuit culture strong. Although faced with challenges of globalization and effects of colonization, Inuit have and continue to respond to these challenges.

Arctic communities are now faced with another powerful force bringing additional pressures on Inuit culture and society. Global climate change is having a profound impact on the Arctic, its sensitive ecosystem and the communities that rely upon the region's natural resources. The impacts are real, immediate, physical and psychological. The health of the Arctic ecosystem affects food security and cultural sustainability. Hunting and fishing are the basis of Inuit culture and economy. Inuit hunters encounter new challenges as ice becomes less stable, travel becomes more hazardous, and animal migratory routes change. Melting permafrost is causing erosion to the coastlines and river banks forcing some communities to relocate.

In addition, warmer temperatures, resulting in a thinning ice pack and increased access, has prompted decision-making that will affect the Arctic and its people. The

world is turning its attention to the Arctic. Development in the Arctic Ocean—offshore oil and gas development, heavy marine traffic and commercial fishing, are beginning to look like viable pursuits. The issues and opinions related to the future of the Arctic are many and diverse. And Inuit are at the forefront of these issues.

The future of the Arctic is embedded in its land and in its people.

Warming of the Arctic will not only affect Inuit, but also will have an impact upon the entire planet. The Arctic will be a key indicator for how people around the world will adapt to the effects of climate change.

Change, adaptation and resilience are seen in these photographs. The images reveal Inuit culture and daily life, which continues in a dramatically changing landscape. The stories that accompany the photographs, the voice of Inuit, help complete the picture. These are their stories.

James Stotts, President
Inuit Circumpolar Council-Alaska

Julie Decker, Director/CEO,
Anchorage Museum

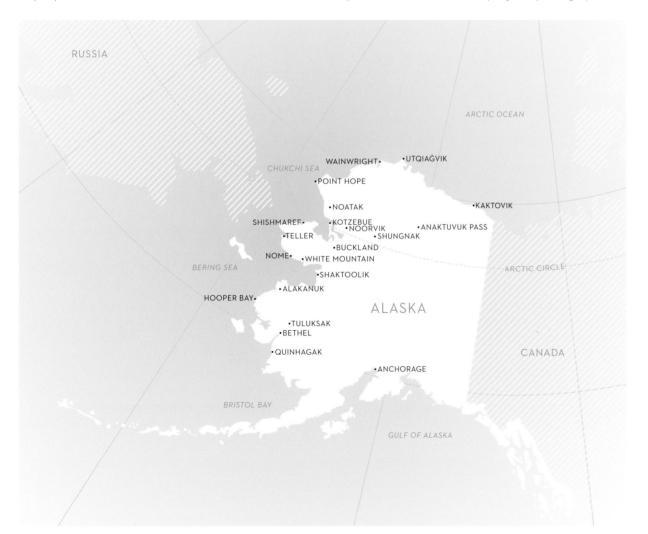

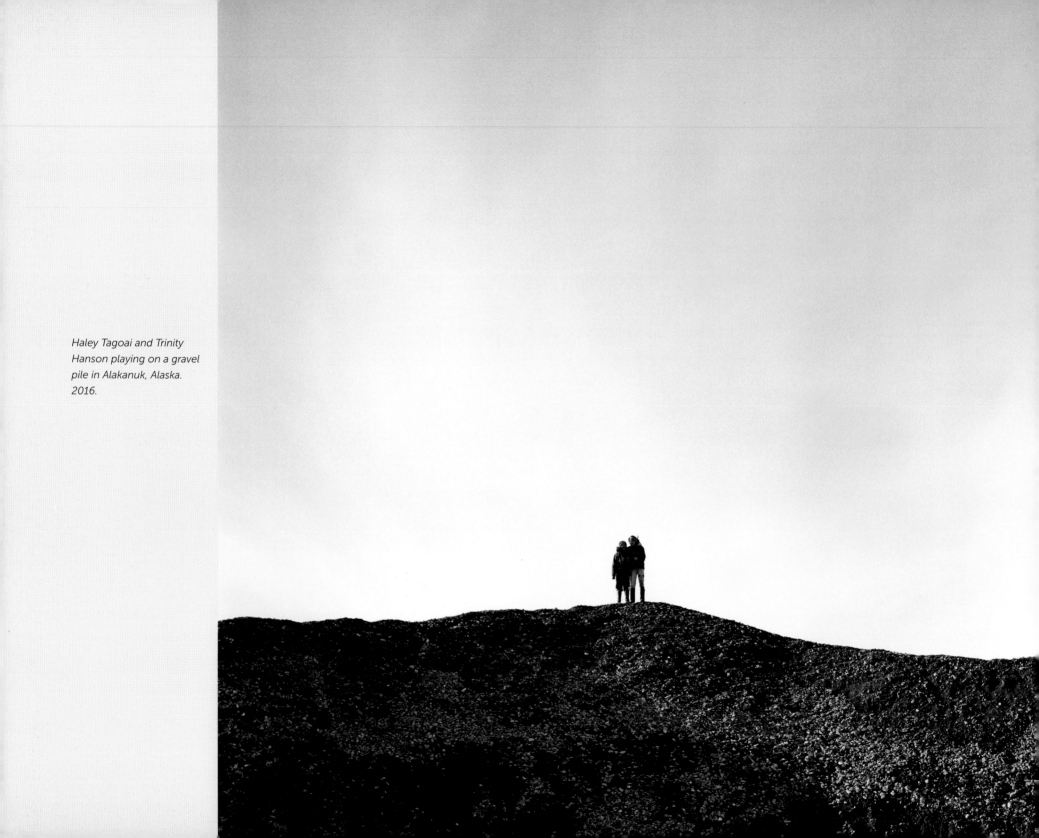

Haley Tagoai and Trinity Hanson playing on a gravel pile in Alakanuk, Alaska. 2016.

ALAKANUK

Alakanuk is a coastal Yup'ik village with a population of about 680. Alakanuk is the Yup'ik word meaning "wrong way," which applies to the village in terms of its location amidst a mix of waterways in the surrounding area. The village is located at the east entrance of Alakanuk Pass, the major southern channel of the Yukon River, 15 miles from the Bering Sea. It is part of the Yukon Delta National Wildlife Refuge. Alakanuk lies eight miles southwest of Emmonak and approximately 162 air miles northwest of Bethel. The village is one of the communities at risk of coastal erosion.

A pair of shoes hangs on a power line in Alakanuk, Alaska. 2016.

Robert Stanislaus, Kobe Cook, Mason Cook, Latrell Alstrom, Joseph Agayar (on snow machine), Yup'ik

"You came here when it's warm. It's all slushy. We are going to help him get out. He got stuck over there, too."
—Mason Cook

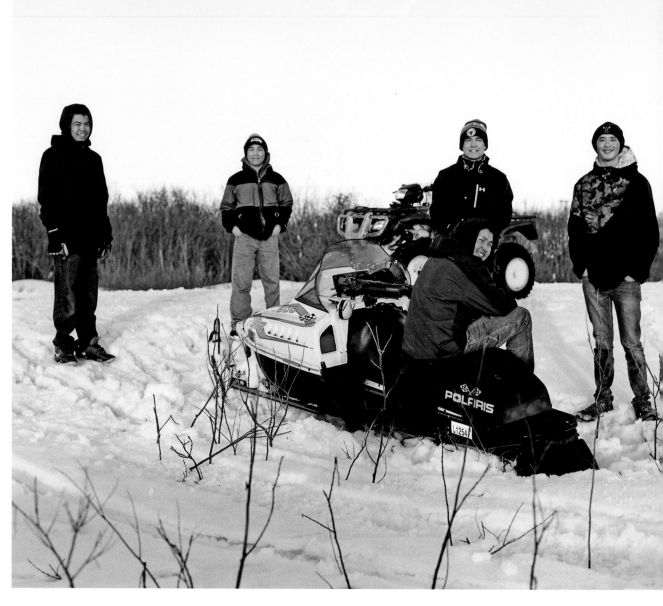

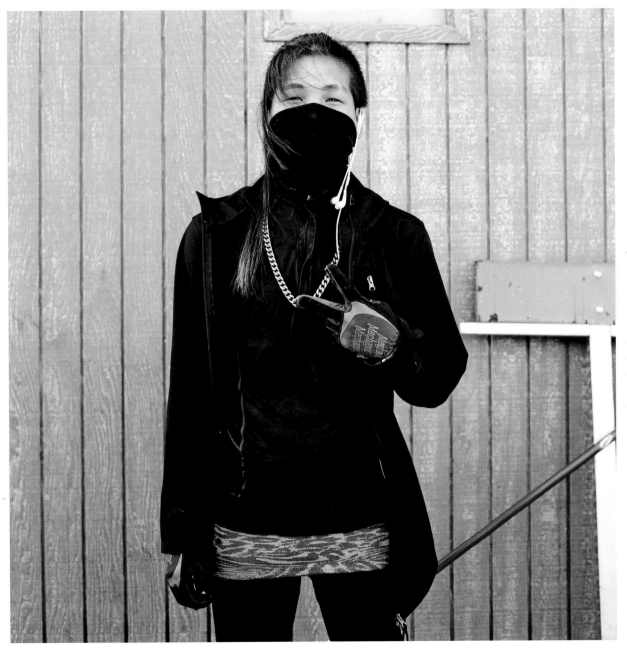

Nathaniel Agathluk, Yup'ik

"I am from Emmonak, Alaska. Other than the nature, it's a pretty boring place. It's pretty peaceful though. I came over here just for the hell of it. I figured it's a pretty nice day to go for a walk—about eight miles or something like that. I figured today I needed a little exercise. So why not do it on a good day like this. The best part is I have to look forward to the walk back."

ANAKTUVUK PASS

Anaktuvuk Pass is an inland Iñupiaq village with a population of approximately 400. Anaktuvuk Pass is located in the central Brooks Range and is nearly equidistant between Barrow and Fairbanks. Anaktuvuk Pass is surrounded by tall mountains and is located in the Gates of the Arctic National Park and Preserve, within the North Slope Borough. Anaktuvuk Pass is situated on a migratory caribou route. During the early 1900s the Nunamiut left the Brooks Range mostly due to the collapse of the caribou population. By the 1940s, several Nunamiut families returned to the area and settled at Anaktuvuk Pass. As recently as the 1950s they still practiced a semi-nomadic lifestyle hunting caribou. They were the last North America nomadic peoples to settle into village life. The landscape of Anaktuvuk Pass is defined by its proximity within the central Brooks Range and between the Anaktuvuk and John River watersheds. The Anaktuvuk River flows north into the Coville River, and the John River flows south into the Koyukon River, a tributary of the Yukon River, which drains to the Bering Sea.

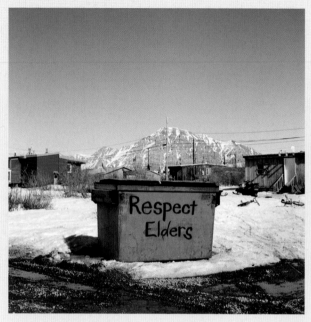

A dumpster in Anaktuvuk Pass, Alaska. 2016.

Ground squirrel caught by Jeremiah Ticket and Llyod Hugo in Anaktuvuk Pass, Alaska. 2016.

Anaktuvuk Pass.
2016.

Ben Hopson, Iñupiaq

"Basically, I hunt and hang out with family most of the year. I do a lot of trapping, sheep hunting, caribou hunting, and got into beaver trapping last year. I get odd jobs here and there. Last summer I was hiking up in the mountains, collecting caribou sheds and bundling those up and sending them to a guy in Fairbanks. That was pretty much my income for the summer. It wasn't much, but it got the bills paid.

We sheep hunt. Sometimes we get them right in the mountains here, and sometimes we have to travel 15 to 20 miles to the east or west. I like to go further out. The majority of the sheep hunters in the village like to stay close to the village. I like to get out further and hopefully see bigger rams."

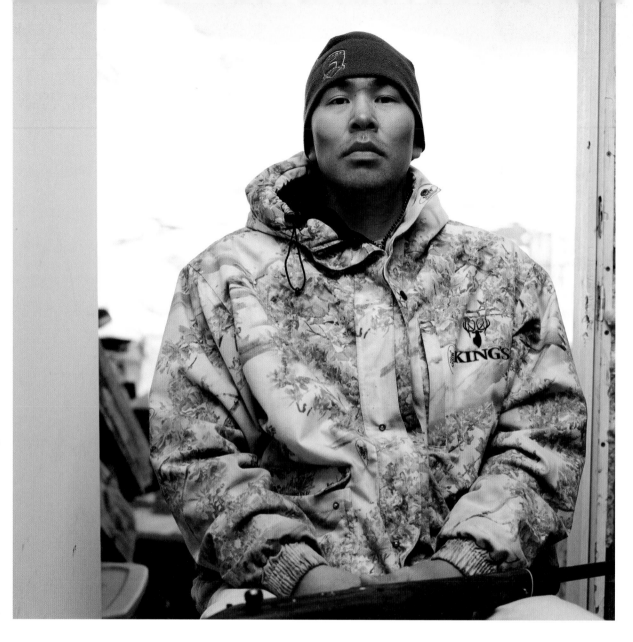

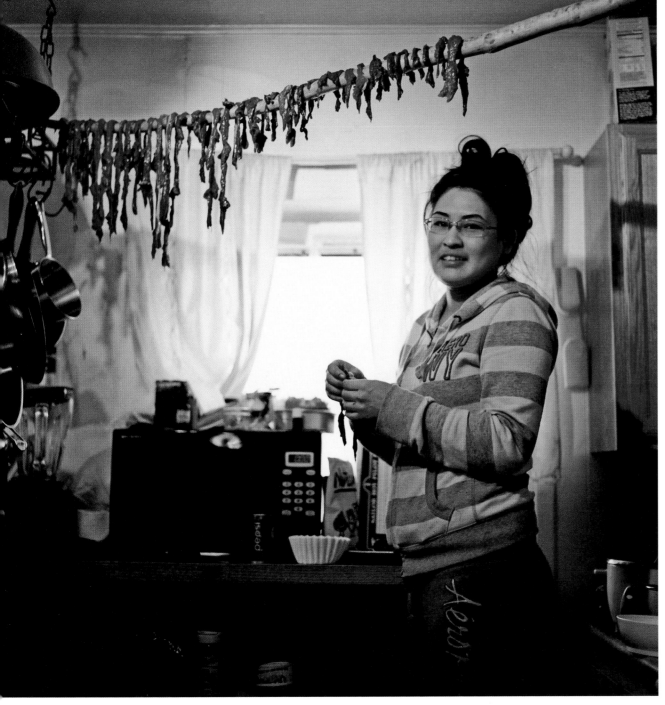

Kayla Hopson, Iñupiaq

"This is an old school way of drying meat. We were just having some raw earlier. I got it up north last week, six days ago. I got this one on my trip to the Haul Road. We didn't see caribou here all winter—there was like one or two small herds that came through. But as soon as there was word they were out, people went out there and caught a whole bunch of them and scared the rest of them away. So this was a big score.

We grind the shoulders with our meet grinder and I gave a bunch to my grandmother. That was probably the most excited I had ever seen her. When I told her I had caribou the other day, she yelled super loud 'Yes!'"
—Ben Hopson. Photographed here is his sister Kayla Hopson who is hanging caribou meat to dry.

Rainey Hopson, Iñupiaq

"I am starting an agriculture business, probably one of the first agriculture businesses on the North Slope. I am going to be growing produce and selling it locally. Pretty much 100 percent of the produce in this village is not from Alaska. 95 percent of produce in all of Alaska is shipped from somewhere else. So what we do get has come a really long way. It's usually picked because it will last on a shelf for a long time. They never pick them because they are nutritious or fresh, so what we get is few and far between. So I started a garden and got interested in it. Then, last year, I fundraised [for] 'Gardens in the Arctic,' and I got $4K and I bought these little gardening self-watering boxes. I set up about five or six families with them and they grew kale and fresh romaine lettuce. Then, this year, I found funding to buy a high tunnel. One of our residents is donating some of their land to grow fresh vegetables and fruit. This particular high tunnel is 26 feet by 36 feet with a steel frame. It conserves heat, concentrates the heat, and will give us a few extra weeks to grow. We will also be giving elders a box of produce once a week for free. My goal this year is to start training people to grow vegetables, because last year it was just me. But, hopefully, it will be a viable future for our economy. I am not doing this to really make money. We want to have fruit and vegetables in there by June first!"

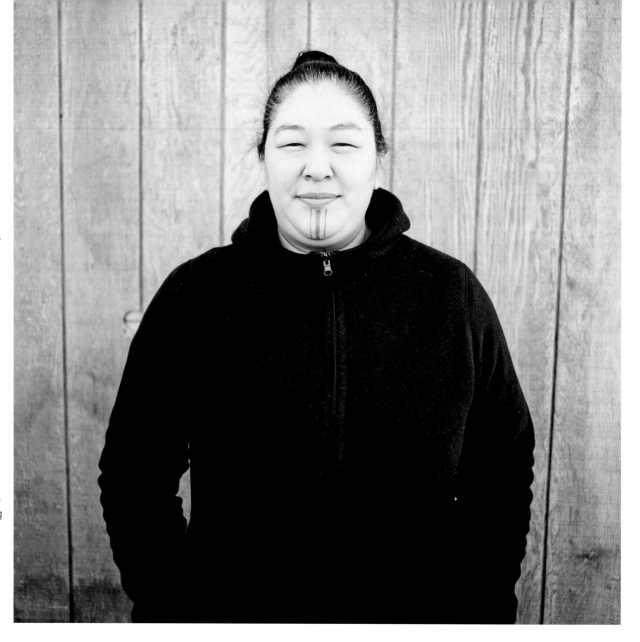

Taktuk Hopson, Iñupiaq

"I made it [parka jacket] last fall. Underneath, the quilted lining part, was from Ben's cousin. Her daughter out grew it. I took the cover off and replaced it with a cover I ordered off of Etsy. The ruff [fur sewn around the hood of the parka] is from Ben's mother, who passed away when they were younger, and I kept it. It's a farmed fox fur, perfect for little girls. My mom passed away when I was really young, when I was 11, so I didn't get to learn from her. She sewed.

I went to college in Northern California and my grand-mother on my stepdad's side lives there. She's a quilter. She bought me this super old sewing machine. It weighed something like 150 pounds. I started sewing there. When I moved back to Alaska a woman from Barrow got me into sewing parkas. She would rip it apart and make you do it over and over again. You have to have a perfect stitching, if it's too wide you will get air gaps and if its too small the stitch will rip through the skin. It's a lost art."—Rainey Hopson. Photographed here is her daughter Taktuk Hopson wearing the parka she made.

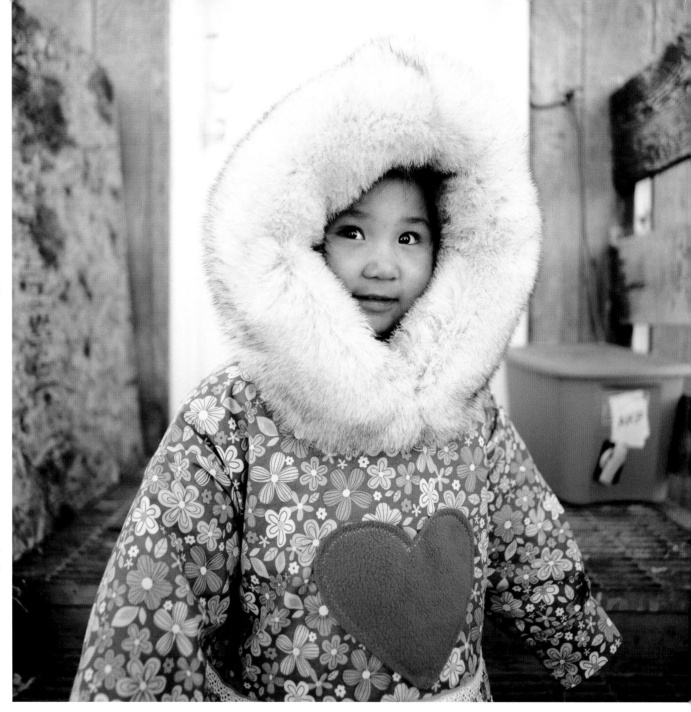

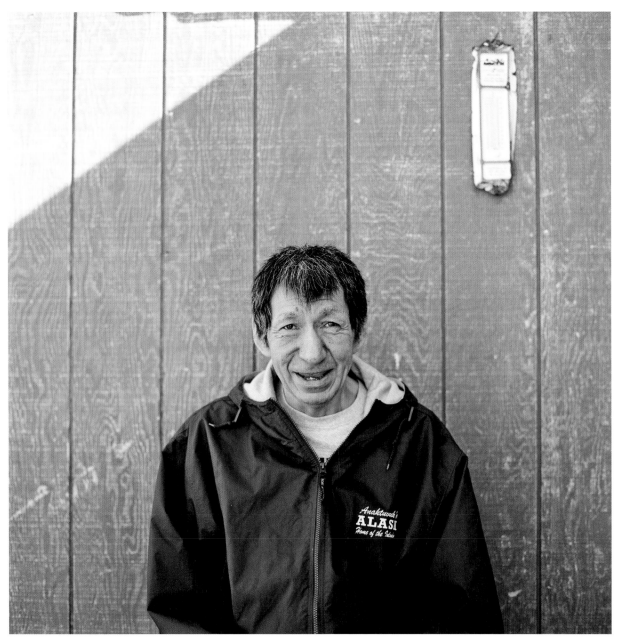

Richard Ahgook, Iñupiaq

"I was born and raised here, downriver about three miles. When I was growing up here we didn't have all this hardware you have here. We didn't have all these vehicles. We lived mostly on dogs and I lived in a sod house when I was growing up. I mostly do subsistence—that's how I grew up. It's a good country."

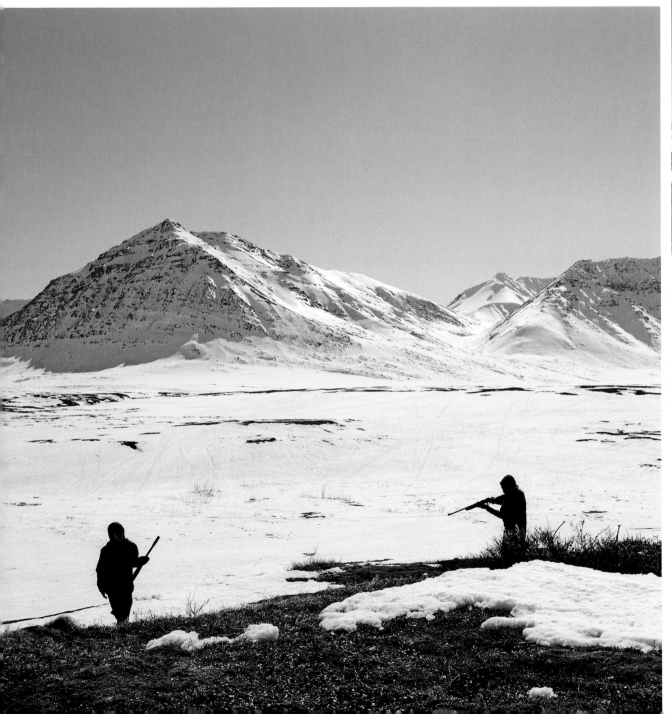

Jeremiah Ticket and Lloyd Hugo, Iñupiaq

"We are squirrel hunting. We either keep them or give them to other people for bait. They use them for trapping—wolf, maybe bear."—Lloyd Hugo

ANCHORAGE

Anchorage is the largest urban city in Alaska with a
diverse population of about 300,000, with Alaska
Natives making up eight percent of the population and
being the largest minority group. Anchorage is located
in Southcentral Alaska at the head of Cook Inlet, about
1,400 air miles northwest of Seattle. Dena'ina Athabas-
kan Indians were the first peoples of the Anchorage
area. The Native village of Eklutna was one of eight
winter settlements and is the last occupied Dena'ina
village in the Anchorage area. Anchorage is an
important hub for all of Alaska, and also connects
Alaska with the rest of the world through the
Ted Stevens International Airport.

Early snow in Anchorage.

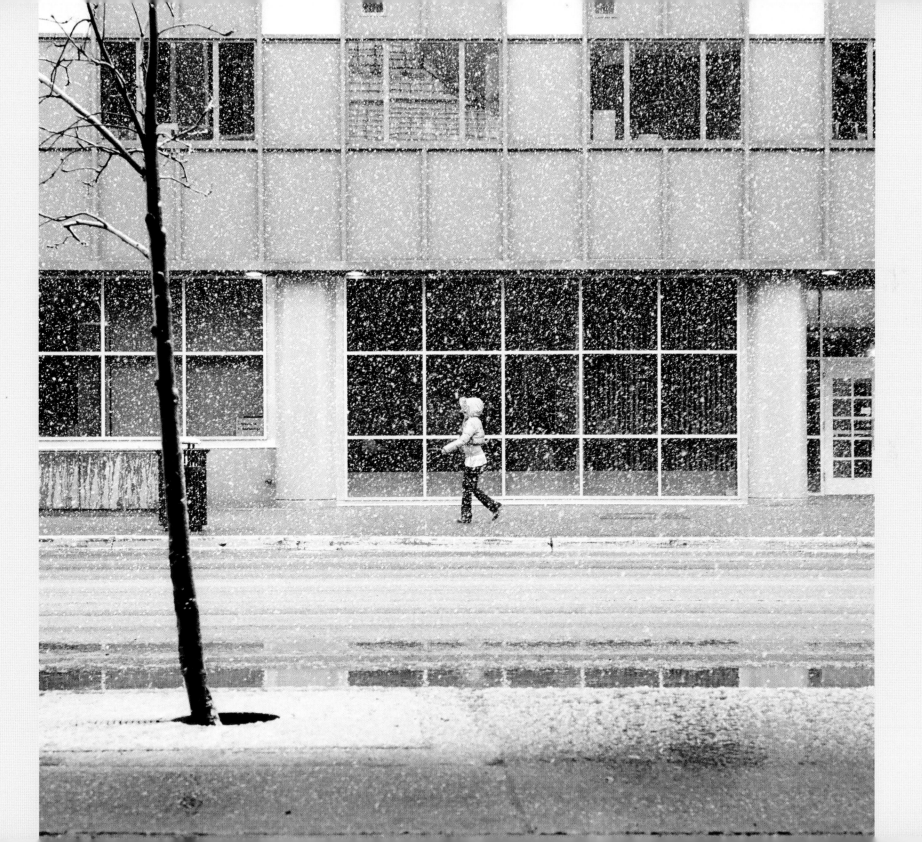

Allison Akootchook
Warden, Iñupiaq

"My rap name is AKU-MATU. My music is mostly focused on the environment. Columbia University had some traditional songs in their archives, and I had some digital recordings from Kaktovik that I made when I was 18 years old. I consider Kaktovik my home. My mom lives there and whenever I go there they say, 'Welcome home.'

I rap as a polar bear, caribou, a whale, and an ancestor from the future. I have a song about generational trauma called, 'My Mom's Song.'

The Arctic is hit seven times harder than the rest of the world with climate change. I am trying to protect my village. I couldn't imagine being Iñupiaq without ice. It's mind blowing what we are going through."

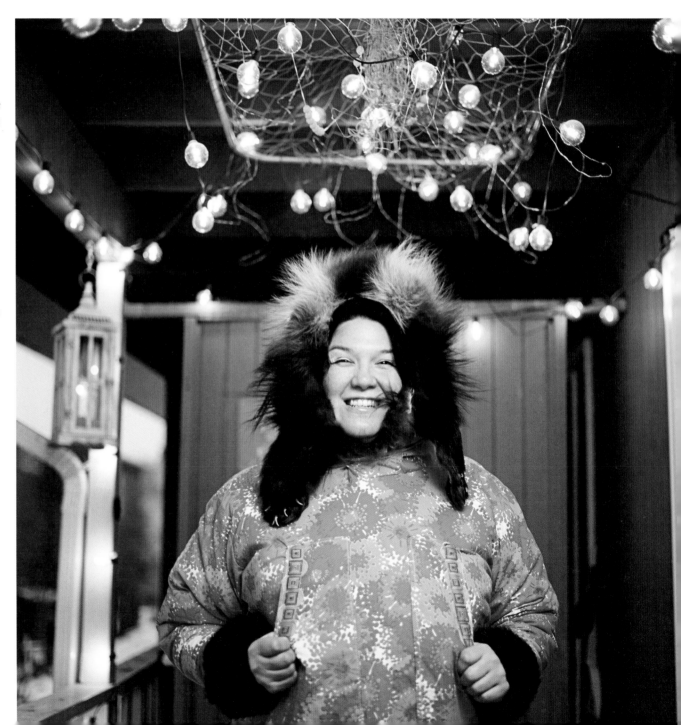

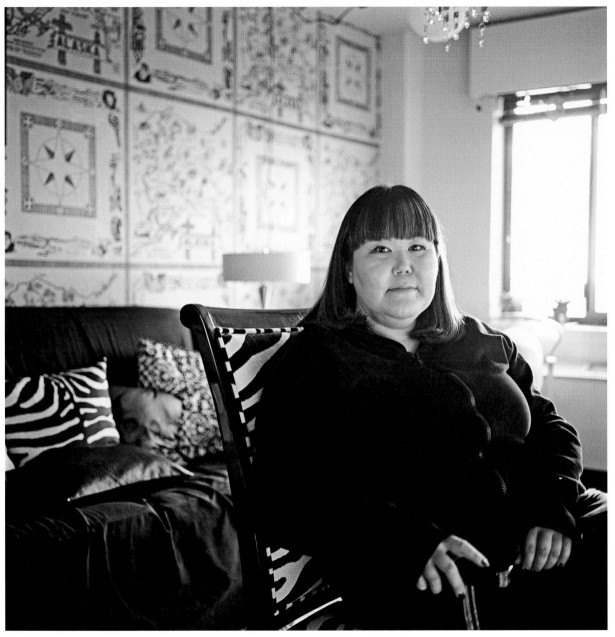

Trina Landlord, Yup'ik

"I grew up in Mountain Village. We lived there until I was seven years old. My earliest memories I have from there was the sense of community. Then we moved to Anchorage. At that time in the '80s, I felt a little lost, because Anchorage was such a big city. When we moved to Anchorage, it wasn't cool to be Native back in the '80s. So, I didn't have a strong sense of self until I went to college at UAA [University of Alaska Anchorage]. I learned more about my Native history, and I started studying my Yup'ik language.

While in college, I also started learning more about ANCSA [Alaska Native Claims Settlement Act] and other Alaska Natives within the state and became very compelled and very proud to be Native, finally. After that I began volunteering in the Native community. I volunteer for my tribe back home. I have lived abroad, but I always come home. There is something very special about this place.

I am working with AFN [Alaska Federation of Natives] now and we are planning the 50th Convention. It's going to take place in Fairbanks. I feel like the experience I have gained in different places; I am able to bring that home now. I had a fellowship at the UN [United Nations] when I lived in Geneva, and I feel like a lot of those experiences and my volunteerism has come to a point to where I can help my community.

We moved away from Mountain Village when I was seven, but I still have an attachment to there. Our last name Landlord was given to my great-grandfather because he was the founder of our community. I feel a sense of pride in that and think it's a cool last name."

Holly Nordlum,
Iñupiaq

"About ten years ago, my mom and I wanted to get a tattoo. I wanted to get a traditional tattoo; my great-grandmother had some. So I started researching traditional tattooing. I started talking to other artists and eventually contacted a tattoo anthropologist. As I learned more about traditional Inuit tattooing, I learned that it was for women and by women, mostly. Men that had them were usually leaders or shamans. But women wore them proudly. They became a marker of a woman's life, as she hit puberty, as she had children, gained skills, and became older. It was really a women's thing to celebrate women's lives."

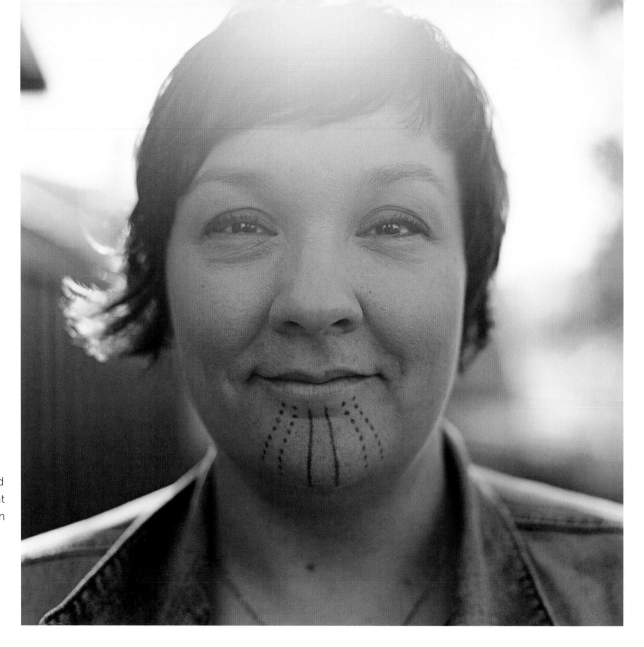

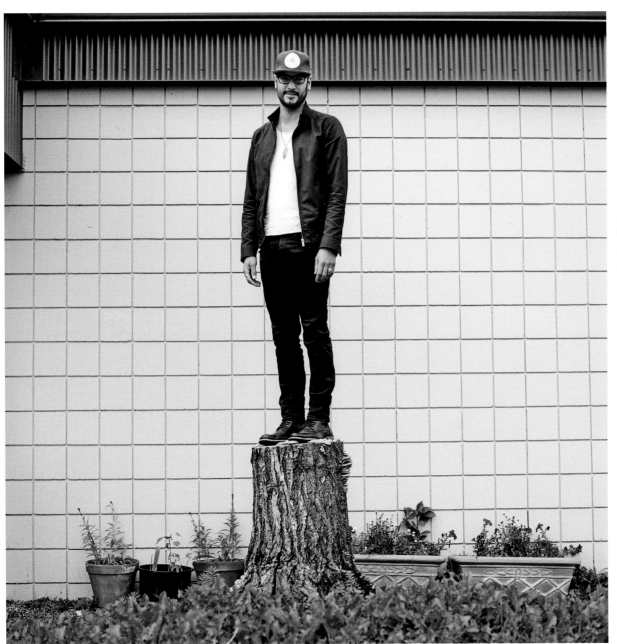

Drew Michael,
Iñupiaq and Yup'ik

"I was born in Bethel in 1984, as a twin. We were adopted out of our culture and I grew up in a home with two white parents in Eagle River. I was really disconnected to my culture. When I was 14, I was really into building things. My father wasn't really into building things, but my mother pushed him into taking me to a carving class. So he enrolled him and I in a carving class at UAA [University of Alaska Anchorage]. I learned how to work with the tools, basic design, and the purpose of masks. We didn't really go into the spiritual stuff.

I always had a hard time understanding my own identity. I think that has been something that has been a theme in all of my work. Transformation and living in so many worlds. Someone once said to me, 'It's like the reality I never lived.' I am not just Native, I am not just white, I am not straight, I am not just gay. I am what I am."

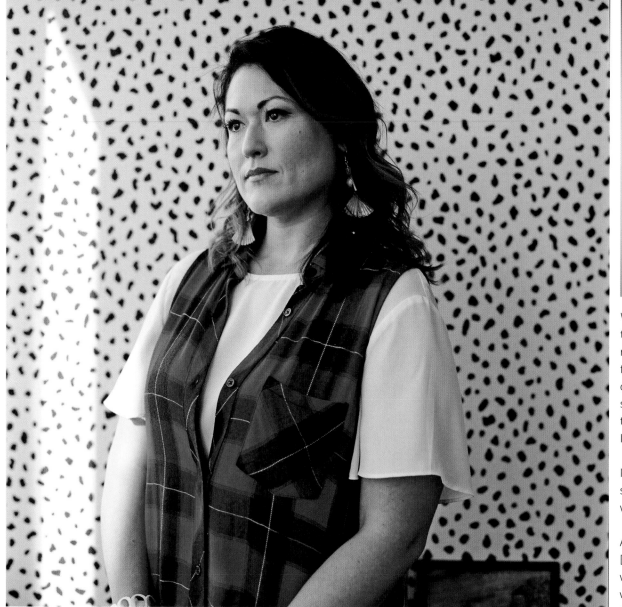

Tiffany Tutiakoff,
Yup'ik

"I was born and raised in Anchorage. My grandmother came from the Bethel area, and my family moved to Alexander Creek in the '30s. It's near the base of Sleeping Lady, 23 miles northwest of Anchorage. We traveled and moved around a lot when I was a kid. My mom is a retired commercial airline pilot. I am an only child and was raised by my mom.

When I was a kid, I was always designing things. I would turn my room into a travel agency. I was very entrepreneurial and creative, but I didn't think there was a career for that type of thing. Through high school and college I didn't know what I wanted to do. I had a lot of starts and stops because of that. I didn't have a lot of guidance at the time or anybody to help me learn what I was good at. I always thought I had to be a pilot or doctor.

I got a job working in Adak to make money to pay for school. Every two months I would fly home for two weeks for flight training.

After I moved back home, I got a job working for AFN [Alaska Federation of Natives], and it was the first time I was exposed to a real advertising agency—one. Northwest Strategies [NWS] at the time had a contract with AFN. I was lucky enough to sit in the conference room and listen to a NWS pitch. I got so excited. But, one thing I noticed was the creative director at the time had no idea who he was talking to. When he started to bring up rural communities, he mentioned Seward. He was corrected immediately by AFN, but I just couldn't believe this guy hadn't done his homework. Here he had this beautiful product and some grasp of who he was talking to, but not fully. I have carried that with me ever since."

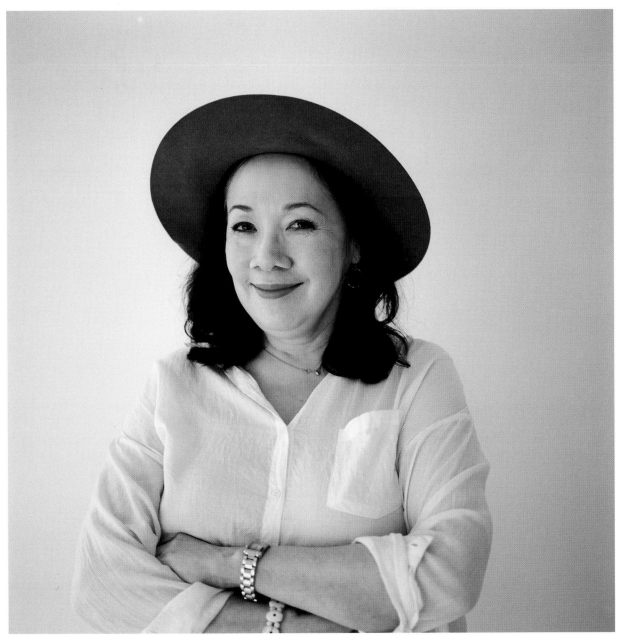

Carol Richards, Iñupiaq

"My parents are both from Kotzebue. My mother has a big family. Her father was from Germany and he arrived by ship. He came up and married my grandmother and they had nine kids.

My dad was born in Kotzebue, but he was sent away to BIA [Bureau of Indian Affairs] boarding school in Eklutna when he was very young. My dad was the smartest in his class so they called him 'Egghead.' He was drafted during World War II and he served in the Coast Guard in the South Pacific. When he came back, after the War, he learned how to fly and became a commercial jet pilot and flew the first 737 up to Alaska.

I went to design school outside of LA, Art Center College of Design and studied graphic design and got hired by Nike. On vacation, I would travel back to Alaska, and they called me the 'Nike Lady' because I brought product back home."

BETHEL

Bethel is an inland Yup'ik community in the Yukon-Kuskokwim region with a population of about 6,500. Mamteriilleq is the Yup'ik name, meaning "Smokehouse People," after nearby smokehouses that housed salmon caught from local streams and rivers. The Kuskokwim River has long been an important resource for the people. In the late 1800s, missionaries moved the city from its original spot, to its current location on the west bank of the Kuskokwim River, 40 miles from the Bering Sea and about 400 air miles west of Anchorage. It's surrounded by the 20-million acre Yukon Delta National Wildlife Refuge, the second largest wildlife refuge in the country. Bethel is a vital hub for the region with 56 villages who rely on Bethel as a primary transportation center, for administering region-wide health care, shopping, and other areas.

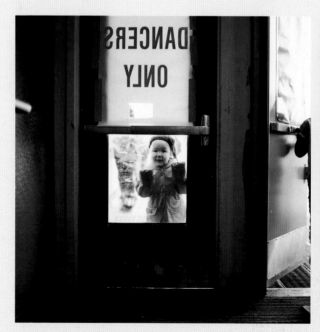

A child playing outside on the deck of the Bethel High School during the 2016 Cama-i Dance Festival.

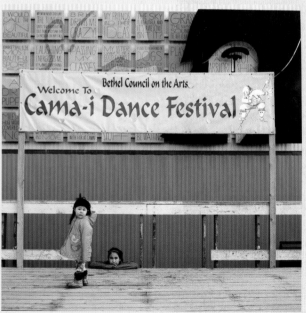

"Nunalgutkellriit Piniutiit Cauyakun: Community Strength Through Drumming" was this theme for the 2016 Cama-i Dance Festival held in Bethel, Alaska.

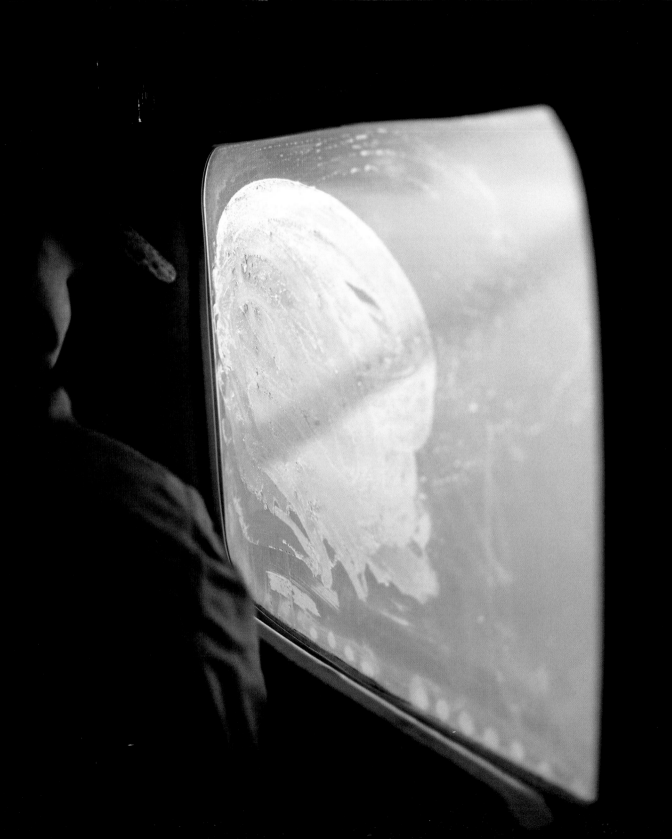

A man looks out the window of a small passenger plane flying between Hooper Bay and Bethel, Alaska. 2016.

Logan Gusty,
Yup'ik

"My favorite thing to do is go out hunting, everyday, pretty much. When the freezer is almost empty, we just go out everyday. There is geese in the fall time, and moose and caribou, we have got options here."

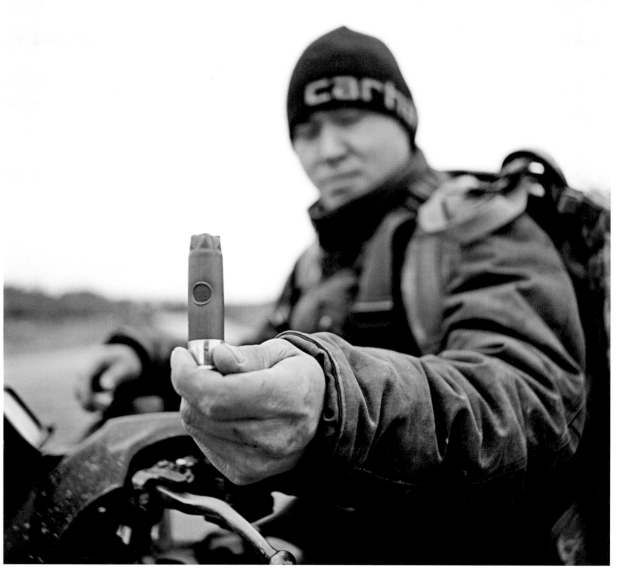

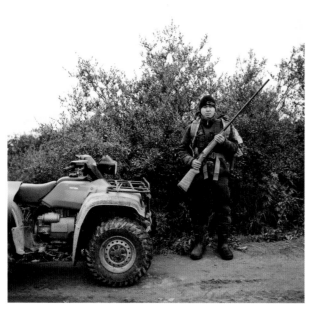

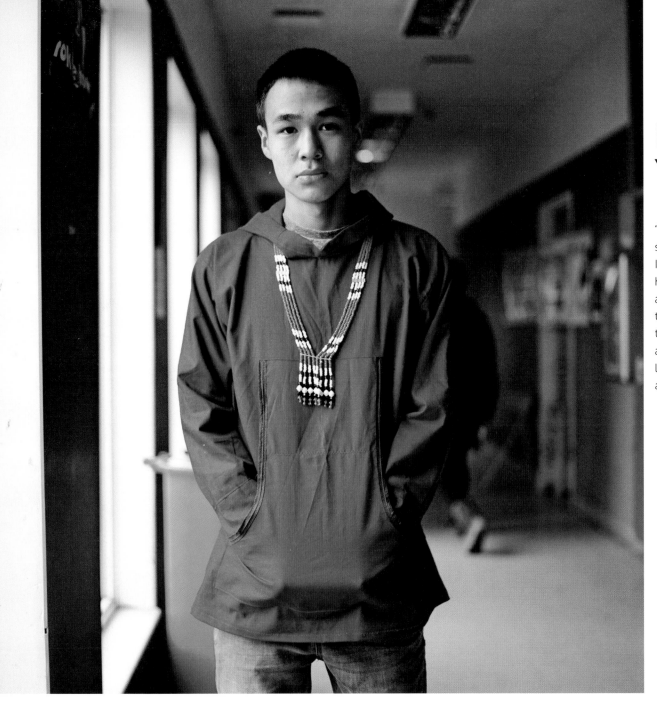

Byron Nicholai, Yup'ik

"I am from Toksook Bay, Alaska, and I like to drum and sing. I have a Facebook page and share some music that I make and songs that I compose. Some of these songs have some messages in them and some of these songs are funny. The songs that I sing are much different from the traditional songs, because in the traditional songs they are a bit longer and have more verses and mine are just one single verse. Some of the messages are life lessons that I have heard from my mom or the elders, and I just take what they say and put it into a song."

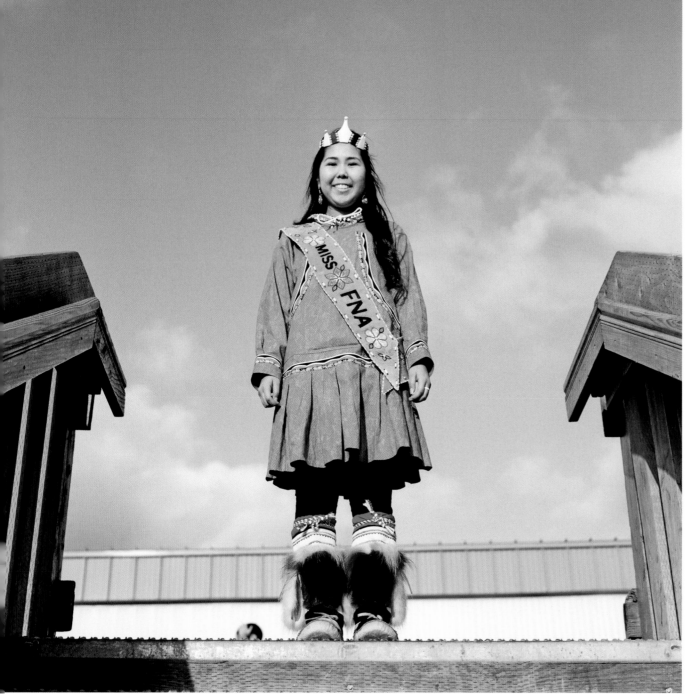

Chanel Alice Tuunralek Simon, Yup'ik

CS: "I am Miss FNA—it's the Fairbanks Native Association. FNA does different community services in Fairbanks. They work with elders and youngsters, and they work to conserve their culture. I was born here in Bethel, moved to Fairbanks where I started Kindergarten, and we stayed there through high school. I then went to UAF [University of Alaska Fairbanks] for two years and just transferred to UAA [University of Alaska Anchorage] last semester. I am half Yup'ik and half Athabaskan."

IAI: How did you become Miss FNA?

CS: "There are different events we are judged on. The first was our regalia, I was wearing my mom's parka. We did a talent [competition], I performed a Yup'ik song and I sang an Athabaskan song. We were also judged on our introduction to the audience, then we were also judged on an impromptu question. We had to pull a question out of a bucket and answer it from there."

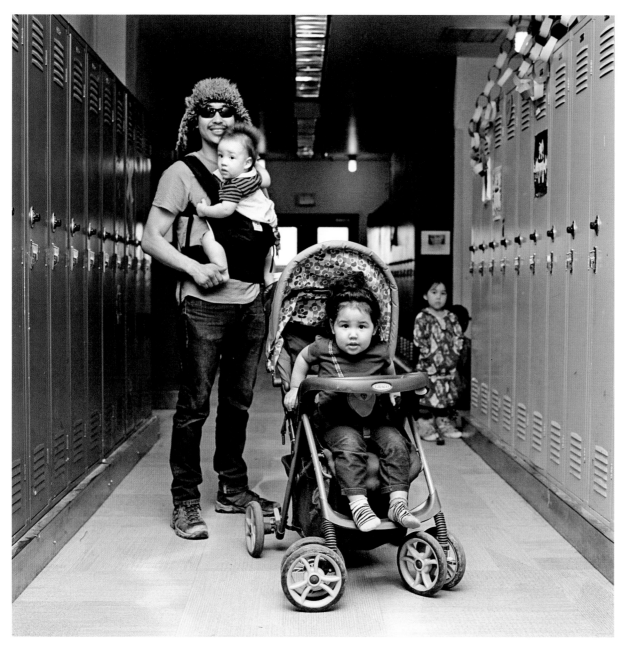

Chato Michael Moss Sr. and kids, Yup'ik

"We have two kids, our daughter is two and our son will be one. I was working on the Farm [Meyers Organic Farm]—it's seasonal. My wife is here too and she is selling earrings at one of the tables here at the [Cama-i Dance] Festival."

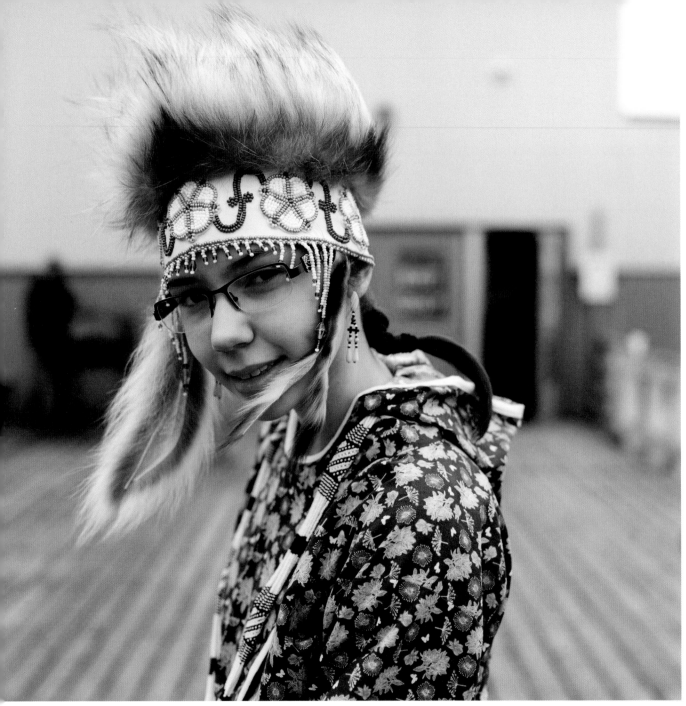

Charlee Korthuis, Yup'ik

"I have been dancing since I was five years old. I am part of the Ayaprun Elitnaurvik dance group. My favorite part about being in the group is the fun of it, learning new dances every week. My mom made my headdress and my traditional belt. My uncle made my dance fans."

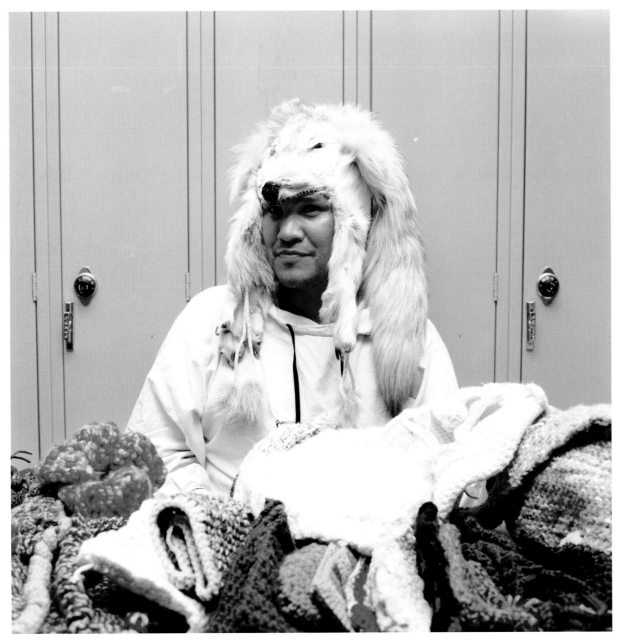

Wassillie Isaac, Yup'ik

"The first time I started beading was in grade school, probably the fourth grade. It was after my mother passed away and my grandmother started to show me how to do basic stitching. My first sewing project was a malagaiyaq [fur hat] during the cultural week at the school. From then, until now, I was sewing something. My craftsmanship started when I was young, my creativity. I am mostly Yup'ik and one-eighth Russian. I was born in Lower Kalskag in my grandmother's house."

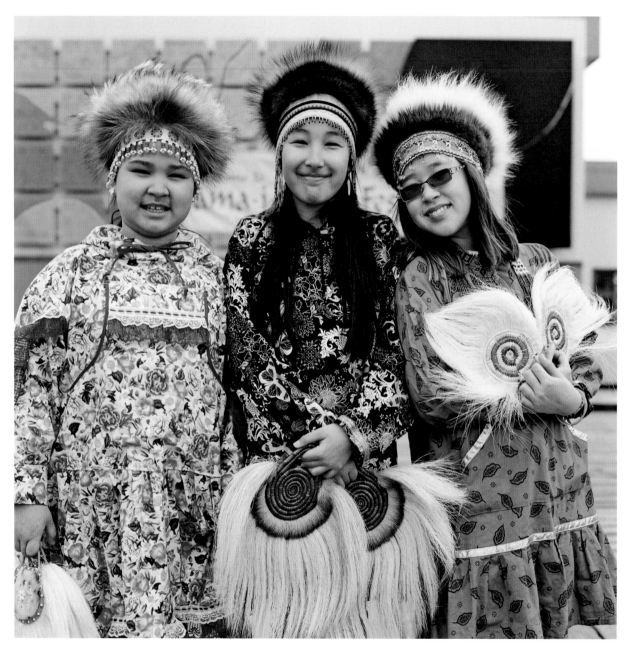

Emma Daniel, Kristen Heakin, Katherin Evan, Yup'ik

"We have all been dancing since kindergarten. We love learning new songs."—Katherin Evan

Gabriel Charlie,
Yup'ik

"I am originally from Newtok, Alaska, but I have been living in Bethel for 16 years. The jobs in the village are taken, so I had no choice but to move here. I have got a two-year-old son I have to support. I used to be a photographer, too, for the Tundra Drums [newspaper] back in the early 2000s. I would also write articles here and there."

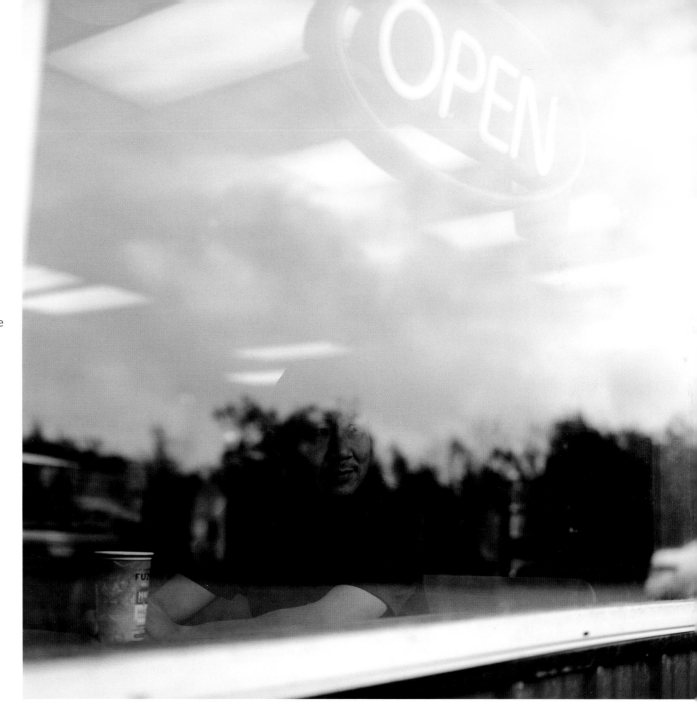

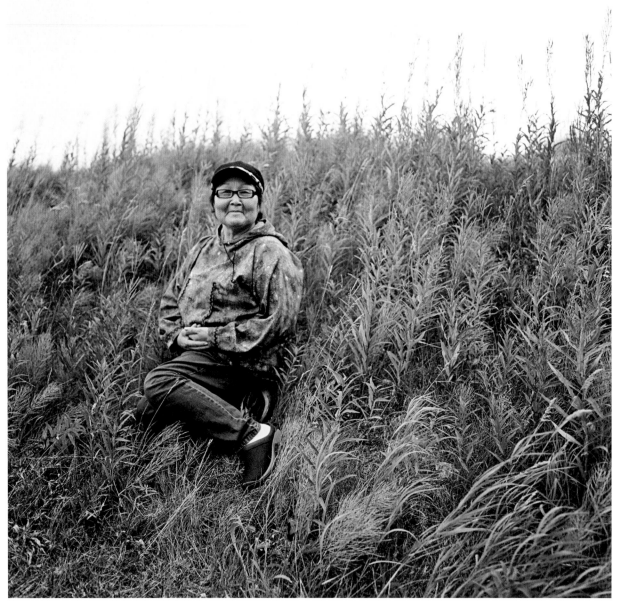

Martha Attie, Yup'ik

"I was born and raised in Kipnuk. I moved up here to Bethel in 1988. I became an alternate health aide in 1978/79.

There have been a lot of changes; back then it was easier. There were no appointments at the hospital, you just came in. Some nights you would have to get up with calls for home visits. There was no privacy—they would even come knocking on the door. We didn't care too much about pay—I would receive my check, I would just sign it and give them to my dad or mom. Didn't even know how much we got paid."

James A. Charles, Yup'ik

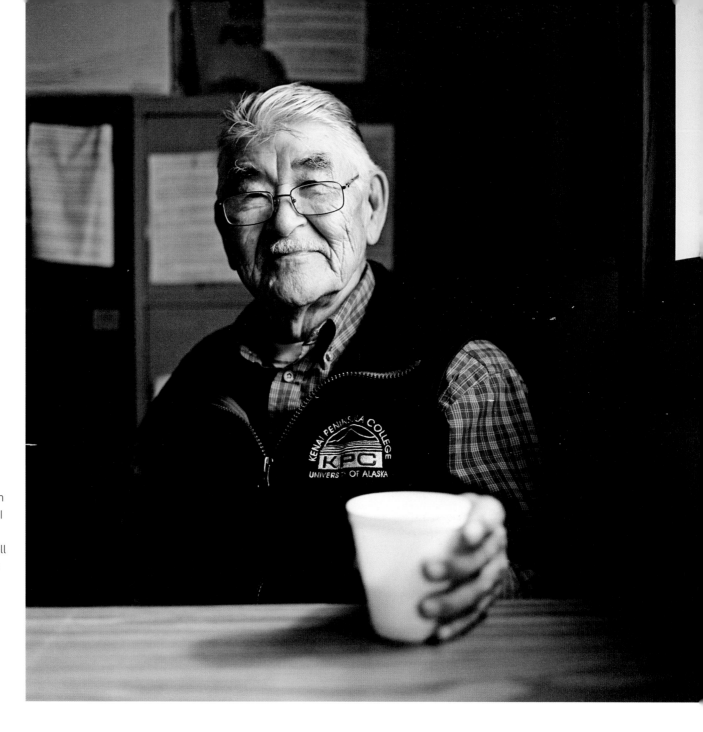

"My mother said I was born at fish camp. My heart is in fishing, both subsistence and commercial. Right now I own five airplanes, and in the 1960s I used to buy fish directly from other fishermen and fly them out and sell them. My Yup'ik name is Aiagiaq, and it means 'always going.' I used to fish up to 40 hours sometimes. With new regulations in these areas, they are only allowed to fish up to six."

Ludwina Jones, Yup'ik

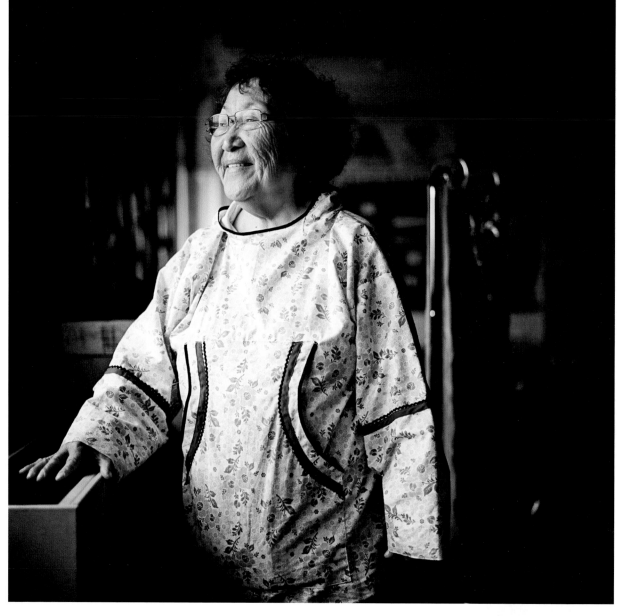

"My name is Ayaprun, one of 13 Yup'ik names. My baptismal name is Ludwina, but then, during high school, they started calling me Lottie, so I started being known as Lottie Jones, originally from Scammon Bay, Alaska. I'm one of nine sisters and a brother, which includes two adopted brothers and an adopted sister, so 13 in the family. I was the first to graduate from high school, then the first to graduate from college—in fact, in the whole village.

I went to college on campus at UAF [University of Alaska Fairbanks], got my degree in 1972, and I have been teaching here ever since. From 1972 to 1990 it was Kindergarten English. From 1992 to 1995, I taught YSL—that's Yup'ik as a second language.

[My mother's] biggest peeve was: 'I need to get a translator to talk to my own grandchildren, my great grandchildren.' She didn't like that. Thinking about that made me want to work harder to change that.

It seems like the bigger our school becomes, the harder we must work to make the Yup'ik language really productive. When we were in the small building, kids didn't hear any English because we were in a closed environment. Now we need to really work on having them speak more Yup'ik. Listen to what those kids are speaking out there in the hall—English. I dream in Yup'ik.

You can be a real Yup'ik even if you don't speak your language, because what if the opportunity to speak it wasn't there? But yet you live your subsistence lifestyle—that's Yup'ik. But to make that element whole, you need the language, the lifestyle, and the culture. Never think you are not Yup'ik because you can't speak the language."

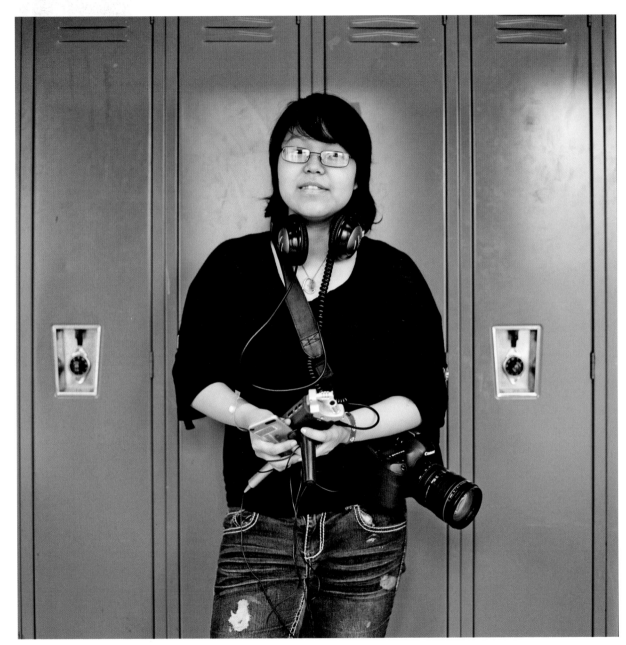

Jackie Williams, Cup'ik

"I am in the multi-media journalism class at BRHS [Bethel Regional High School]. I am doing a story on traditional local dancing, Yup'ik dancing. I have been into journalism for a long time I guess. I just joined this class and my favorite part is taking photos. I do plan to pursue journalism after high school."

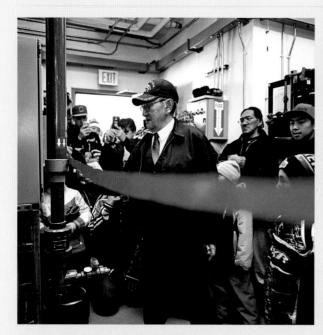

Photographed here is Nathan Hadley, a respected Iñupiaq elder, cutting the ribbon for the new water and sewer treatment center in Buckland, Alaska.

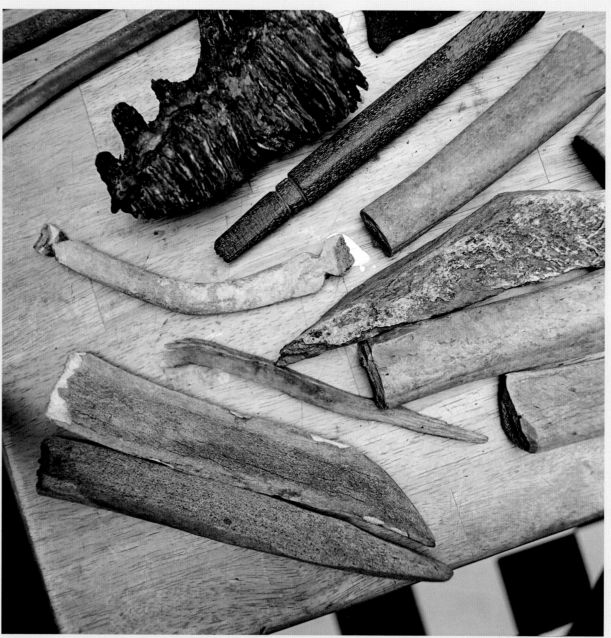

Artifacts found by the mayor of Buckland, Alaska, Timothy Gavin. He found the artifacts in an old settlement upriver of Buckland and said that he could date some of the artifacts as far back as 1897, based on an old rifle he had found with the serial number still legible.

BUCKLAND

Buckland, traditionally known as Nunatchiaq, is an Iñupiaq village with a population of approximately 400. Buckland is located on the west bank of the Buckland River, about 75 miles southeast of Kotzebue. Prior to settling at the current village site, residents moved from one site to another along the river at least five times in recent memory, to places known as Elephant Point, Old Buckland, and the New Site. The presence of many fossil finds at Elephant Point indicate prehistoric occupation of the area.

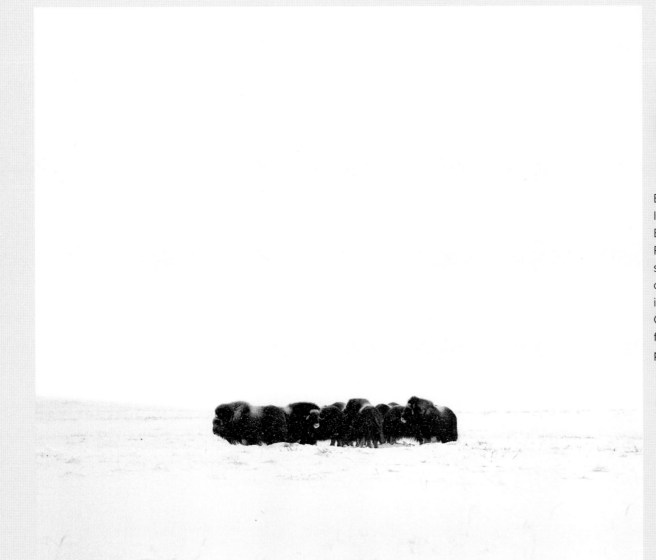

A herd of muskox three miles south of Buckland, Alaska. 2016.

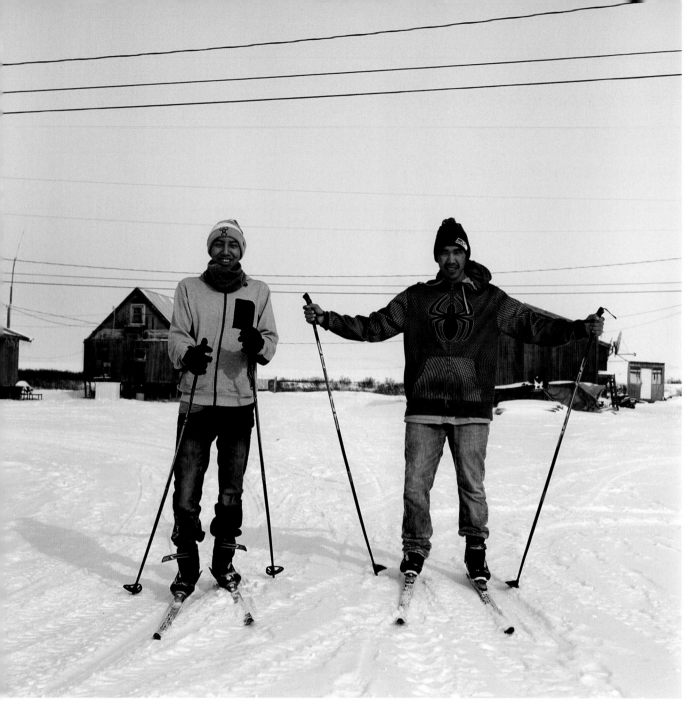

Andrew Hadley (right) and Trayton Ballot (left), Iñupiaq

"In 2005, RurAL CAP [Rural Alaska Community Action Program] helped revitalize cross-country skiing in school, when they donated skis to the school and helped with funding for two years. Since then NANA [Regional Corporation] has stepped in and has purchased new skis for the school, funding the program."
—Terri Chapdelaine, school teacher in Buckland, Alaska.

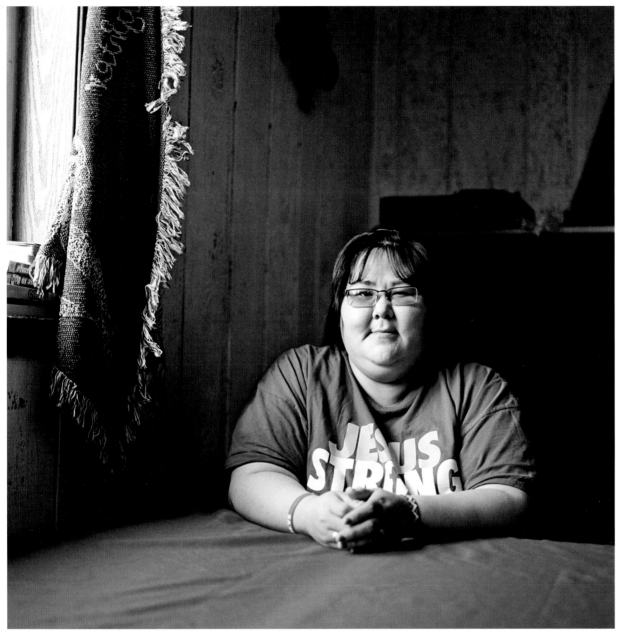

Audrey Thomas, Iñupiaq

"I am originally from Kivalina. I have been in Buckland for two years. I have three kids. A lot of people tell me 'Addii, you are like your dad. You never smile in pictures!'"

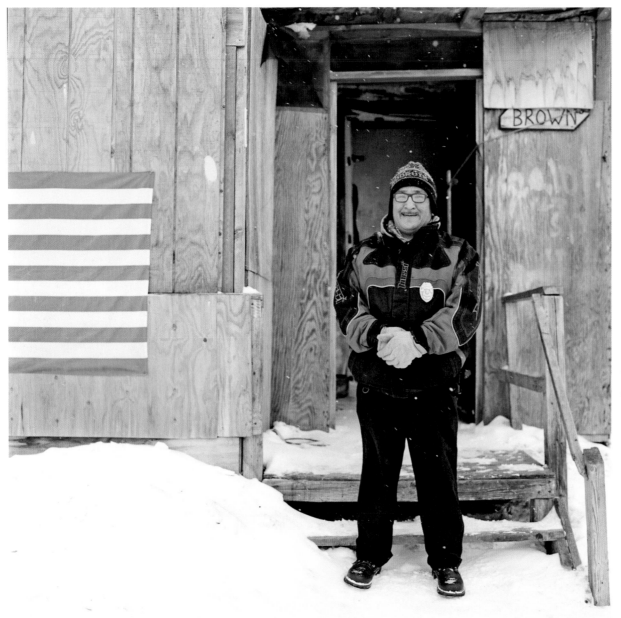

Calvin Brown Sr., Iñupiaq

"I am originally from Selawik, Alaska. I moved here [to Buckland] in '91 or '92. I started working at the school in '96, as the custodian. I worked there for 14 years. A friend of mine passed away and I couldn't work there anymore—too many memories.

I became a carpenter. I went from labor, to carpenter helper, to plumber. Now I am the VPO [Village Police Officer]. It's a permanent job. I like it. I like protecting people. This village is awesome. I like this town."

Charles Foster,
Iñupiaq

"I am originally from Selawik, born and raised right there on the river—no hospital, no clinic. My mom was a health aid for over 17 years. She delivered me herself, right there in the village, with no help. If I am not hunting, I am thinking about hunting. If I always had gas, I would always be gone. Sometimes my wife says that I love the country more than I love her, because I am always out there. Ever since I was seven years old, I would get myself ready and go stand by the door and say, 'I am following my dad, I am following.' I wanted to follow and I wanted to go hunt. The most exciting is wolf hunting and for wolverine. I sell them for gas and to people who want to make ruffs and clothes. My wife is really getting into ruff making. I still want wolf mittens. My wife always teases me that because I am originally from Selawik, that I migrated here to Buckland with the caribou."

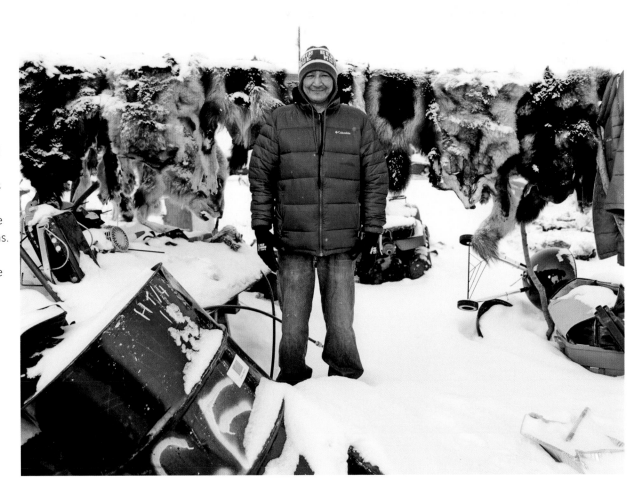

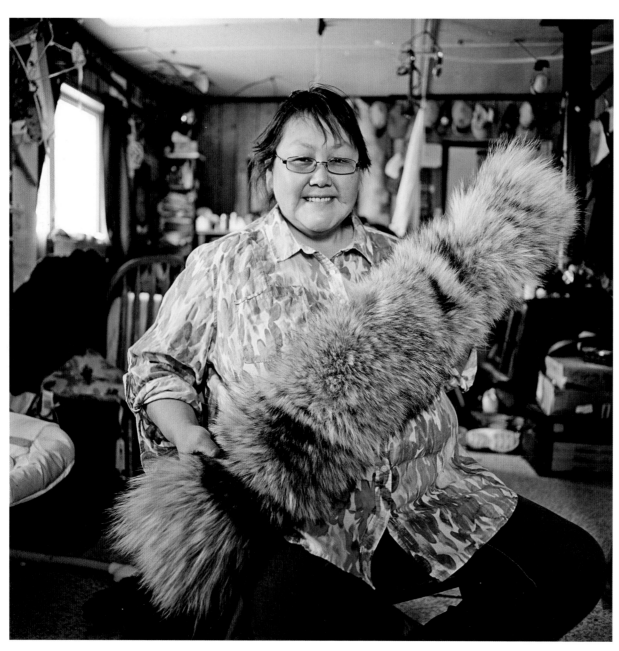

Minnie Foster, Iñupiaq

"I am working on mittens, to take my kids to the hot springs or fishing. We like to go out fishing. It's about 55 miles to Kobuk Lake. I also like to make beaver hats. I started learning how to do this in my 20s, from my mom, I watched her doing it all the time. We were taught to pass this down to our children."

Timothy Gavin Jr., Iñupiaq

"Right here I have five beavers, four otters, and one martin, which are not normally out right now. It's supposed to be about 40 below [Fahrenheit] right now and being so warm, some days it's above zero right now. We normally don't see these until about April. But look, they are sitting right here and I just got these in the past month [March]. Right now they are skinned and stretched. I need to scrape them. Then my wife sews, she will make a parka out of them."

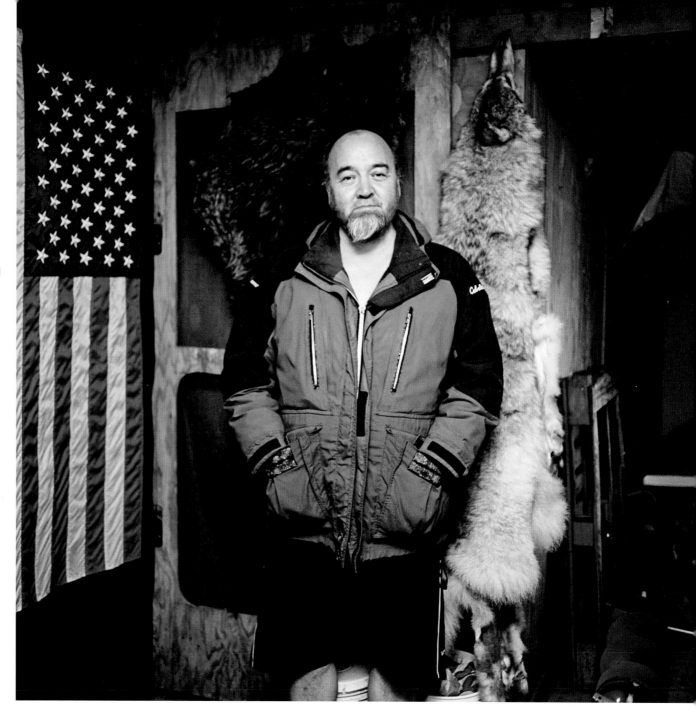

HOOPER BAY

Hooper Bay is a coastal Yup'ik village with a population of approximately 1,000, the largest village in the Yukon-Kuskokwim region. Askinuk is the Yup'ik name, which refers to the mountainous area between Hooper Bay and Scammon Bay. The village is located along the Bering Sea coast about 20 miles south of Cape Romanzof and about 500 miles west of Anchorage. The original site of Hooper Bay is located at Nuvomuit, an ancient seal hunting camp to the south, a short distance away from the Bering Sea. In the 1960s Piamuit residents moved to Hooper Bay.

Flying between Hooper Bay and Bethel, Alaska. 2016.

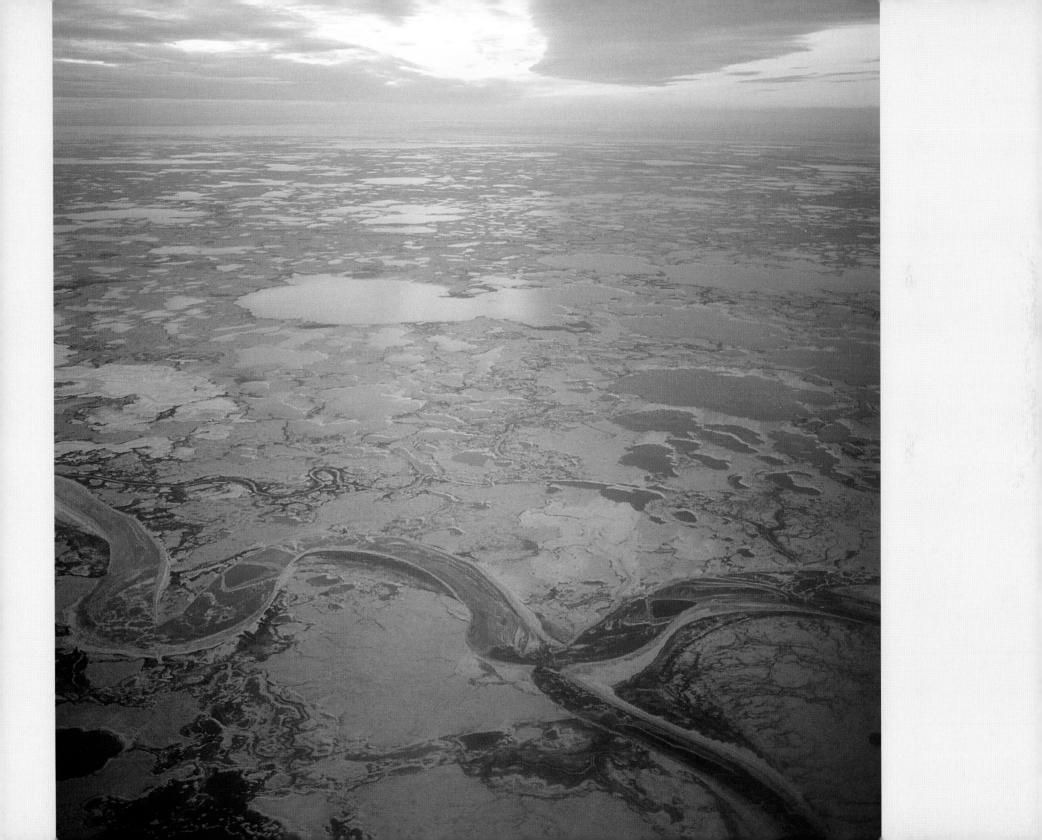

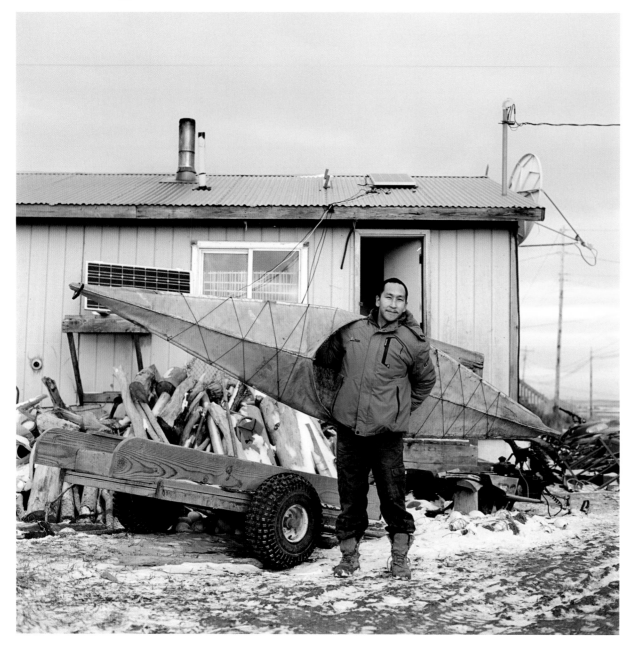

Axel Joe,
Yup'ik

"I started building kayaks a couple years ago. I learned how to make them online, and the design is based on traditional kayaks. I have made two of them so far. The skin is made of ballistic nylon; the frame is made of PVC pipe, bamboo, plexiglass and regular wood. I use them to go get seals, birds, and for fishing too. I also make throwing harpoons. They're made out of bamboo."

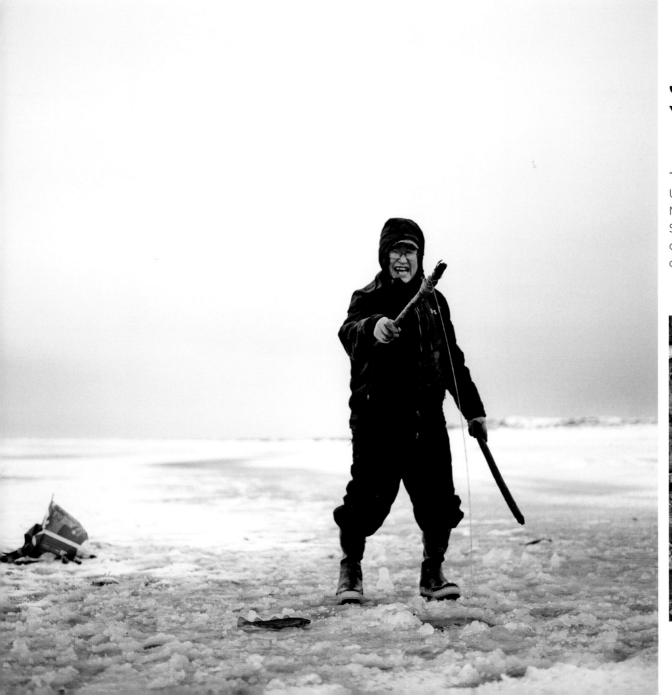

Jerry Moses,
Yup'ik

"This is our first time ice fishing this season for tom cod. Usually the ice freezes up in October and it's already November. Nowadays we don't get too much snow. Seven fish is good for me, fills up my stomach. I will be catching a few more and then head home. It's a lot of fun."

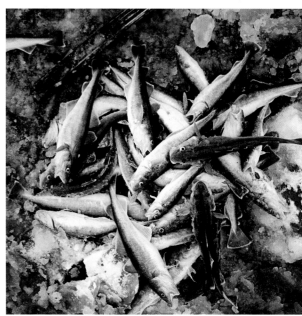

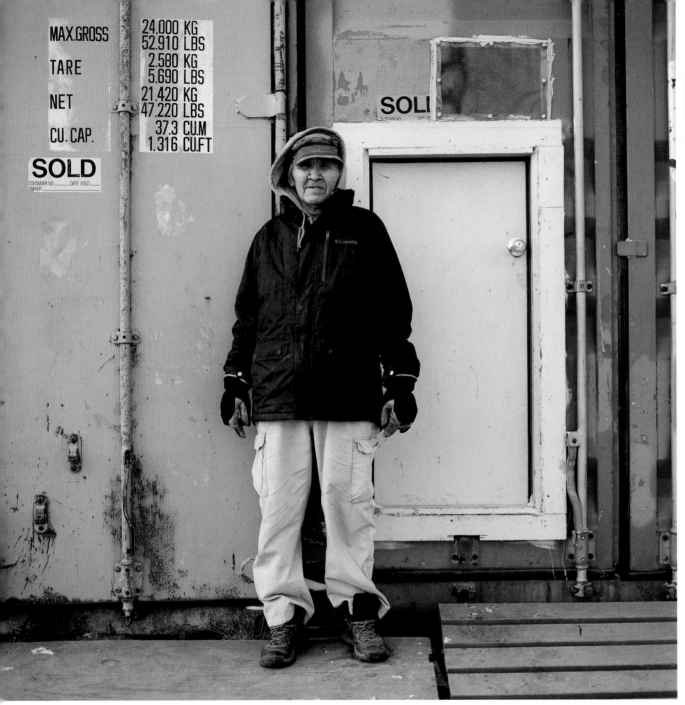

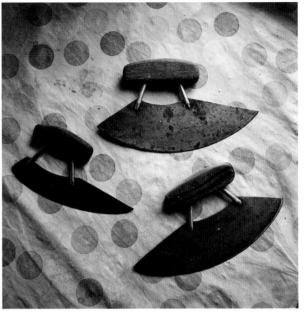

Don Tall Sr., Yup'ik

"I make ulus and harpoons. I have been doing it for over 20 years on and off. I learned by myself and with the help of my mom. This is my own design for cutting larger fish and stuff. The blade is made from a saw blade. I made the handles with hickory, [walrus] ivory, or bone. Some of them are made for fish and some of them are made for birds or seals."

Marlene Hill
and Arnoldine Hill,
Yup'ik

"We just came back from packing water for drinking water. We pulled it from a pond that is about two miles away from town. We drink it straight out of the pond. They keep a hole open in the pond, and if it freezes over you use an ice pick to open it back up."—Arnoldine Hill

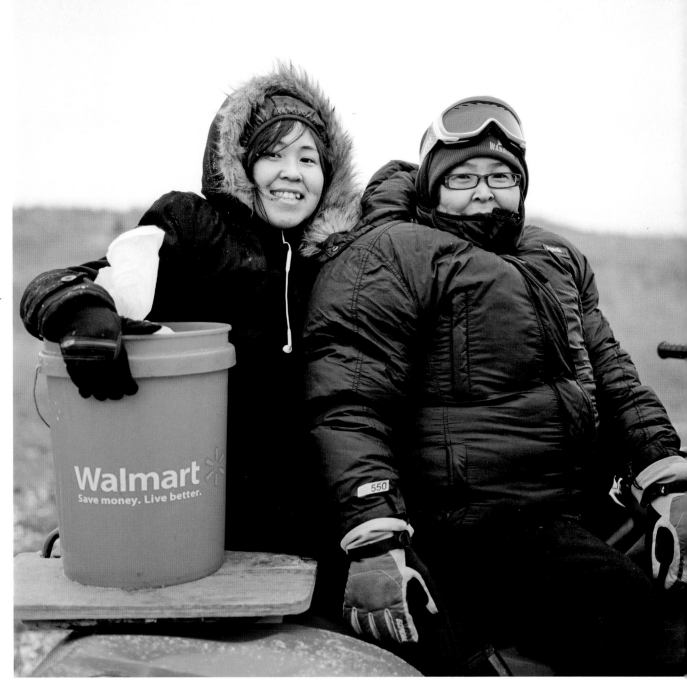

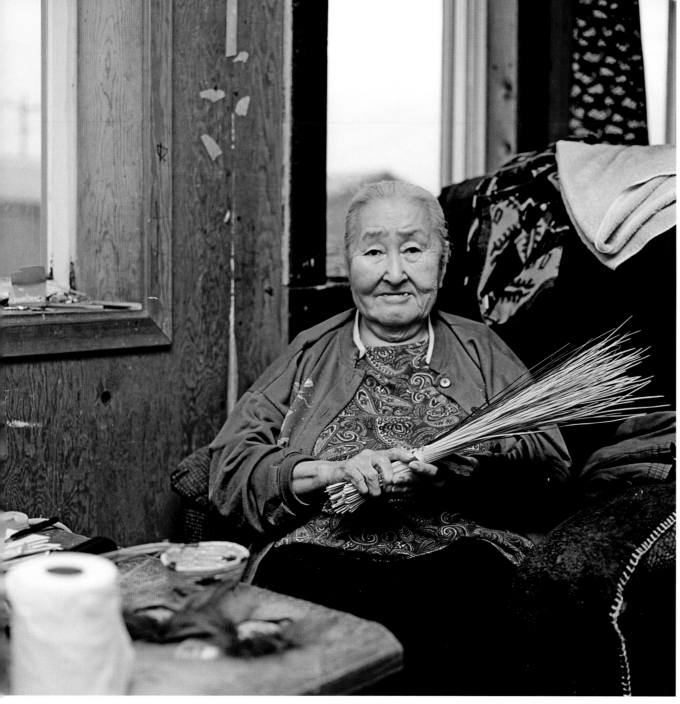

Mary Simon,
Yup'ik

"I used to live up in the mountains. When my dad died, we moved down here. That was in 1952. I have been making baskets since I was 19 years old. The baskets are made of grass; we get it down by the ocean. When the grass turns to this color, we pick it. Then we boil it in water with a little bit of salt, and then it won't break. Lots of work. We build lots of baskets; I don't know how many. I learned how to make baskets with my sister, I would watch her. She died. I also learned how to make boots from her."

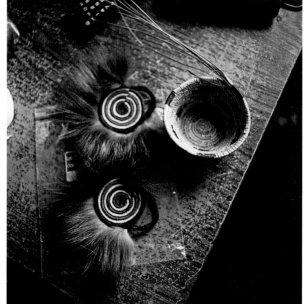

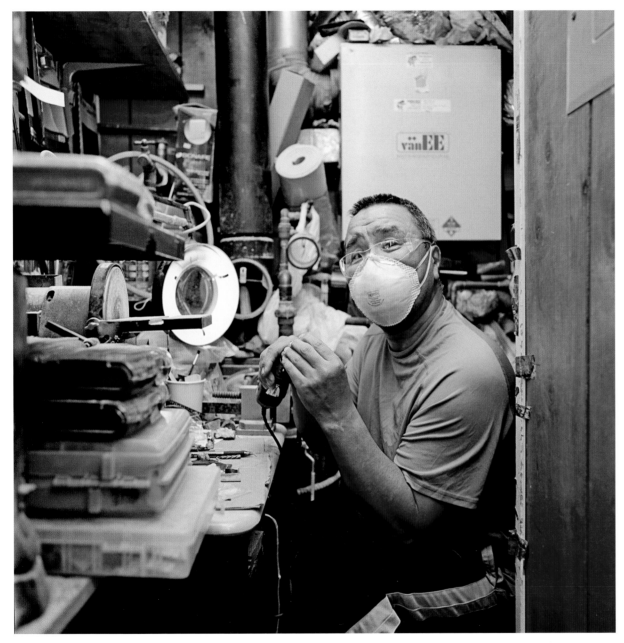

Steven Stone, Yup'ik

"I do a lot of arts and crafts, mainly carving with ivory, sometimes driftwood, all raw materials. I do a lot of work with baleen, whale bones, walrus ivory, and mastodon, all pertaining to my background and my ancestors. I try to keep the tradition going. I try to present my artwork as storytelling, before the modern days.

Me and my wife Christine do a lot of combination work, too. We work on dolls and baskets together. My wife is one of the well-known basket weavers and does all the very fine stitch work. I will make the body of the doll and she will make the outer layers, like the seal gut raincoat. The newest one we started working on is a basket. She made the basket from beach grass, and I made the caps. Right now, my favorite material to work with is mastodon ivory."

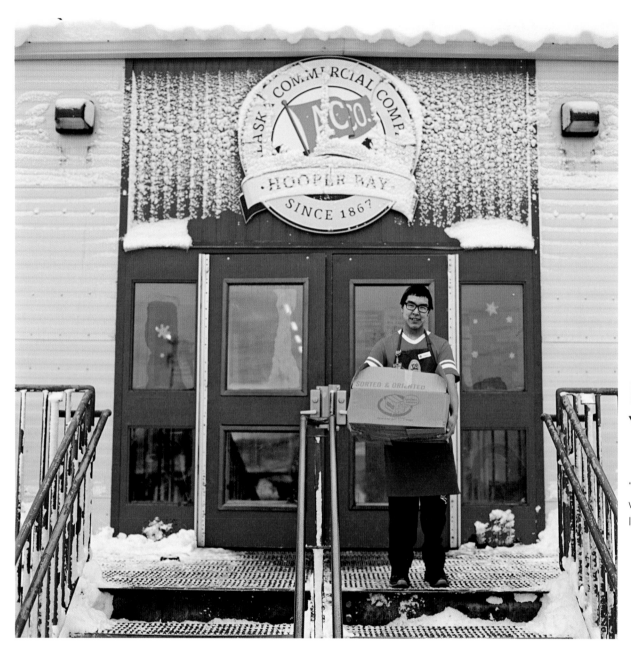

Preston Olson,
Yup'ik

"I am 17. I was born in Bethel and raised in Hooper Bay. I work at the AC [Alaska Commercial Company] store and I enjoy it."

Renee Green, Yup'ik

"My mom is from here, and my dad is from Boston, Massachusetts. We grew up here and then moved to Anchorage when I was in the tenth grade. I stayed in Anchorage on and off until 2004 when I got my degree. After I got my degree, we moved here permanently. My husband is from here too.

This is my 13th year teaching here. I try and teach them traditional stuff. Recently, I brought in a tom cod, and we opened it up. I showed them the organs and labeled everything and ended up making a traditional soup. The kids got to bring a cup home and share it with their family.

As we get older, it seems like we are really wanting the Native food. Yesterday I said to my husband, 'I feel like having walrus today.' Then this morning when I woke up, I said, 'I want to have walrus for breakfast.' As we get older it's important to us."

A polar bear at the bowhead whale bone pile in Kaktovik, Alaska. 2015.

KAKTOVIK

Kaktovik, traditionally known as Qaaktuġvik, located on Barter Island, is an Iñupiaq village with a population of approximately 260. Kaktovik is located 90 miles west of the Canadian border and 280 miles southeast of Barrow, within the North Slope Borough. The village lies on the northern edge of the 20-million-acre Arctic National Wildlife Refuge. The ruins of old Kaktovik can be seen from the road near the airport. Kaktovik is one of the communities at risk of coastal erosion as well as flood-risk due to strong storm surges with waves that fill up the nearby lagoon.

Kaktovik, Alaska. 2015.

Maktak, which is bowhead whale skin and blubber, in Kaktovik, being prepared for Thanksgiving by the Rexford whaling crew. Kaktovik, Alaska. 2015.

Alicia Solomon, Iñupiaq

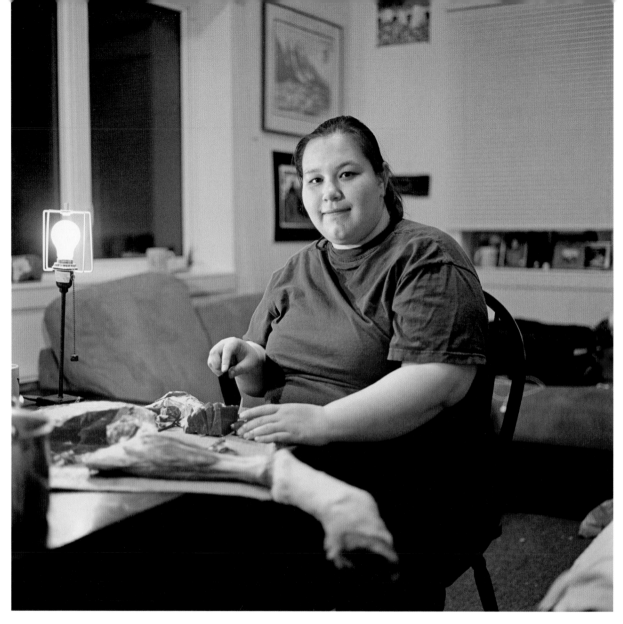

"I am Iñupiaq. I grew up in Kaktovik my whole life. I work here at KIC [Kaktovik Iñupiat Corporation] as the general manager, and I am the wife of a new whaling captain. We just started a crew this year and we caught the biggest whale. It was 50 feet, nine inches. The tail was 16 feet long! But it was really good maktak [whale skin and blubber]. Our whaling crew is called Silver Star. It was [my husband's] dad's whaling crew name, so we just used it.

My favorite part about living in Kaktovik is the peace and quiet, all the people here. We all know each other. We share our food. The best part is the food we eat off the land and the ocean, and we share it with each other, and we are not stingy.

I was on my dad's crew growing up. I knew how things were and we had a lot of elders teaching us. We would go help them and they would teach us how to do things like clean the intestines, cut the heart, cut the kidney and how skinny to cut the maktak for boiling and how small to cut the meat and tongue. Then everybody is welcome into your small tiny home to come eat!"

Kate Lambrecht, Iñupiaq

"My name is Kate Lambrecht and I am in the third grade. My favorite subject in school is science. I want to be a teacher when I grow up. My favorite thing to do in Kaktovik is go swimming in the pool over there."

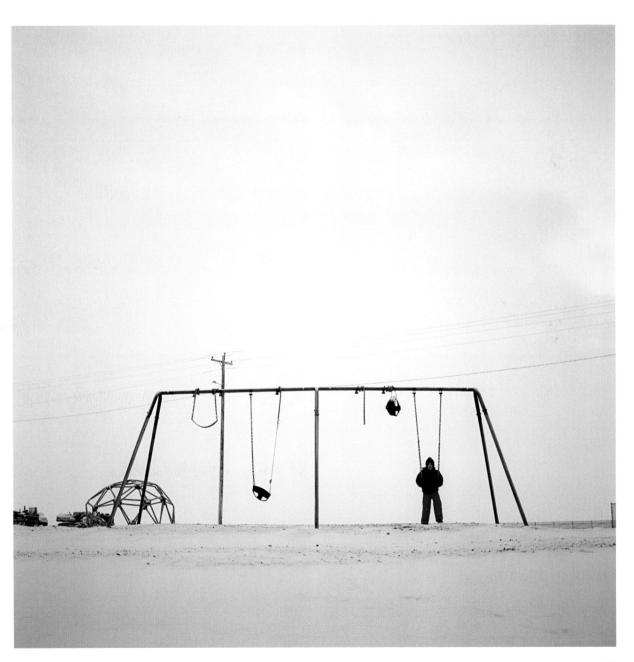

Darren Kayotuk, Iñupiaq

"I started getting into photography in 2009. I got into it for family, Mother Nature and northern lights. Mostly northern lights. It gets pretty cold taking their pictures.

There are a few photographers here in town catching up to me. There are a lot of tourist photographers here now due to the polar bears.

I went kayaking one summer and fell in. I lost two cameras and the lens. The lens didn't work for nine months. I tried it every month and it finally worked after nine months. Went right down in the middle of the lagoon. The water was calm and I was taking a picture of the mountain's reflection in the lagoon, then I put my camera away, lost my balance and fell in."

Issac Akootchook, Iñupiaq

"I was born in 1922 in a sod house here. There is a lot changing, more and more changing. That's the way it is. Today our young people don't have much work. We have got to do something for our young people; they need to think of who they are. They need to work together, and be reminded of their culture. That's what we want, that's the way we should be.

The pictures [referring to the pictures behind him] are important for your family. More history for your background."

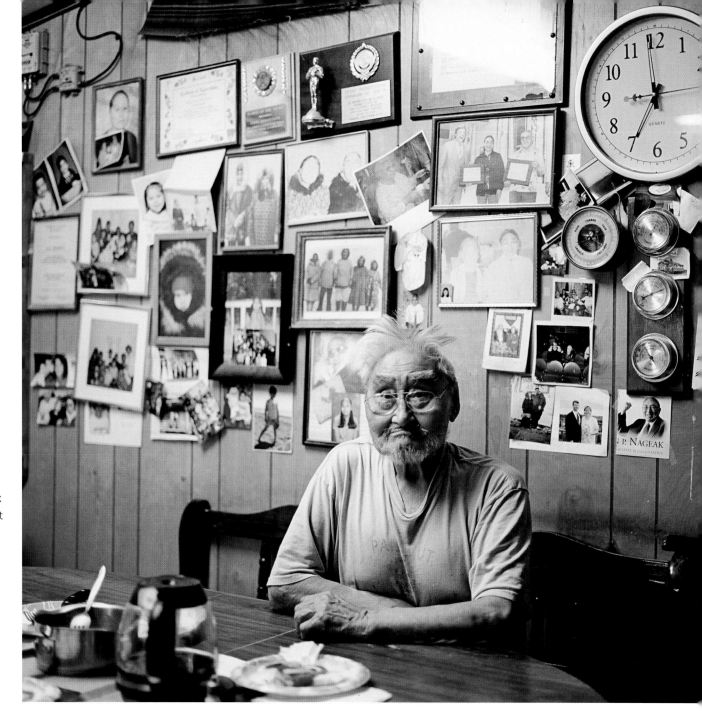

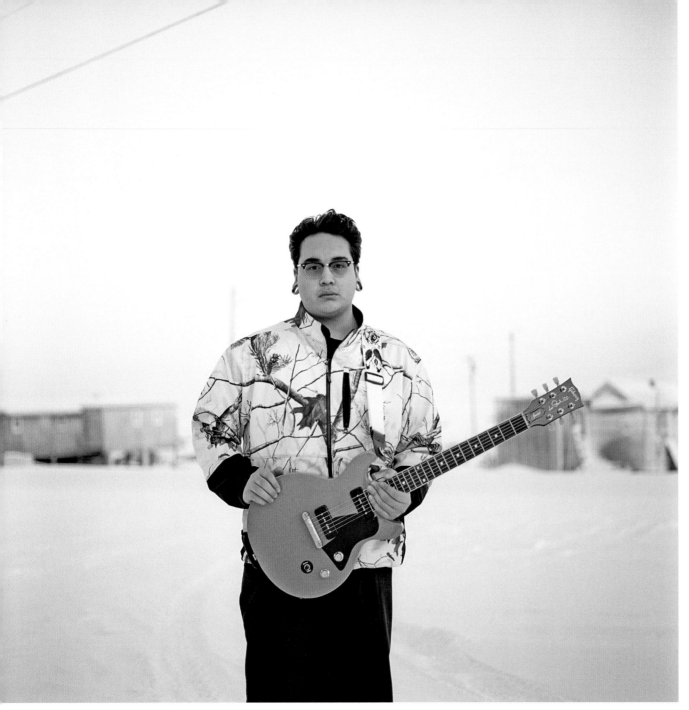

Jonas Mackenzie, Iñupiaq

"I started getting into music eight years ago. I started playing guitar six years ago—a few chords and learning from my uncles and cousins. And then I started singing four or five years ago. I used to watch my uncles playing and wanted to start playing. My cousins were listening to all kinds of rock and roll and I would watch all kinds of music videos and see Slash playing. My favorite right now is ACDC and I am really into old '50s rock and roll, and old country like Hank Williams and Johnny Cash."

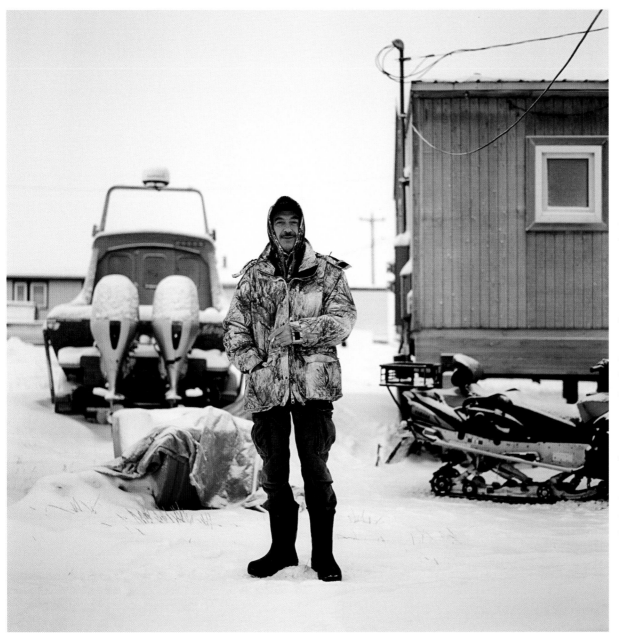

Bruce Inglangasak, Iñupiaq

"I am originally from Canada. I have dual citizenship. So, I can come and work here or live here. My parents and grandparents are from here; they moved to Canada back in the '30s.

I am a subsistence hunter and gatherer and I run tourist boat tours here. I am Kaktovik's first polar bear guide. When I came here, the State of Alaska had an economic problem and they had no work here for any of the local guys. The only people that were working are the people who had a position with the North Slope Borough power plant, clinic, or school. Nothing for the community.

I can tell you, there are a lot of people trying to get their noses in here. But our community, we don't want that. This is a community-based operation for the community. The people who live here, they are the only ones experienced. Our people here, we know every nook and cranny. We know where to go for our animals at any given time."

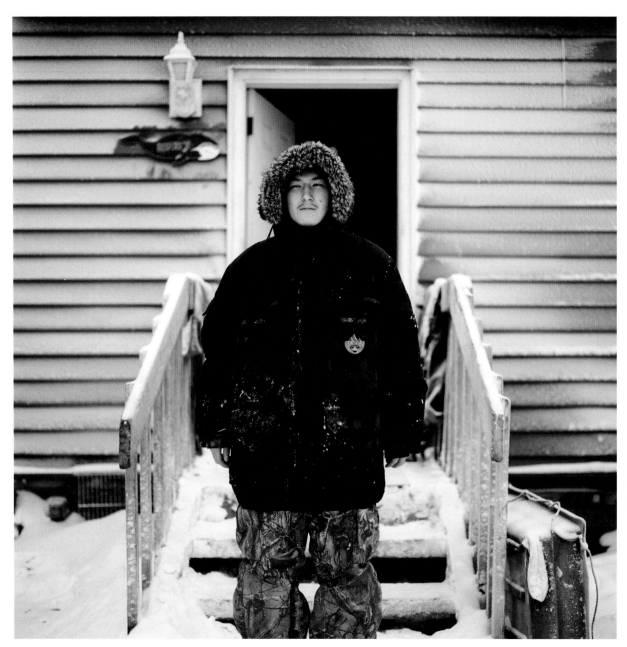

Levi Rexford, Iñupiaq

"I grew up here all my life. You are going to get a lot of good pictures."

Mary Ann Warden, Iñupiaq

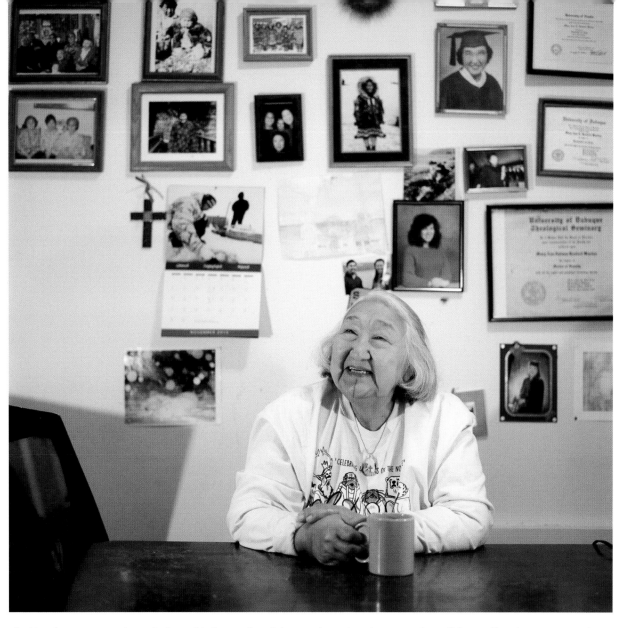

"Eddie Rexford and I are both adopted. He was adopted later. I was adopted because I was named after my aunt's and uncle's first daughter. Her name was Mary Ann, and she had died. When my sister was born, they decided to move to Barrow, and the only way we traveled back then was by dog team or boat. It was in February. They decided to leave me behind, and Martha, his daughter by his first wife, begged them to take me along, she told them she could carry me on her back, but they didn't listen. They left me behind with my new parents, Herman and Meldred Rexford. Spring came early that year. They came back by boat. When they came back, they tried to take me back with them to their home and family. I cried; I wanted to stay with my new parents. So they just left me there with them.

When I was little, we traveled by dog team to go hunt sheep in the mountains. My mom would dress me in caribou snow pants, boots, and parka; I was nice and toasty. I used to pick frozen berries while they trapped squirrels. I remember one time Hulahula River was frozen, they put a sail on the sled and we sailed down to the edge of the river. That was so cool. We always trav-

eled by dog team, and my dad would sing and yodel. We would watch the sky and the aurora; it's dark and the moon is bright, so we would know where we were going. Those were good times.

I remember when the Army first came. They came with big ships—noisy, noisy. We had a tent down there and I remember I was with my uncle and we were down

there to take care of our fish net. But they came and we got scared, rushed into our tent and covered ourselves up. Those GIs or whoever they were came peeking into our tent. We had a nice quiet village and then they came. They were so loud, with all of their equipment and building. They were building a warning system during the Cold War. We moved our little sod house from where the airport hanger is to over here."

Marie Rexford, Iñupiaq

"We are getting the maktak ready to serve during Thanksgiving. We caught this whale on September 23rd. It is a bowhead whale. We are allowed three, our quota. We had lost one, so we had asked one of the villages if it was okay to have one of their whales, and we are thankful to Kivalina for giving up one of their whales. In the past we did that with them. We knew we would be short on maktak if we had only two, so we asked one of the captains to ask them. Ours was 44.6 feet long.

I am the captain's wife, second in authority. Actually, first from what I was told. When I found out, I said, you all know what to do, do your thing. My first crew I went on was my dad's crew. I was 16. Then I married Eddie. I used to go out with his uncle's crew, then he passed the crew down to Eddie, and that's when we found out how it really works... Eddie's uncle showed us how the authority works, how to do this and that. How to talk to new crew members, what not to do out there and what to expect from them.

You're not supposed to holler when you're hunting. You keep quiet; you keep your eyes out for the blows. All eyes are always looking out because there is a whale out there somewhere. You will find it, and sometimes there is a bunch of them, all at once, one strike, we go for that one strike. We never caught two whales at a time before. I never want to see that happen because it will drain out everybody, trying to cut them up and get them put away before the polar bears get to them.

There is 24-hour Nanuq Patrol during whaling, because we've got polar bears waiting. You can see one of our pictures over there, one of our guys is bringing blubber to a polar bear that didn't want to go away, so they brought him some blubber to keep him away from the cutting."

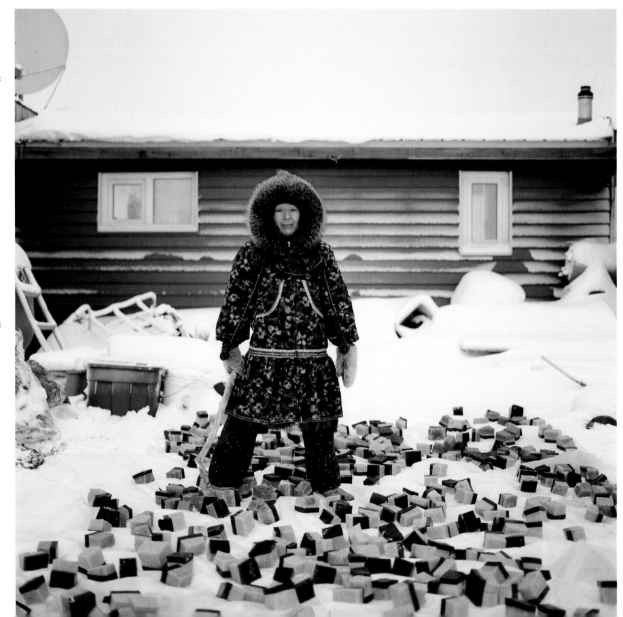

Linda Soplu,
Iñupiaq

"I lost my twin sister in 1988. My daughter in there [inside the house] is named after her. Her name is Lucy."

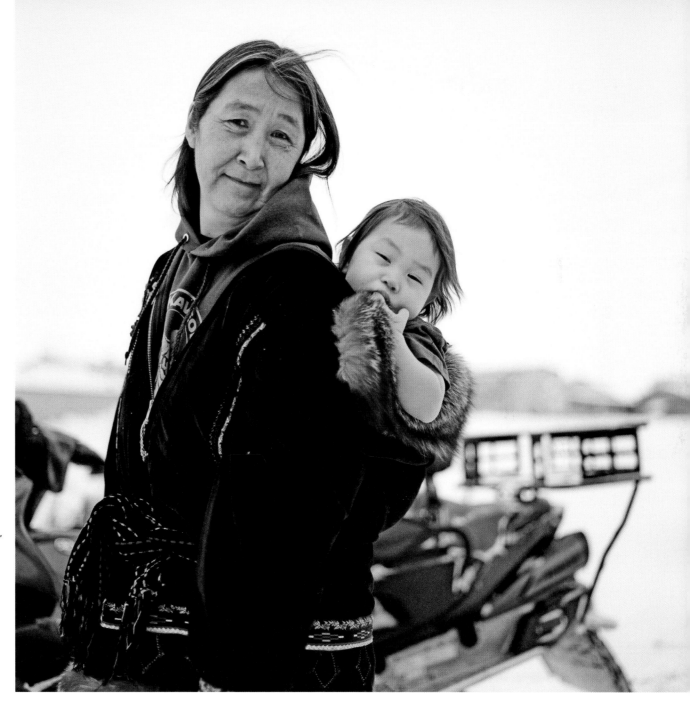

Nora Jane Kaveolook Burns, Iñupiaq

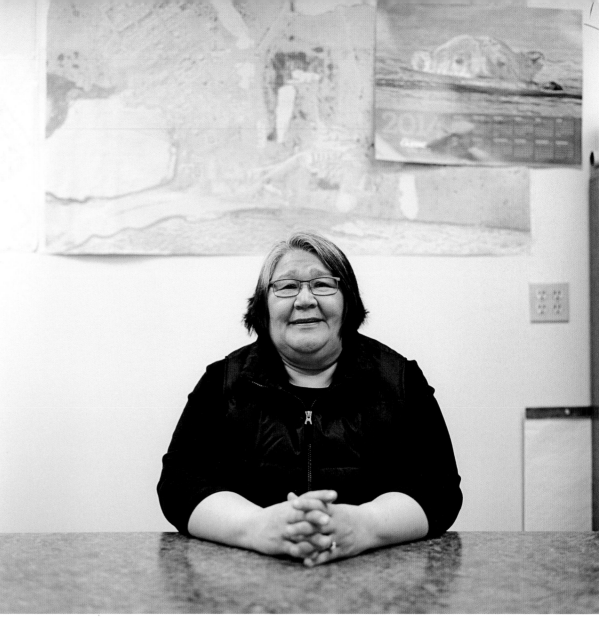

"I am the current mayor of Kaktovik. This is the third term that the Council has selected me. I have been in the Council since 1992 or 1993, when my girls were small. I grew up here for the first 12 years of my life. My dad was a teacher and he transferred to Barrow in 1969. I finished high school in Barrow, then went to college, and then went back to Barrow. I met my husband in 1988 and then we moved here.

We are working on a lot; promoting healthy communities, polar bear patrol, tourism, and making sure there are monies to run the city. It's getting harder and harder because the funds are getting less and less. We are working to be sustainable and protecting the sea animals that we have. So we are against offshore drilling, that's where all of our fish that we harvest come from. We are working to protect our way of life up here and better education for our children.

Tourism is a good and bad thing up here for the boat guiders. They make money, but it's just for a short span of time. It's seasonal. But when they start coming in in August, September, and October, the flights are always booked, and you have to book your flights way out just to make sure you have a seat. We are working on making it better. There is just one airline here and when elders have medical needs it takes them longer to come home when the flights are all booked. Cruise ships are talking about trying to come here too. And we have to tell them that there's not enough room here to accommodate everybody. There is just enough room for the ones that are already here.

Our island is shrinking; on the north shore, on the bluffs, you can see where the ocean is breaking the permafrost. Even our tundra is melting, that's our next big problem. It's happening every summer. You have to level your house, but they don't have the equipment to level their own homes to keep them straight."

Tori Inglangasak, Iñupiaq

"I graduated in May. I have been helping my dad do tourism for a year and a half now I think. He got me this truck in December for a graduation present. I do tours. I like to watch the bears—I like it, and I am going to get my six pack [captain license] soon. After I go to the Tribal College in Barrow, I am going to come back and work again with my dad, and hopefully after I am done working I am going to go for my six pack.

I grew up partly in Canada. I was six when I moved here. It was difficult at first. I missed family, I couldn't cope with school. But, I got through it. It's change, and it's hard, but it's change. It feels good. I love this village. My favorite part about this village is whaling and hunting. I love going hunting in the spring. My least favorite part about this village is drama. We have drama—teenage village drama. I get hooked into teenage village drama way too much."

An abandoned bike on the Kotzebue Sound facing northwest.
Kotzebue, Alaska. 2015.

A dog team on the frozen Kotzebue Sound, photographed
from the observation deck of the Nullaġvik Hotel in Kotzebue,
Alaska. 2016.

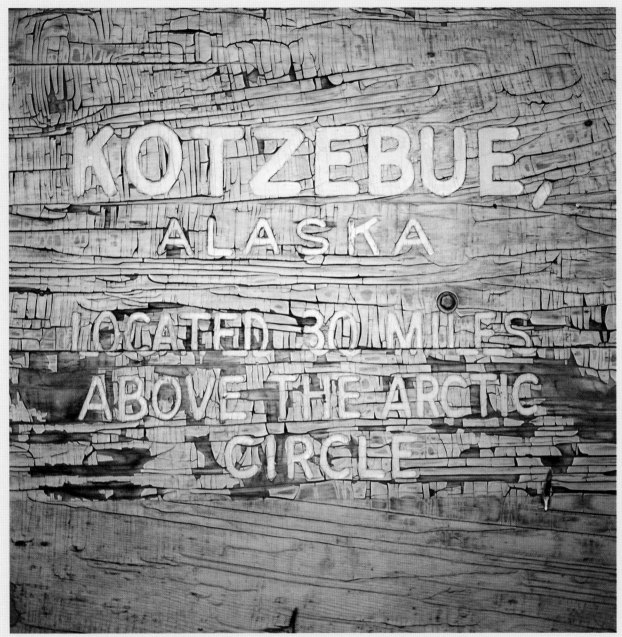

Kotzebue, Alaska is the regional hub town in the northwest Arctic region. 2015.

KOTZEBUE

Kotzebue, traditionally known as Kikiktagruk, is an Iñupiaq village with a population of approximately 3,500. Kikiktagruk is the Iñupiaq word meaning "almost an island." Kotzebue has been home to Iñupiat for over 600 years and is the largest community in northwestern Alaska. It is located along three miles of a gravel spit on the Baldwin Peninsula, which extends into Kotzebue Sound near the mouths of the Kobuk, Noatak and Selawik Rivers. Kotzebue is 26 miles north of the Arctic Circle and 549 air miles northwest of Anchorage. Kotzebue is a gateway to the region's other communities, and to natural wonders such as the Bering Land Bridge National Preserve, the Noatak National Preserve and the Kobuk Valley National Park. Kotzebue is a vital hub for the Northwest Arctic Borough with eleven villages who rely on Kotzebue as a primary transportation center, for administering region-wide health care, shopping, and other areas.

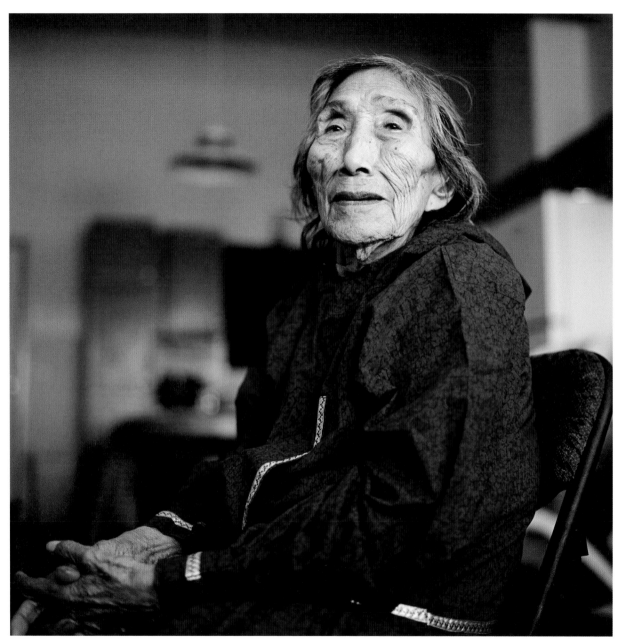

Beulah Ballot,
Iñupiaq

"Burnette is my maiden name and when I was married, I was Ballot. We never married the way they do today. We prayed, and held our hands together—no rings—and I still honor [my marriage]. I was born above Selawik, we lived up there. Stink fish, aarigaa ['it's good' in Iñupiaq]. That was my favorite. I was a tribal doctor; I was a midwife. When I played basketball in 1986 I took a trophy home."

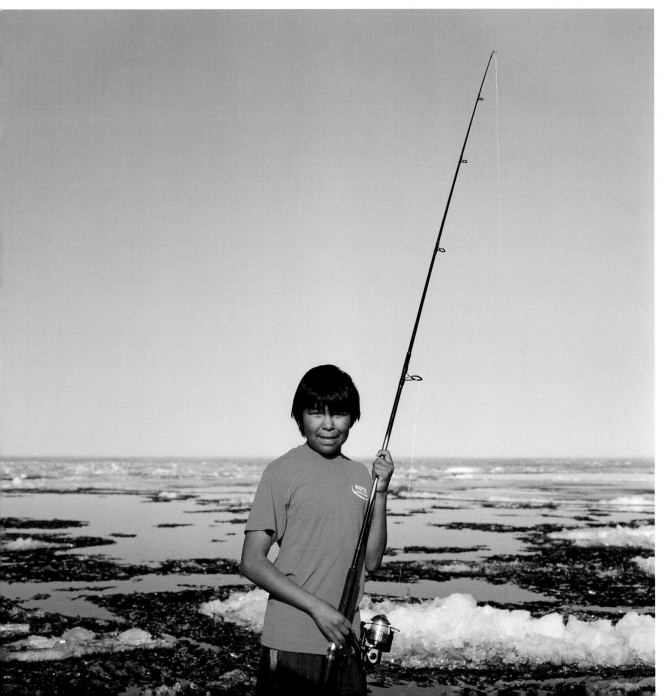

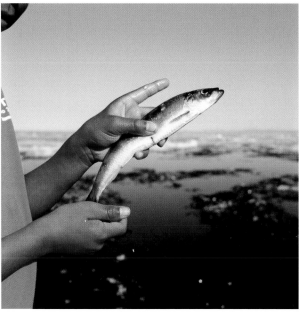

Trenton Nazuruk, Iñupiaq

"I am fishing for herring. They're early this year. We make pickled herring. You have to skin it, and take off the head and tail, and jar it for about a day and a half."

NOATAK

Noatak is an inland Iñupiaq village with a population of approximately 500. Noatak has been home to Iñupiat for about 5,000 years. Elders selected the current site of Noatak for its significance of seasonal hunting and fishing, trapping, strategic location to access various camp sites, supply of wood for heating, and abundance of fish. The village is located on the west bank of the 396-mile long Noatak River, a few miles west of the 66-million acre Noatak National Preserve. Noatak is 55 air miles north of Kotzebue, 70 miles north of the Arctic Circle and within the Northwest Arctic Borough.

Youth doing the "crawl race" as a part of the Christmas activities in Noatak, Alaska.

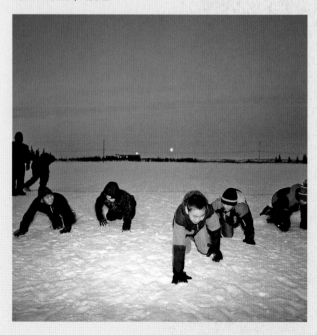

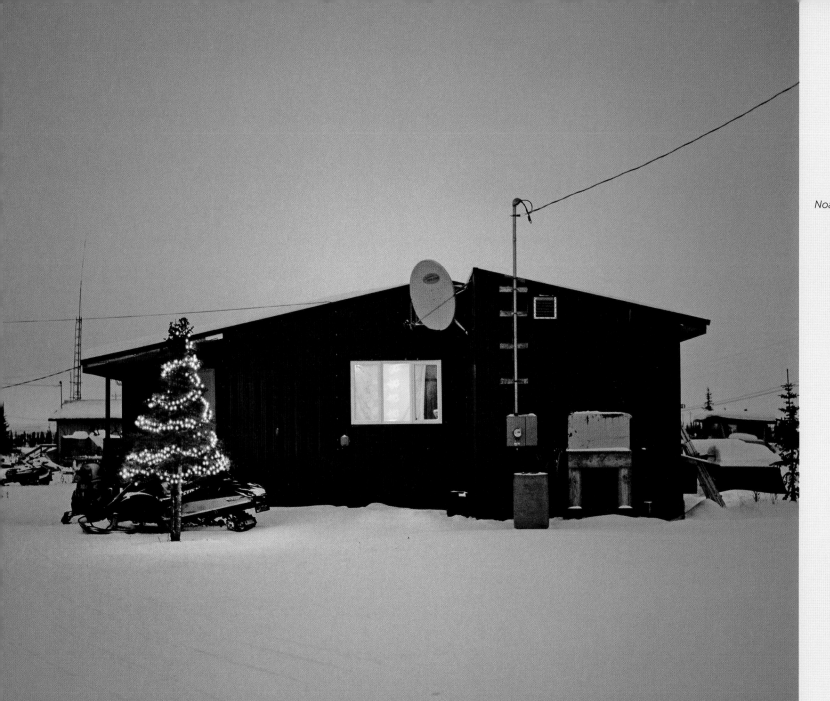

Noatak, Alaska. 2015.

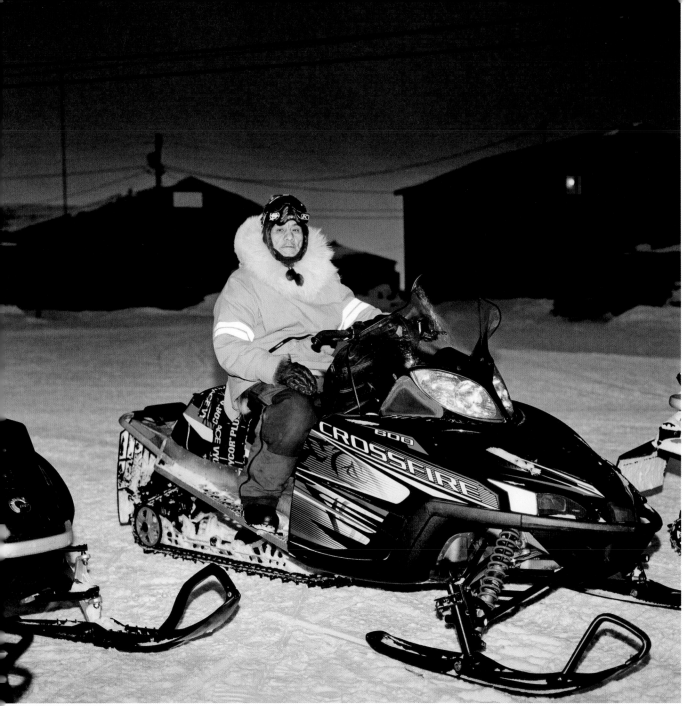

Enoch L. Mitchell, Iñupiaq

"We are getting ready to go check out the proposed Red Dog [Mine] haul road for our village's fuel. It's about a three-to-four-hour trip [on snow machine] to get to the haul road from here. I am taking the National Park Service. I am their local expert. I have hunted in this area all of my life. It's pretty rough out there."

Lonnie Arnold, Iñupiaq

"Ever since I can remember, I have been participating in the Native Games—from zero to three years old I started. My favorite game is the Eskimo Crawl Race. That one is pretty fun. I am one of the judges here at the Christmas activities Native Games at the gym."

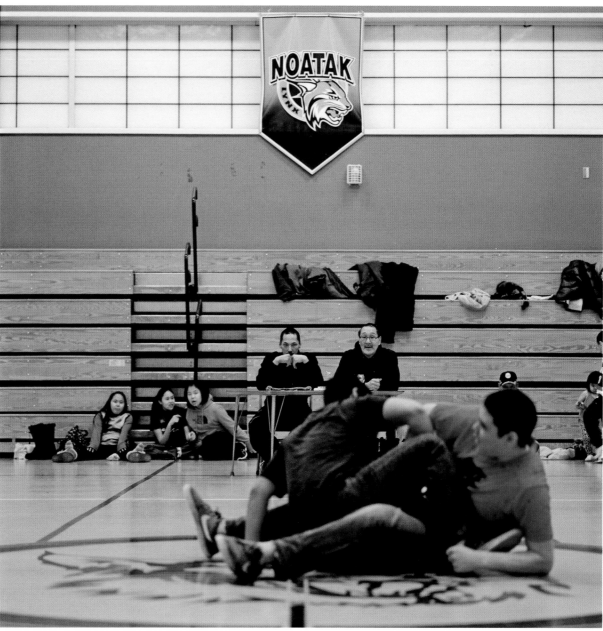

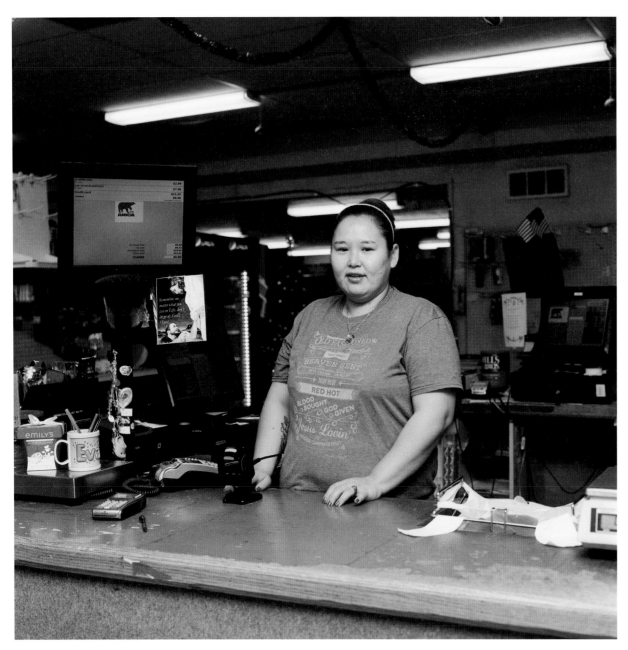

Eva Wesley, Iñupiaq

"I just started working here [Noatak Native Store] on call last month. It's good; it's village life. I am used to it. I am married to Percy Wesley. We have been married for 12 years and we have five kids. We recently dedicated our lives to Jesus. We did it as a family and we have been going around gospel tripping. We have done a couple trips so far to Buckland, Deering, Noorvik, and we are going to Kotzebue. We hold church services, usually there are about ten people. It's called Fellowship Group."

Fred Vestal, Edwin Vestal and Lester Vestal, Iñupiaq

"We are all brothers. They call us the lumberjacks. We are cutting this wood for our uncle. He lives in one of the oldest homes in Noatak. We call this an odd job. People are always asking for wood to burn. We have to go two to three miles out of town to get the wood. You have to find it."—Edwin Vestal

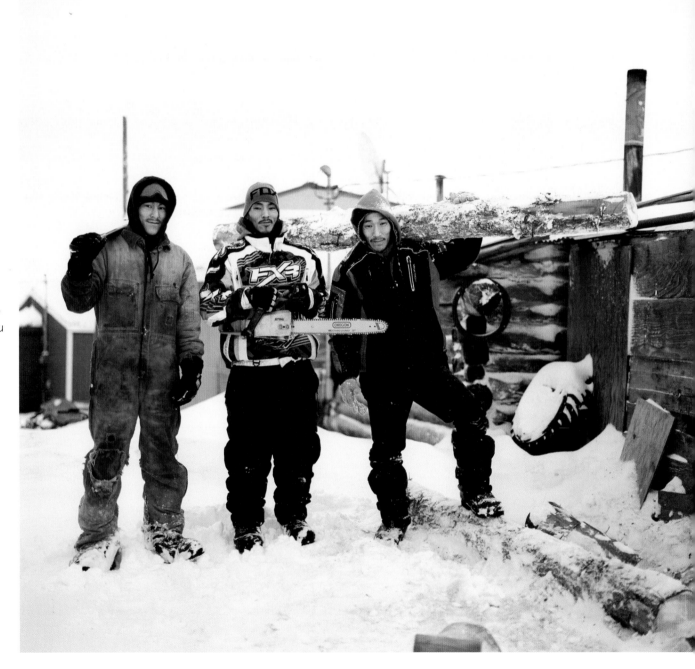

Martha Burns,
Iñupiaq

"I am originally from Kotzebue. I married a man from Noatak, that's what brought me here. I had 13 kids, one adopted. My brother arranged my marriage even though I was going with someone.

I have been in Noatak since 1948. I like Noatak. We would go hunting just across from Kotzebue, every summer we would go down there to hunt ugruk [bearded seal] and stuff for our food. That's how we live—we go around the world.

I like to go berry picking. I like to do things, but I can't do anything anymore, but my boys are taking good care of me. I am 85 years old, some people can't believe it! I can still understand English and Eskimo. That's how I was raised. My dad was a pastor in Noatak and Kivalina. We would travel to Kivalina with dog team. That was the good life. I love the outdoors."

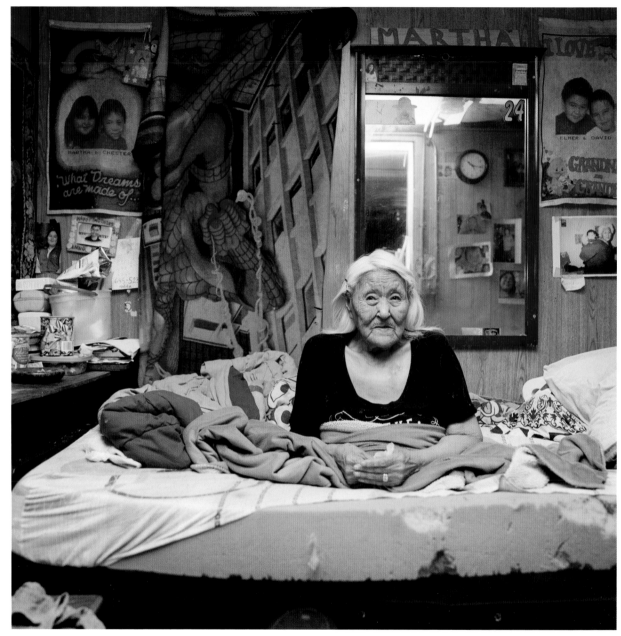

Peter Norton,
Iñupiaq

"I just gave my Aana [grandmother in Iñupiaq] Viola
Norton a ride home from the gym."

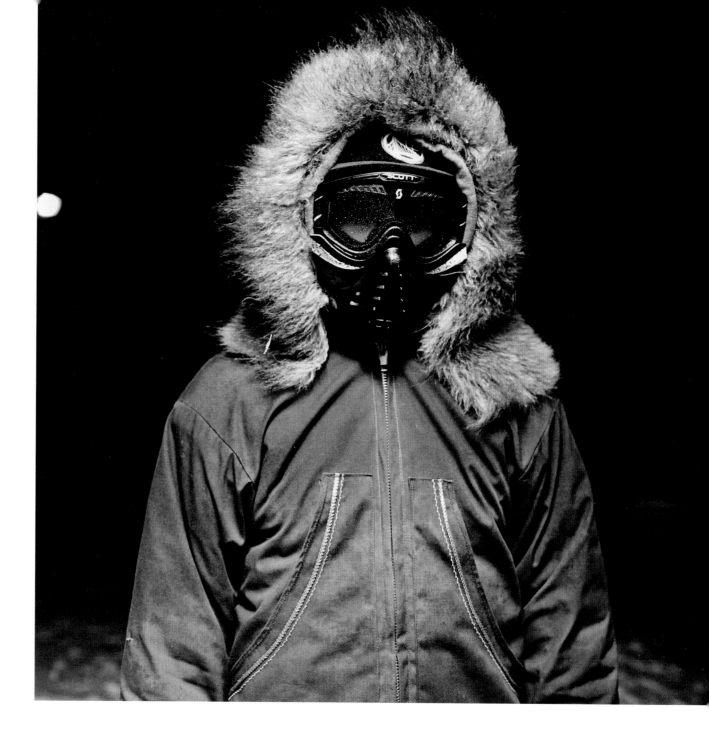

Philip A. Booth with his adopted sons Philip Jr. (middle) and Brandon (right), Iñupiaq

"I turned 80 on the 26th of this month. My dad was a chief reindeer herder when I was growing up. We grew up with the reindeer. We had a boat and a 22-horse-power Johnson motor. When the snow machines started coming in about 1965, I was the first one to buy a snow machine in those days. It was a Johnson 14-horse. Slow, but sure faster than a dog team anyway. Then in 1966, in the fall-time people started buying them. From there on, no more dogs. Gas was cheap, not like now when it's $10 a gallon."—Philip A. Booth

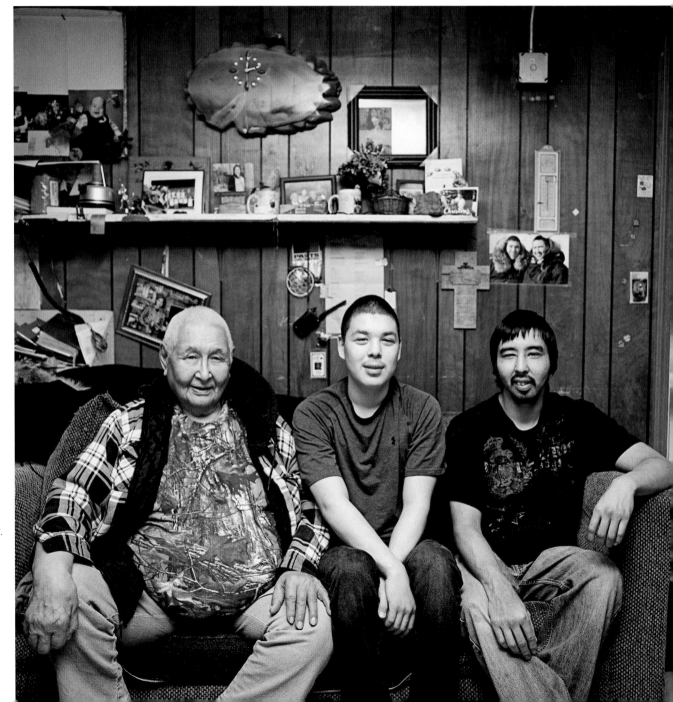

Steven Booth, Iñupiaq

"I live in Anchorage now. I am here for Christmas and family. I grew up coming to the Christmas games. I used to partake in the games. I was diagnosed with leukemia in 2012, so I don't have much strength left to do anything—bones hurt. I moved to Anchorage because it has warmer weather and it's easier on my body, and it has all the fresh food and the greens, the stuff my body is lacking. I do miss it here. It's good to live here, but I had to move for my health. I work as a tribal doctor for Southcentral Foundation [an Alaska Native health provider]. I was trained in '97 for four years. I work with blood, germs, migraines, and breeched babies."

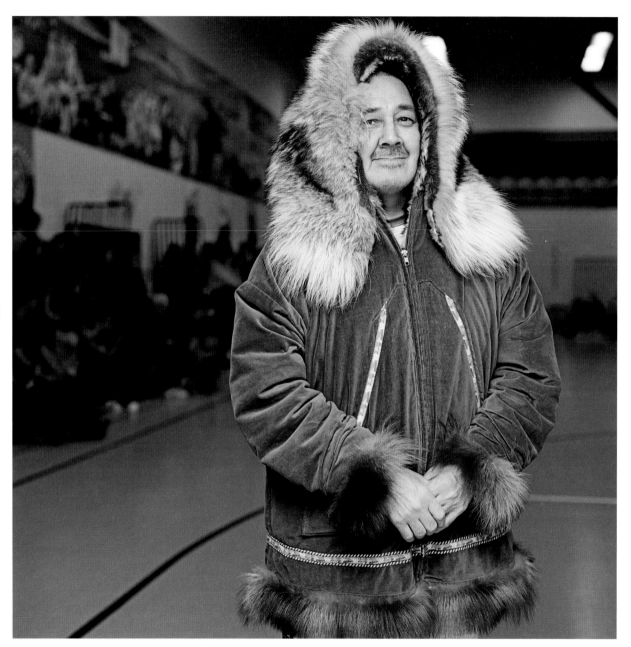

Whittier Burns, Iñupiaq

"I was born and raised right here on February 20, 1957. Full Iñupiaq bred. My mother was going to have me in a fishing camp, but they brought her back here and I was born in a log cabin. In my early years, when I was 14 or 15, I used to take care of dogs—86 of them to be exact. 46 belonged to my dad and me, and then 40 were owned my dad's friend, a guy from Nome. He came from Nome to here and stayed up here for six months. I used to have to go feed them before school early in the morning, at six in the morning. A lot of mouths to feed. Those were the good old days—no power, no running water. We used to have to pack our own water and use dog teams to go get wood. We started using snow machines in the 1970s. When the guy went back to Nome, he called my dad and told him he got a snow machine. My Dad said, 'What is that?' He said, 'An engine with track, and skis.' My dad went up to Kotzebue with a dog team and came back with a snow machine.

There were hardly any jobs in the region before they formed NANA. My first job was here in the village; I was a lineman. I would watch the engine drivers dig. I was about 13 years old. In '82 I started training for NANA. We were the first ones to go up into what is now called the Red Dog Mine. We would go up there in March and come home in October. We were doing core drilling, exploration drilling. Those were the good old days—work, work. After that I worked for contractors. I was even a council member in my teens. I got paid $5 a meeting, and that was a lot back then and helped the family. I was also a village police officer back then for four hours a day. That was a tough job. It was all personal. You don't want to arrest relatives but you have to. The village would take care of them and make them work for elders."

Eugene K. Monroe Sr., Iñupiaq

"I am full-blood Eskimo. I went to grade school here, then I went to Mount Edgecumbe for high school [boarding school in Sitka, Alaska], and after I graduated I got drafted into the Army. I spent two years in Washington around Seattle—Fort Lewis. I didn't go overseas. A lot of times we would get packed up all ready to go, but we never did go. That was in '59 and '60.

After I got my discharge, I came back home and got married in '62. And after that, I went on, life went on. I went to work in Kotzebue for 13 years for the hospital—public health service. We settled down, made a house, raised a family. We have three daughters and one son. Our first son got in a hunting accident across from Kotzebue. He went across with his friends on snow machines. He passed away. He was 17. He loved to go out, he and his buddies. It was a horrible thing for us.

We moved back to Noatak, and I went to work for the school. I retired from there. Bernice and I run a bed and breakfast here now."

The colorful Christmas lights that are strung up all year in downtown Nome, Alaska. 2016.

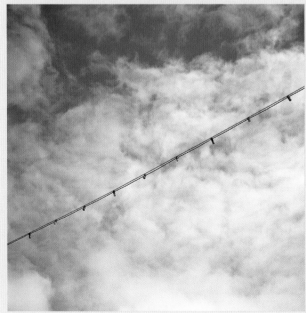

Friends, Tiana Brown and Mason Krier, fishing for pink salmon, otherwise known as "humpies" on the Snake River in Nome, Alaska. 2016.

NOME

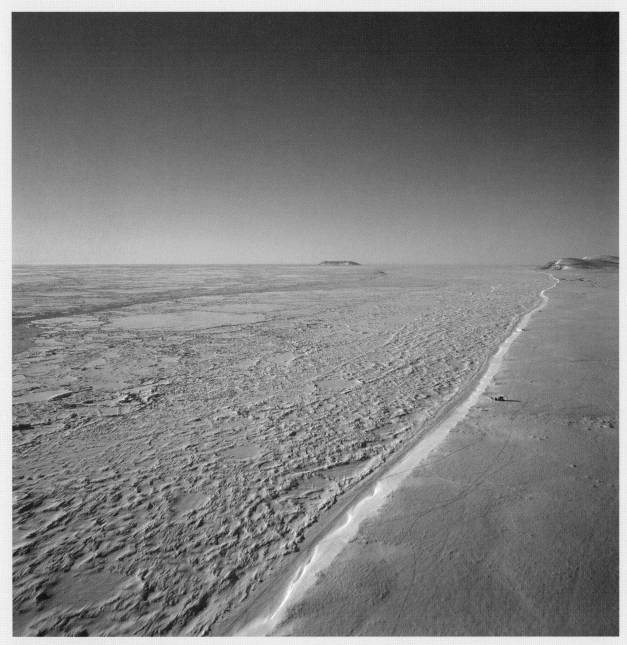

The community of Nome is located on the south coast of the Seward Peninsula on Norton Sound. The population of Nome is approximately 3,500 and includes a diversity of Iñupiaq, Yup'ik, and St. Lawrence Island Yupik residents. It lies 539 air miles northwest of Anchorage, 102 miles south of the Arctic Circle and 161 miles east of Russia. The Three Lucky Swedes discovered placer gold in Anvil Creek in 1898, which brought on the gold rush. In 1899 the population of Nome rapidly increased to 28,000. Gold mining has made a return in Nome and continues today. Malemiut, Kauweramiut, and Unalikmiut Iñupiat occupied the Seward Peninsula historically with a strong culture and adaptability. Located on the edge of the Bering Sea, Nome is a vital hub for the 19 villages of the Bering Strait who rely on Nome as a primary transportation center, for administering region-wide health care, shopping, and other areas.

The coast of Nome, Alaska facing west, en route to White Mountain, Alaska. 2016.

Blaire Okpealuk, Iñupiaq

"I am full Iñupiaq. My grandparents come from Little Diomede, and my grandma comes from Russia. I am originally from Wales. We used to live in Anchorage, but we moved here because my family is here. I really wanted better health care for my son—better education and more opportunities."

Jessica Gologergen, St. Lawrence Island Yupik

"I work two jobs here—at the coffee shop and evening shifts at the rec' center [the community gym]. I am saving up to go back to Hawaii and do modeling—well, continue my modeling. I was an import model for maybe four months, then I came home."

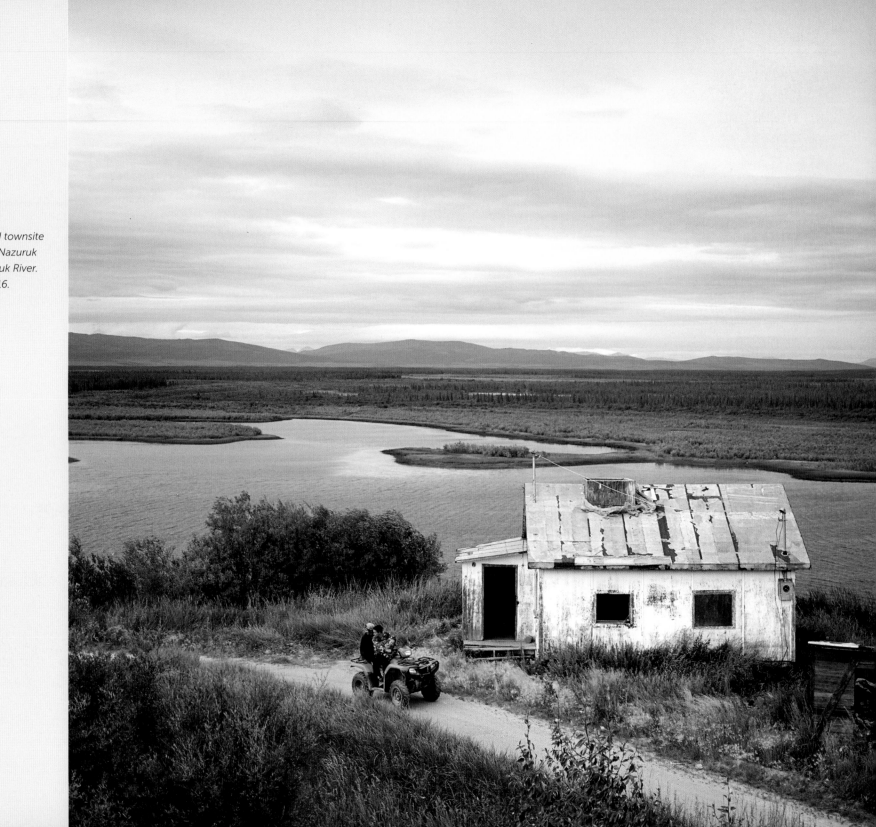

Overlooking the old townsite of Noorvik and the Nazuruk Channel of the Kobuk River. Noorvik, Alaska. 2016.

NOORVIK

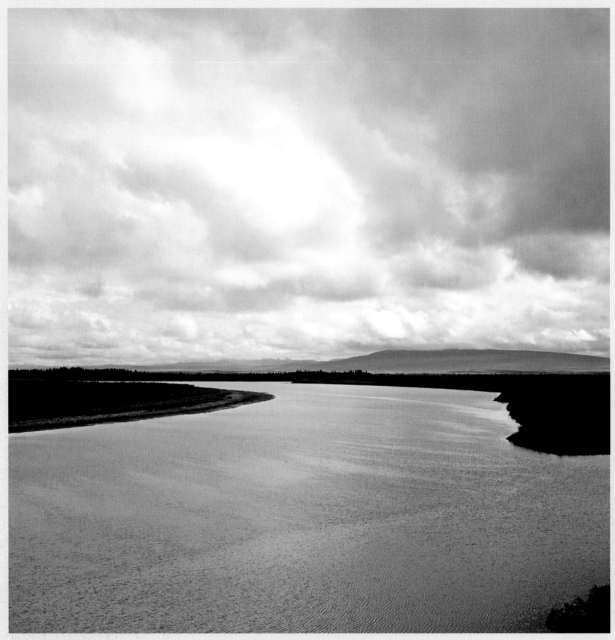

Noorvik, traditionally known as Nuurvik, is an inland Iñupiaq village with a population of approximately 670. Nuurvik translates to "a place that is moved to" in the Iñupiaq language. The village is located on the south bank of the Nazuruk Channel of the Kobuk River, about 30 miles downriver from the southern border of the 1.7-million acre Kobuk Valley National Park. Noorvik is 42 air miles southwest of Kotzebue on the opposite side of Hotham Inlet, also known as Kobuk Lake. It is in the Northwest Arctic Borough. Noorvik was settled in the early 1900s, primarily by people from Deering, a village 75 miles away, across the Kotzebue Sound and Aksik, a village located a short distance upriver.

The Nazuruk Channel of the Kobuk River from Noorvik, Alaska. 2016.

Secret swing in Noorvik, Alaska. 2016.

Bradley Jackson, Iñupiaq

"I am 11. I like to walk, hang out with friends, go to the BNG [Boys and Girls Club]. We play games, play with computers, and have snacks."

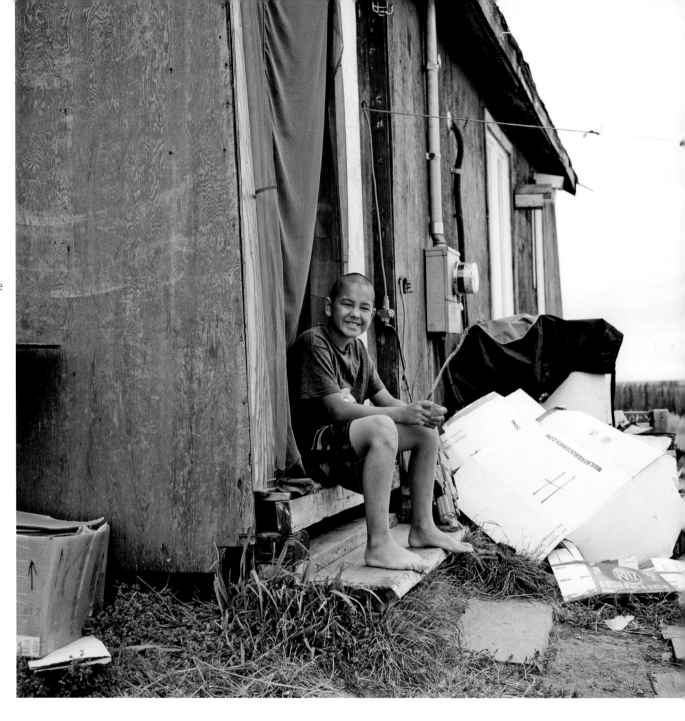

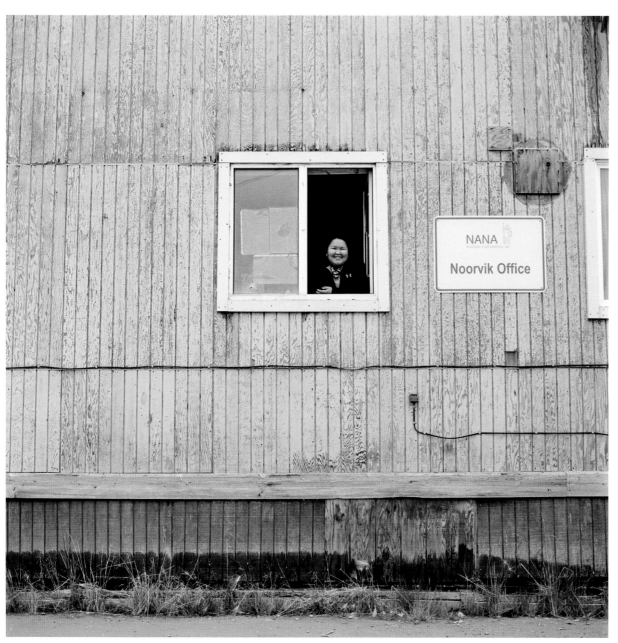

Sophie Georgine Cleveland, Iñupiaq

"When I first graduated from high school, I left Noorvik. I moved to Palmer, lived there for a few years, got a job. Then I moved back home in 2010. I started working here at NANA [Regional Corporation] a few months ago. I help our shareholders with anything I am capable of doing. I have a lot of people that come in and we have a lot of shareholders. There are about 650 people that live here. It's one of the bigger villages.

When I am not working at NANA, I work with the kids. I open the gym, and I help out the community when it needs help. I like fundraising. We even have softball games down at the beach. Yesterday we helped out the elders. We went to most of the elder's homes and hauled out their trash and took it to the dump. I also work with the school. I set up mock job interviews for the seniors and juniors, to help them in the job market. The kids love it. I keep pretty busy, I like it."

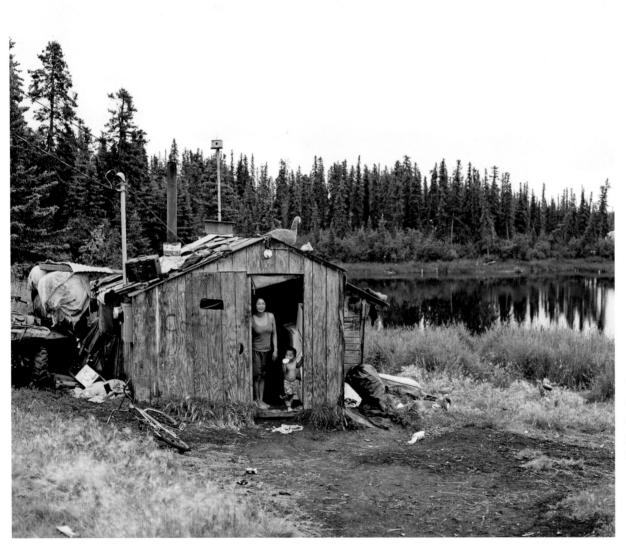

Diane Coffin, Iñupiaq

"I love it here. I have a few kids; my oldest one is living downtown. We pick berries and have fun with my children. It's been a great season, a lot of fun. We were just picking blueberries. I haven't gone out for salmonberries yet."

Helen Wells,
Iñupiaq

"I grew up in Selawik. I married a man from here, and we moved here. As soon as I got married, I moved here. He was a Christian, and I enjoyed Bible school. When I got to Noorvik, I started going to Bible school here. After that, I started working at the Bible school teaching. I had no babies for a long time. I had only one when I was 35."

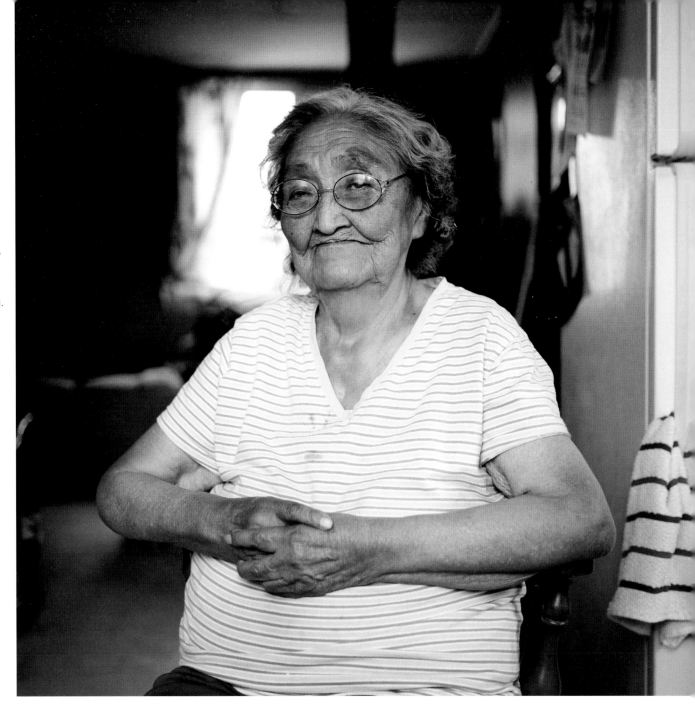

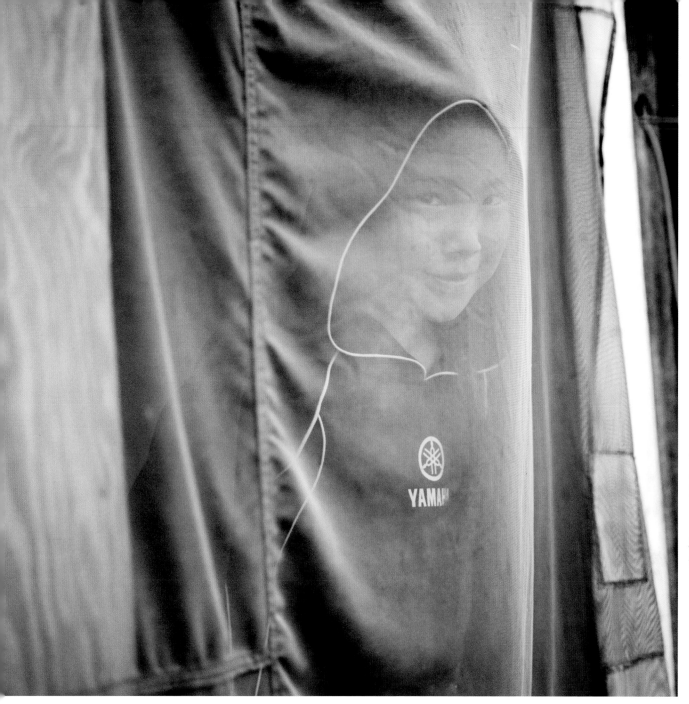

Jennie Massaun, Iñupiaq

Jennie Massaun, behind a mosquito net at the entrance to her home in Noorvik, Alaska. 2016.

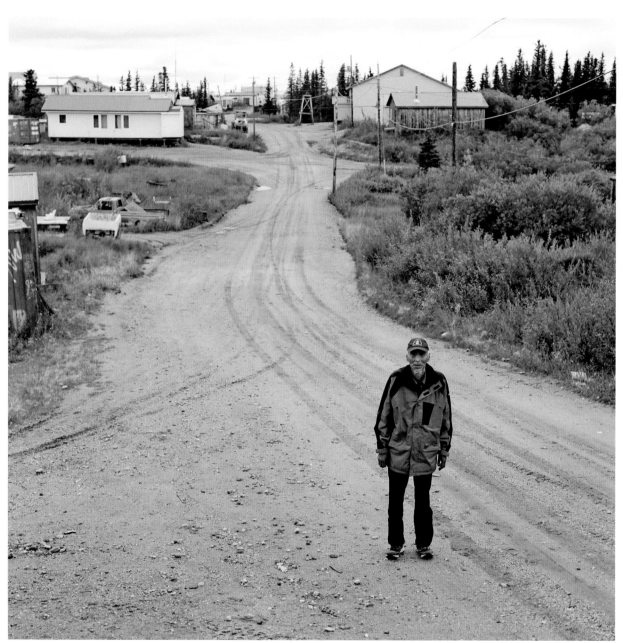

Kirk Sampson, Iñupiaq

"I am full blooded Iñupiaq. I am part of the [Native Village of Noorvik] Tribal Council. I am a Council member, and I just got back yesterday from a conference we had in Kotzebue. We talked about the road projects happening in Noorvik. We are working with AVEC [Alaska Village Electric Cooperative]. They are trying to put in some more solar panels.

You see those fish racks across the river? There's people fishing; they have their nets in the river. They dry and smoke their fish across the river because the beach over here is sandy, and when it gets windy the sand gets to the fish. Noorvik is the only village with a sandy beach. Any other village you go to is either tundra or gravel. The island across from here is all sandy too. Kids go swim in the water over there."

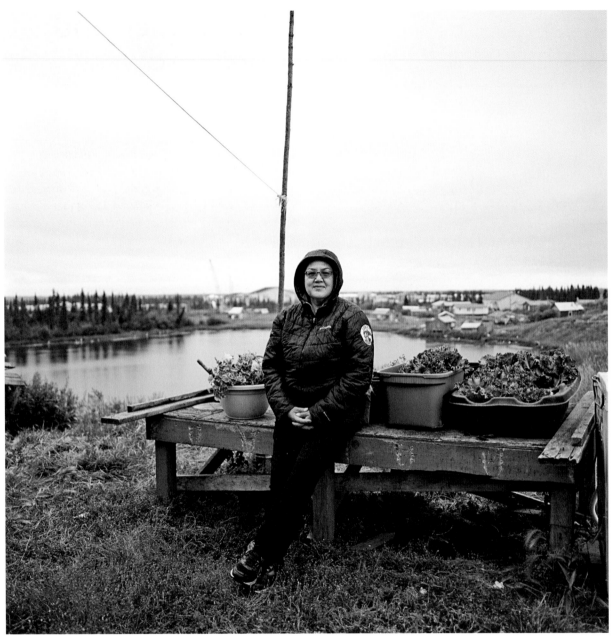

Karen Jackson, Iñupiaq

"This part of town is the old village. This is the original village, before they moved down there. The house we live in was built in the '40s. It's one of the last original homes built up here. The whole town moved.

I have had a lot more in the garden. I don't grow in the ground itself, because I don't know what's in the ground. So I put my plants in the pots just to be safe. Last year I grew cabbage, kale, broccoli, cauliflower, lettuce, and celery. The cold spell got them, so this is what's left. Here, I have just lettuce and flowers."

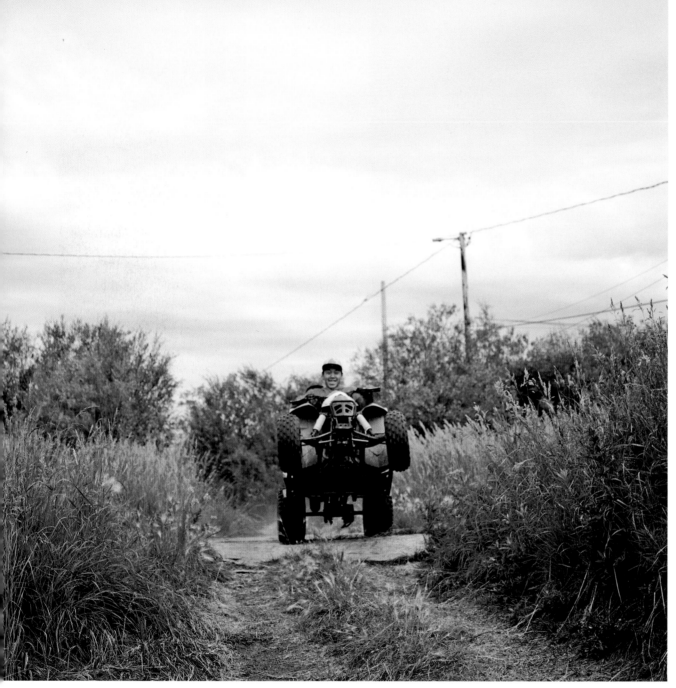

William Jack and Adrian Brown, Iñupiaq

"We are just out riding Hondas [four-wheelers]. We start school on the 17th. It was a good summer. We travel a lot in the summer. Next summer I will probably go back to Kotzebue and get a job. In the summer a lot of kids travel or go stay with family in other towns. Most kids will stay and go swim at sandy beach or at the boat beach. My dad and his dad are like brothers."
—William Jack

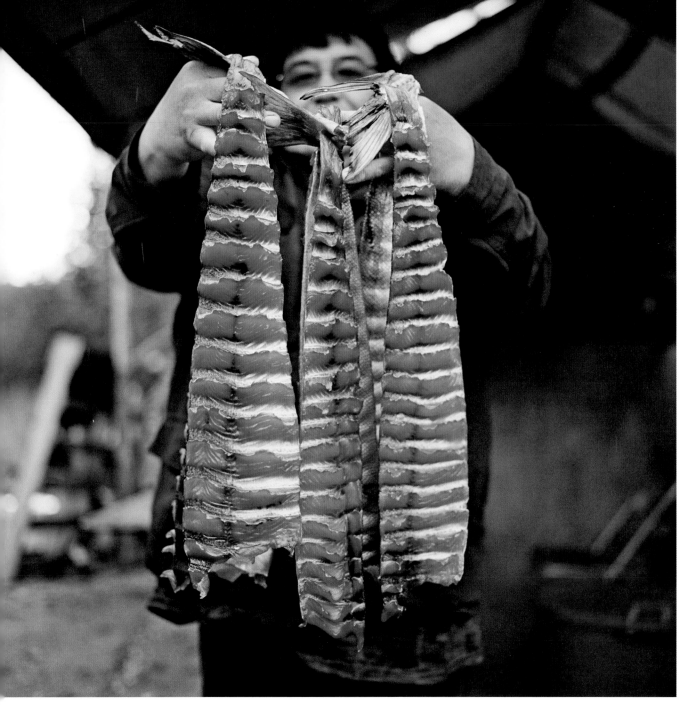

Lloyd Morris, Iñupiaq

"I have never lived anywhere else, and I have never intended to move away. When I was in school and when I graduated, my parents were expecting me to go to college. When I was done with school that was it. I told my mom I was done with school and not going to college. She told me okay, but I had to do something. She wanted me to do subsistence with her. I am glad I did now. She depends on me for that. I can gather food for the family and friends.

I have no regrets. I do a lot of fishing, mostly fishing. I am fishing for salmon right now. I smoke the salmon. In the spring, we get white fish, fry them up, or ferment them. It's a really slow run right now. In the summer, we get the salmon; in the fall we get sheefish, white fish, and pike. Pike, too, are here in the spring. We usually get smelts in the spring, but these last few years they didn't come up our river. In the winter we get sheefish or mud shark. I check my nets three times a day, everyday. We can fish all year. Busy, busy."

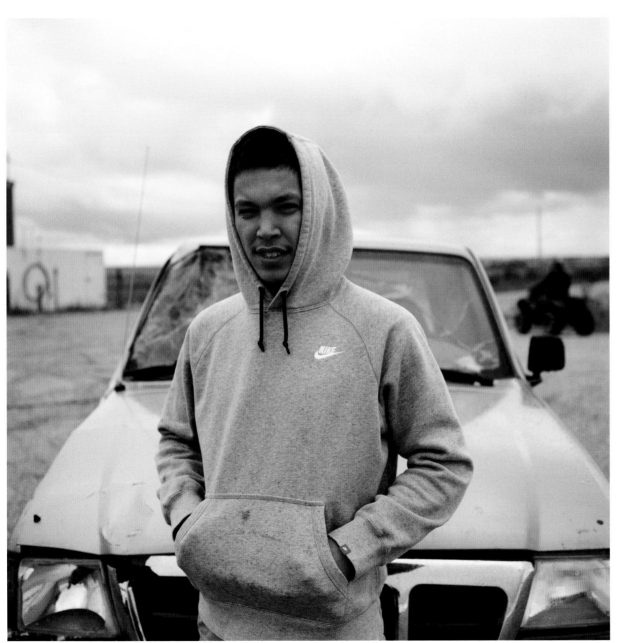

Lonnie Tebbits Jr., Iñupiaq

"I have been the Bering Air agent for about a year. It's a steady job. I worked at Bering in Kotzebue for a year, and I heard that they were wanting to replace the previous agent out here. So, I applied for it. I grew up out here."

Bowhead whale bones at the old village. Point Hope, Alaska. 2016.

A painting of an Iñupiaq in a traditional qayaq on a dumpster in Point Hope, Alaska. 2016.

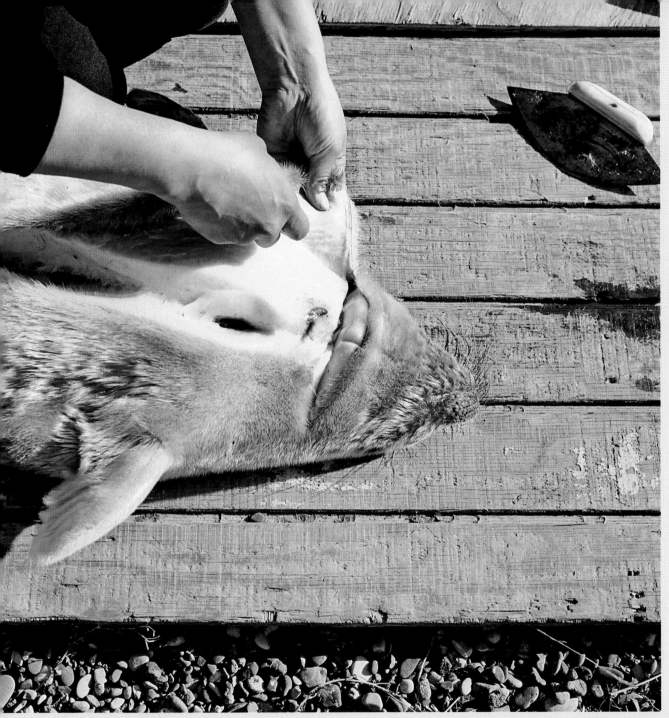

POINT HOPE

Point Hope, traditionally known as Tikiġaq, is a coastal Iñupiaq village with a population of approximately 700. Point Hope is located approximately 280 miles southwest of Utqiaġvik on a spit of land off the western coast of the Chukchi Sea within the North Slope Borough. Erosion and a threat of storm flooding from the Chukchi Sea led to the village's relocation to higher ground in the mid-1970s. The spit of land on which Point Hope lies resembles an index finger, for which Tikiġaq is named in the Iñupiaq language. It is reportedly the oldest continuously inhabited village on the North American continent with over 2,500 years of recorded history. Old Tigara, Jabbertown and Ipiutak, are prehistoric sites, which were inhabited as far back as 600 B.C. Ipiutak and the surrounding archaeological district are on the National Register of Historic Places. In addition to the prehistoric village sites, there are old burial grounds in the area including a cemetery marked by a fence made of whale rib bones standing on end.

A seal being harvested by Adela Lane in Point Hope, Alaska. 2016.

Adela Lane, Iñupiaq

"This is my first time skinning a seal by myself. I have cut seal before, but with help from my mom. My dad wants seal soup and he wants a small seal so I told my cousin, 'If you catch a small one, bring it on over.' You have to get it done while it's nice and fresh. My dad will enjoy this seal soup."

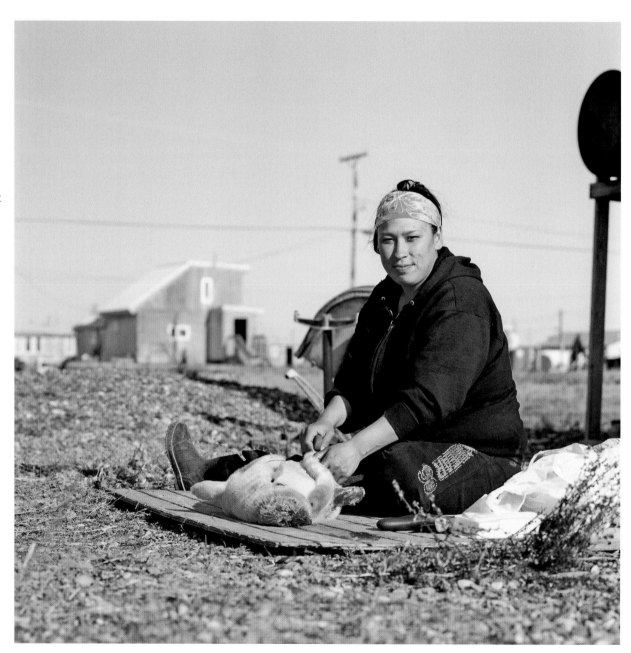

Jon Ipalook,
Iñupiaq

"I am working on baleen. It's a hobby I have worked with over the years, at different times of the year. I will work at it. It just happens to be a really nice time of the year to be working with it.

I picked this hobby up as a young one, growing up here with my grandparents. I was raised here throughout the whaling season, sent up from Kotzebue. So I got to start really young. I just kept with it and worked with it over the years and handed it out to family members as gifts. Throughout the years it has grown in it's own popularity with family members and other people wanting to purchase it. I am working on a whale's tail today and it will be a display piece for a bracelet set with earring hangers. They had a really good harvest [of bowhead whale] this year, so I am very fortunate to be working with some awesome material."

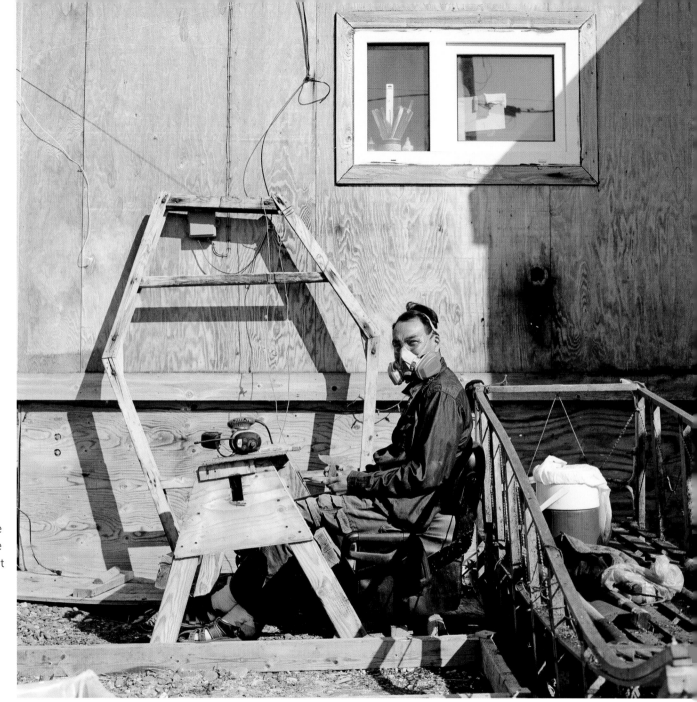

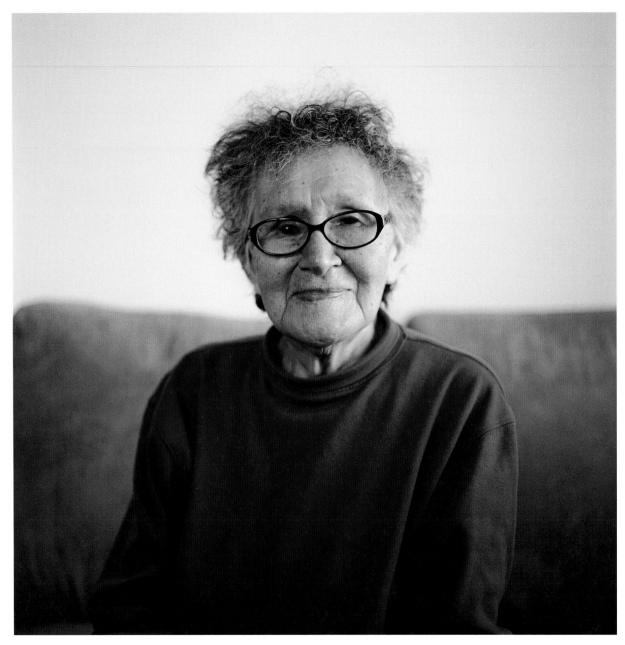

Irma Hunnicutt, Iñupiaq

"I was a health aide for a long time. It was interesting working in the health field. When I was a little girl and my dad would look at my hands and he would say, 'You're going to be a nurse!' I asked, 'How do you know?' But, when I grew up I got interested in health.

When people used to get sick at night, we would walk to their house. Nowadays we have vehicles, Hondas [all-terrain vehicles], and snow machines. Just before I retired they got an ambulance.

You should have seen us when we first moved here in 1975. The clinic was still down in the old town site. It hadn't been moved yet. Me and Lydia [her co-worker], after we would see someone in their home, we would have to walk down to the clinic to use the phone, the one and only phone we had was down there, two miles down at the old town. Then we would walk back. Everyday at 4 p.m., we walked. Then finally they got us that one public phone here in town. People would be waiting to make a phone call, and Lydia and I would be waiting to report to the doctor. Everyone would try and listen and we would whisper into the phone for people's confidentiality."

Jimmie Milligrock,
Iñupiaq

"I am moving my boat over to the other end of town to get it ready to go ugruk [bearded seal] hunting later."

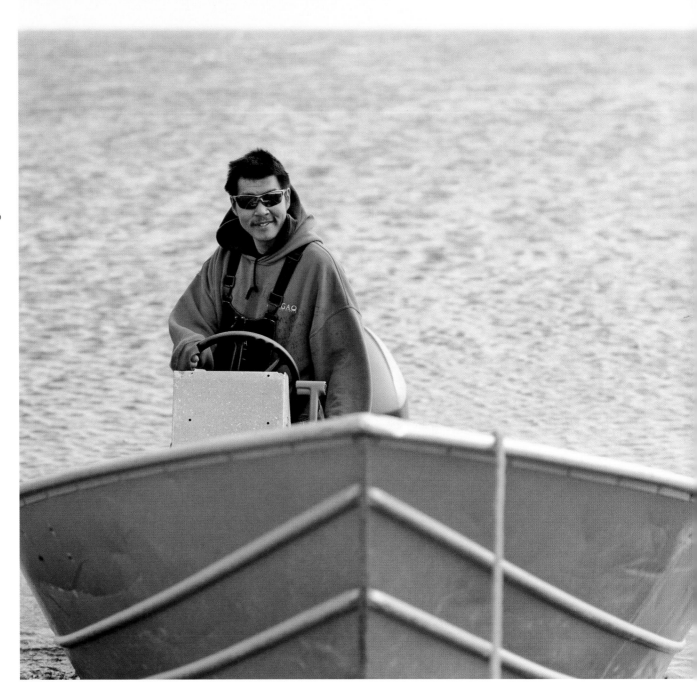

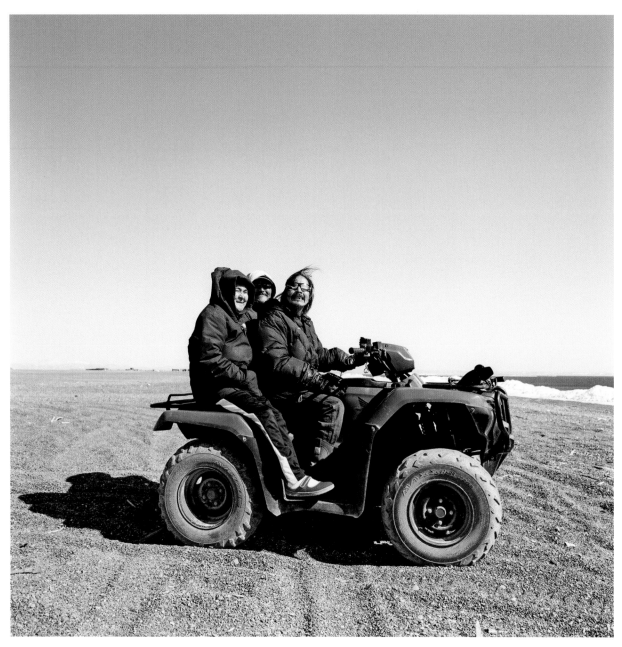

Ricky George,
Edna Nashookpuk,
Caldon Sampson,
Iñupiaq

"We are checking to see if there is anything out there. Checking to see if there is any [bowhead] whale or ugruk [bearded seal]. The water just opened up and it's been about a week since it opened up. I think it will be mostly big whales coming through now. People are mostly going after ugruks now. I didn't go whaling this year because of my back—arthritis—but next year I will probably go. I miss it, even though it's hard work."
—Ricky George

Tariek Oviok, Iñupiaq

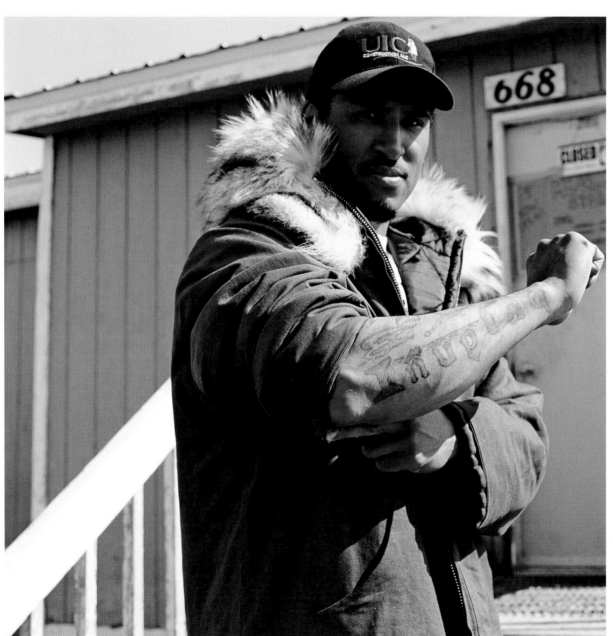

"As far as your question of 'what's new,' this is my first year having a whaling crew. That in itself, is almost unexplainable. I am humbled. I guess the best way I can describe it is, if you know the context of whaling and our history here in Point Hope with whaling, you know that the whaling captains here, they call them umialiks. They were relied upon so heavily because our economy back then was much different than today. People back then truly depended on our subsistence, and food was our survival and people looked to the captains for help. A lot of the rules are still instilled today, no different from 6,000 years ago. So it's important to me and I don't take it for granted for one second."

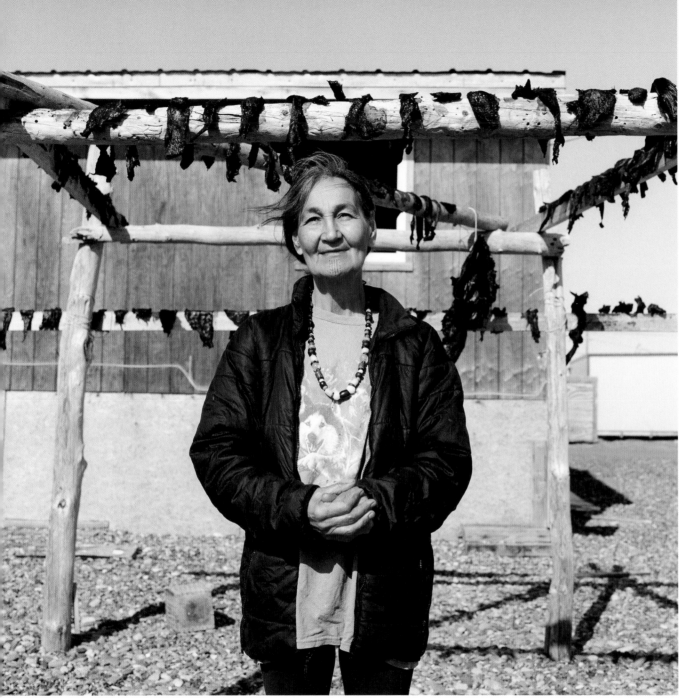
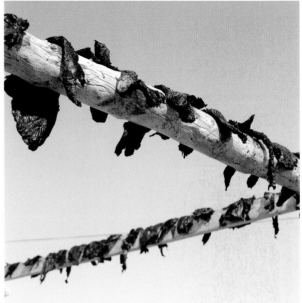

Shirley Ipalook, Iñupiaq

"My nephew gave me some ugruk [bearded seal] meat. I cut it up into strips, hang it to make dried meat. Then we will put it into some oil and eat it with other fish, seal, or bird. A lot of times I just store it in bags and my kids will eat it right from there, better than beef jerky. I also just started my garden. My son made me a lean-to. The south wind beats me up, and I can't get my peas to ripen because of the south wind, so my son built me a lean-to.

I have been gardening for the past 30 years. I also collect greens and use them for teas. I am learning a lot about plants, I took a botany class in Kotzebue. It was awesome! It made me realize there is so much more out there than we realize and we can utilize it in our diets."

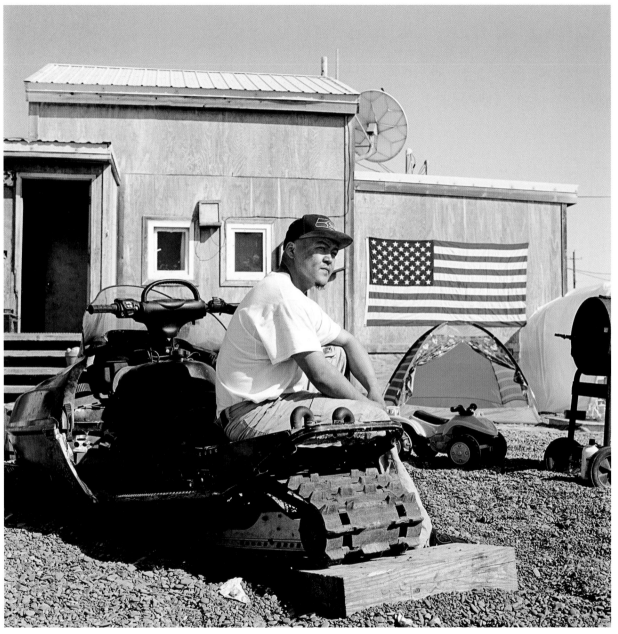

Scotty Ipalook, Iñupiaq

"It's like I said, it's Frankenstein [referring to the snow machine]. I would go around town and look in people's yards and ask them if they were going to throw away their machines. And I would tell them I would to take it to the dump for them, and they would still have parts on them that are good. I would take the parts and accumulate parts until, voila!, I built a machine. We built this one last year for water skipping. It had slight issues with the exhaust, but I think I got that figured out now. I ended up using it throughout half the winter.

I started working on snow machines when I was little. When I was four, I started pulling my brother to the shop and even though I wasn't working on machines then, I was still asking about them. My older brother was a racer for a little while and so he always had fast machines for me to watch him work on and ride. My older brother would say to me, 'If you finish your homework everyday after school, you can go ride my four-wheeler after school.' It was an incentive for me to stay out of trouble when I was growing up. Now I do that with my nieces and nephews."

QUINHAGAK

Quinhagak, traditionally known as Kuinerraq, is a Yup'ik village with a population of approximately 340. Kuiner-raq is the Yup'ik word meaning "the new river channel." Quinhagak is one of the oldest villages in the Yukon Kuskokwim region, dating back to 1,000 A.D. The village sits on the bank of the Kanektok River along the east shore of Kuskokwim Bay, less than a mile from the Bering Sea coast.

Quinhagak, Alaska. 2015.

Silver salmon drying in Quinhagak, Alaska. 2015.

Village graffiti. Quinhagak, Alaska. 2015.

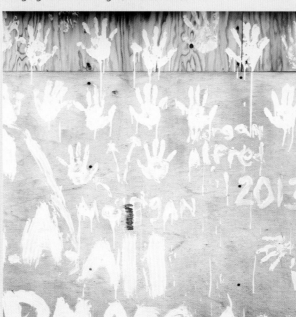

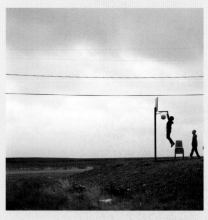

"Forms of acculturation between countries of the circumpolar North can be obvious, or subtle. One area where acculturation shows itself is in team sports: In Chukotka, it's soccer; in Greenland, it's team handball; in Canada, it's hockey; and in Alaska, it's basketball. These sports are imports from down south. They are not traditional Inuit games. We love these games. This is one acculturation that Alaskan Inuit support whole-heartedly."
—Jim Stotts is Iñupiaq from Utqiaġvik, Alaska and living in Anchorage, Alaska. Photo taken at Quinhagak, Alaska. 2015.

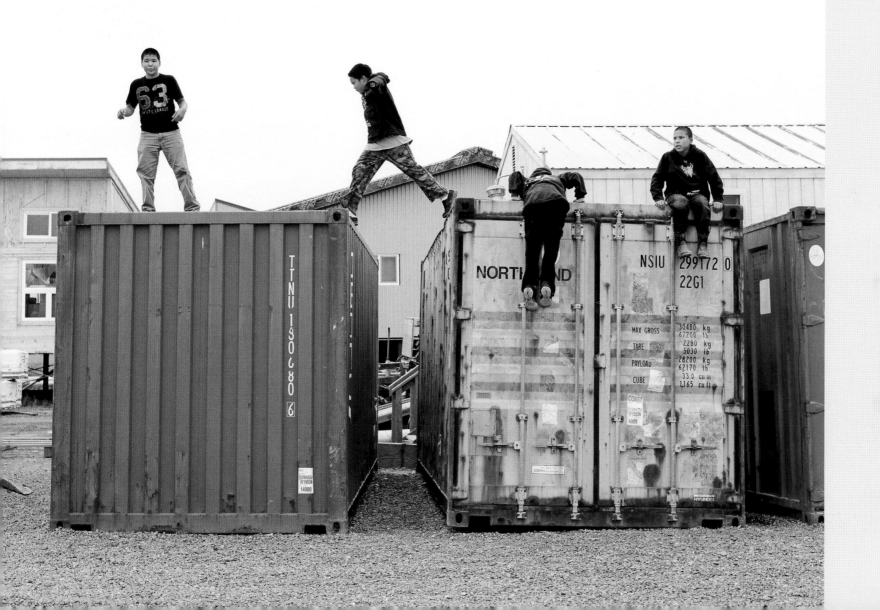

Kids playing in Quinhagak,
Alaska. 2015.

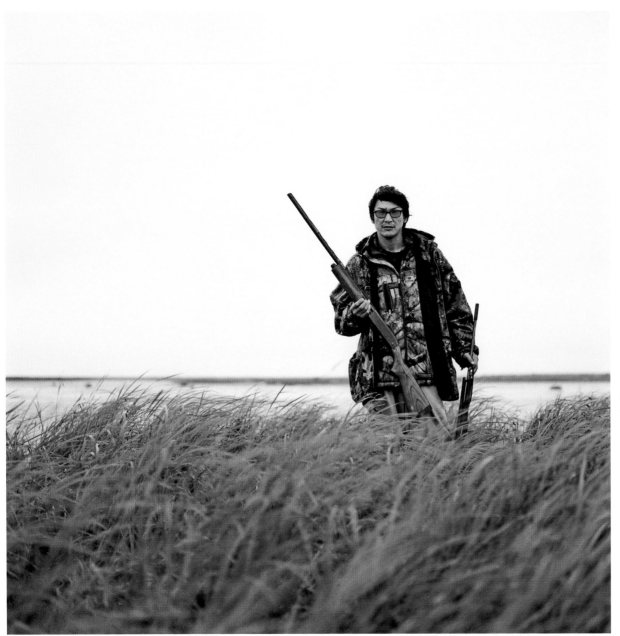

Adolph Smart, Yup'ik

"I like to go hunting during the summer. I got 16 birds in the last couple of days."

IAI: What do you do with all the birds? Do you share them?

"I fill up my freezer."

Annie Cleveland, Yup'ik

"We call them Quagciq [wild sourdock plant] in Yup'ik, I don't know what we call it in English. I take the stem off and this is what I cook. The only recipe I know is boil it really good until it's mushy, drain it, and then smash it, and put a lot of sugar in. Mix it with sugar and milk or seal oil."

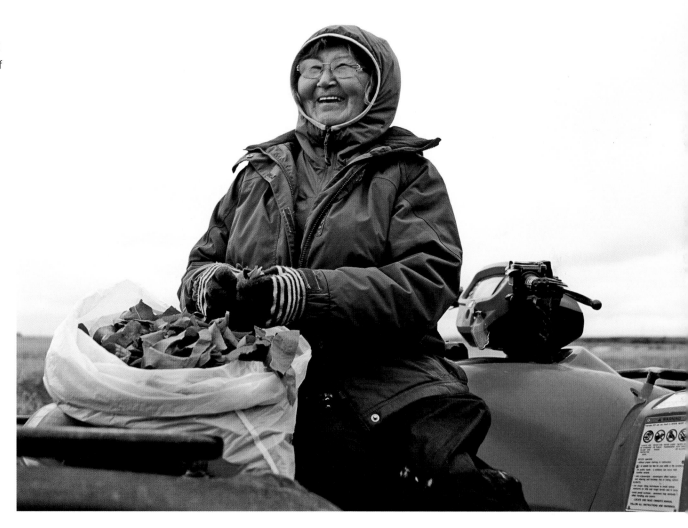

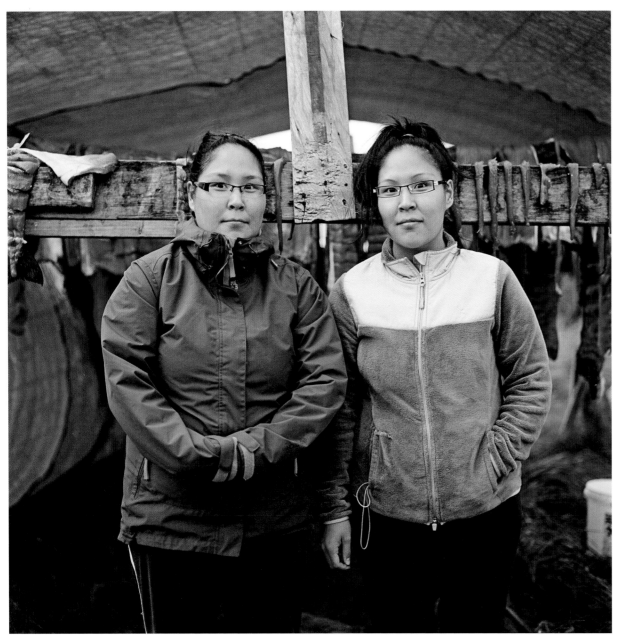

Brittany Cleveland and Taryn Andrew, Yup'ik

"After cutting the silvers [salmon], we put them in salt water and then dry them for three or four days. After drying them, we smoke them and then they will be done. It takes about two weeks from catching them to eating them. It's a passed down recipe."—Taryn Andrew

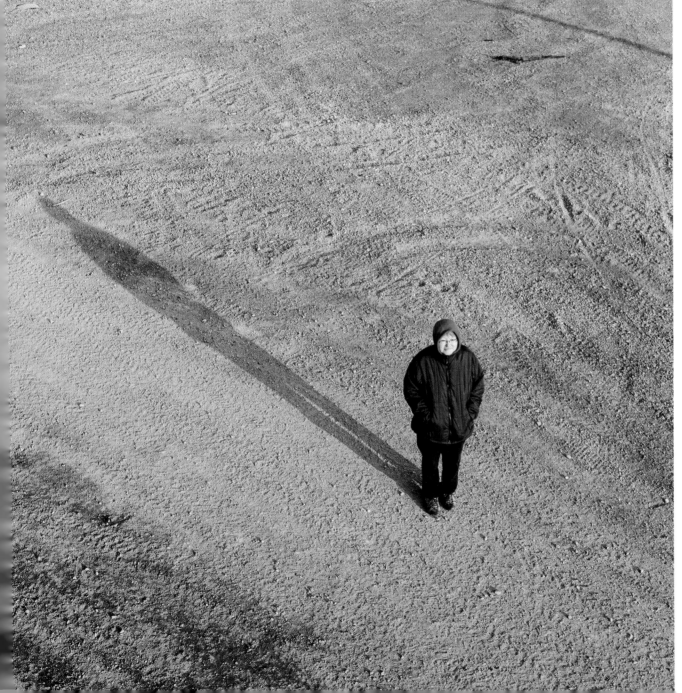

Emma Frances, Yup'ik

"I was born and raised here. My mother passed away after I was born and my biological dad adopted me out. I go by Frances because there were three of us Emmas in town when I was growing up. I work at the laundromat. It gets me along with my phone bill and water bill."

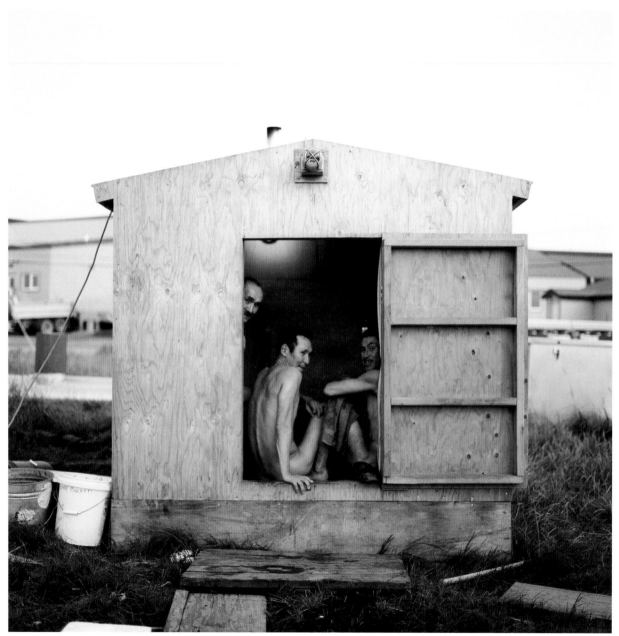

Robert White (right), William Sharp (middle), John Sharp (left), Yup'ik

"We wash our bodies and try to wash the dirt off after we work out there—relax and get clean, I guess. It's called a steam house. We work all day and then this is where we come."—William Sharp

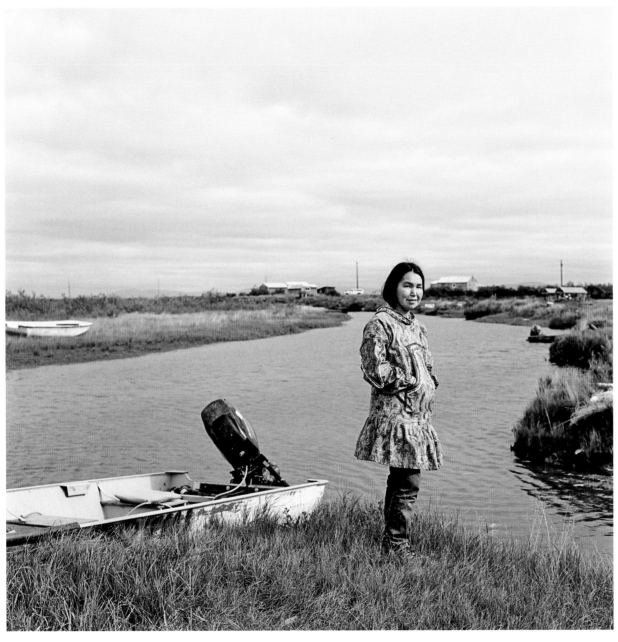

Karen Atseriak, Yup'ik

"I am just checking on my boat. It's still there! I commercial fish during the summer, and I work at the school. I love the clear, clean river here, and I live a primarily subsistence life here—fish, birds, walrus, seal, moose and caribou. I am happy."

Keri and Elton Cleveland and family, Yup'ik

"We are going berry picking and duck hunting!"

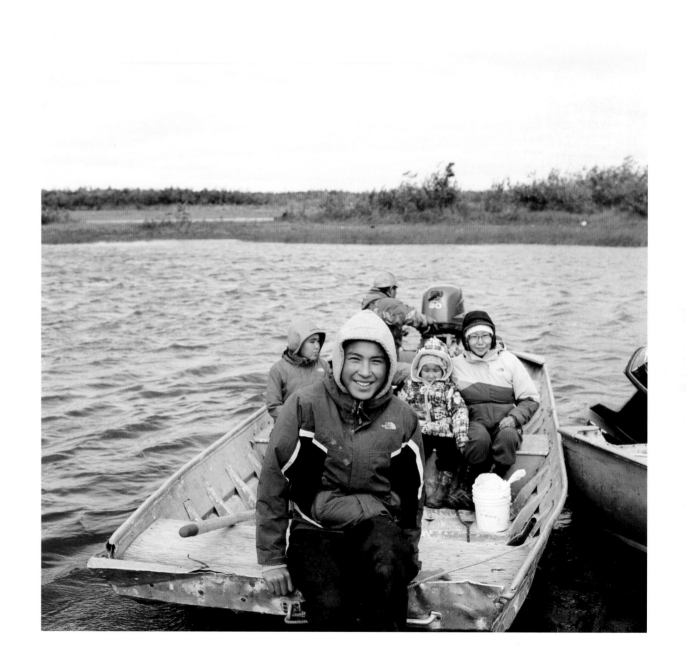

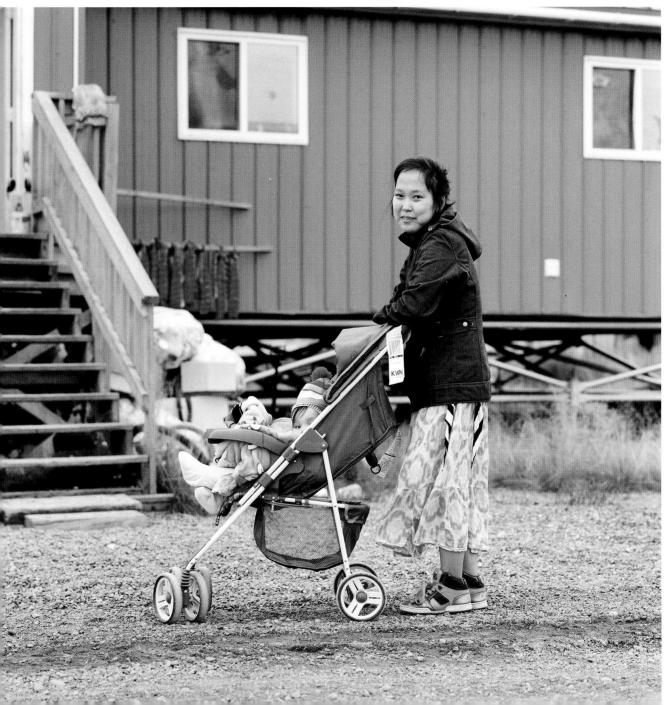

Kristy and Zoe Mark, Yup'ik

"I am 25, but look younger. My daughter just turned 11 months old today. I had her at Bethel. It seems scary to have a baby out here. Since I had her, it's been mostly just me and her. She's growing a little too fast."

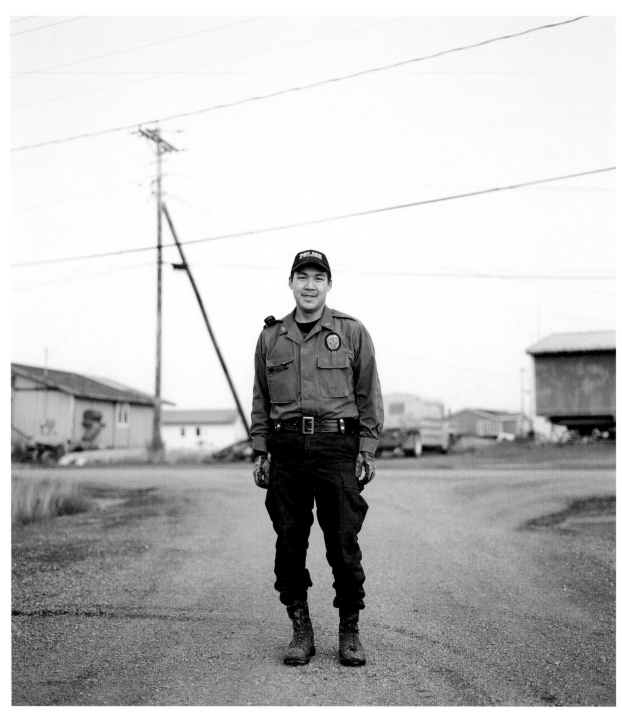

Phillip Charlie,
Yup'ik

"I started this Monday. This is my first drunk call. I just want to help people, and make their lives better. I grew up here and in Bethel."

Joshua Cleveland, Yup'ik

"I like to make people laugh. It's better to be happy, and not to be sad.

I was born in Eek, Alaska and moved down here to Quinhagak when I got married 50 years ago. I have spent most of my adult life in public service to Quinhagak. I started off doing administrative work with the Tribal Council, then [Alaska Native] land claims came about and I was involved in the village corporation as being one of the incorporators here in '73. I was involved for 20 years and retired after that.

I was a fisherman for a long time on the Kuskokwim [River], so I became involved with the fishing concerns of the state. The [fish] resources have been getting low—even here. We are still able to sufficiently get our subsistence needs. We were restricted for the first time this summer for the take on king salmon; we were restricted to fishing three days per week. Some people weren't happy, but it didn't affect their ability to take what they need. People aren't able to do full-time work out here, but as long as we have the subsistence resources available, we are still able to survive out of our own effort. But we have to be willing to make an effort to take it."

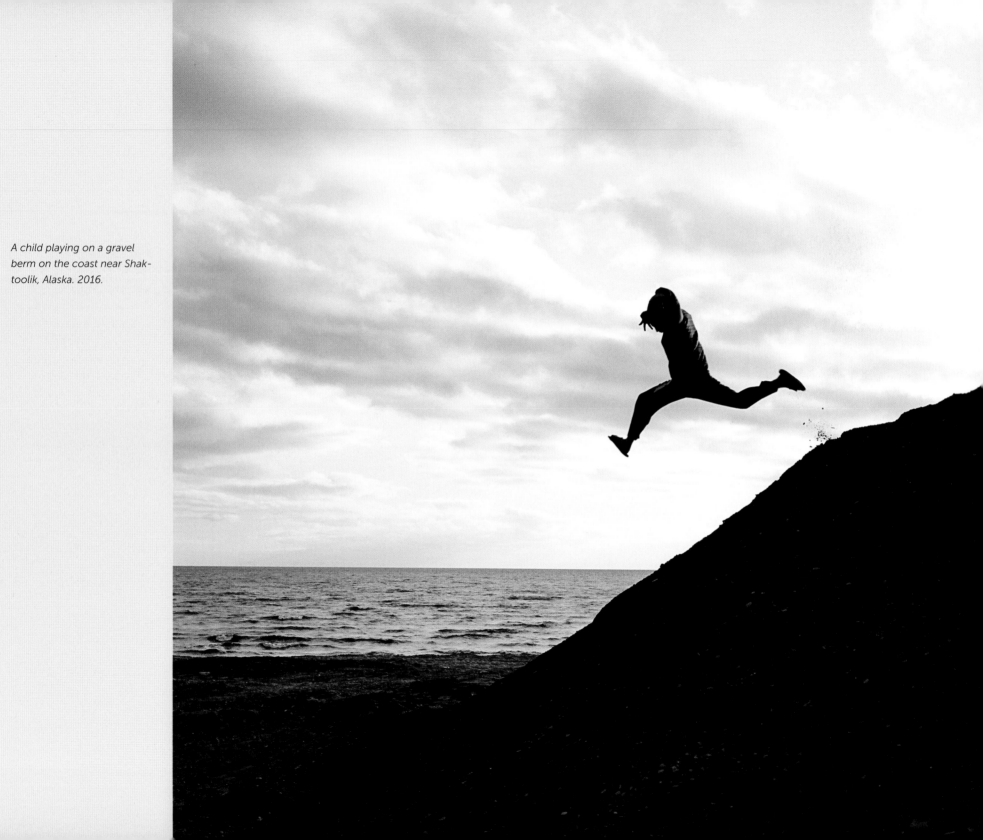

A child playing on a gravel berm on the coast near Shaktoolik, Alaska. 2016.

SHAKTOOLIK

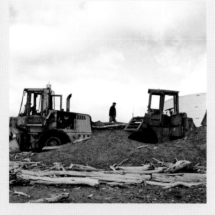

Clothes being line dried in Shaktoolik, Alaska. 2016.

Primarily made of gravel and driftwood, the Shaktoolik berm is the village's only protection from storms and coastal erosion. 2016.

Shaktoolik is a coastal Malimiut-Iñupiaq village with a population of approximately 250. It is located in the Bering Strait region along the eastern shore of Norton Sound, ten miles southeast of Cape Denbigh and the Reindeer Hills. The village lies on a gravel sand spit separated by the Tagoomenik River. It is 125 air miles east of Nome and 34 air miles north of Unalakleet. The Tagoomenik River and the Shaktoolik River converge at Shaktoolik Bay and empty into Norton Sound about two miles northwest of the village. The Shaktoolik River extends 60 aerial miles to the northeast, with its headwaters located in the hills that separate the coastal drainage from the Yukon River.

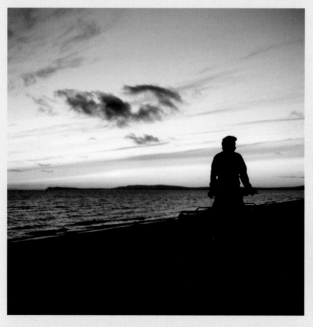

A man driving a four-wheeler looking for kids out past curfew. Shaktoolik, Alaska.

The Norton Sound from Shaktoolik, Alaska. 2016.

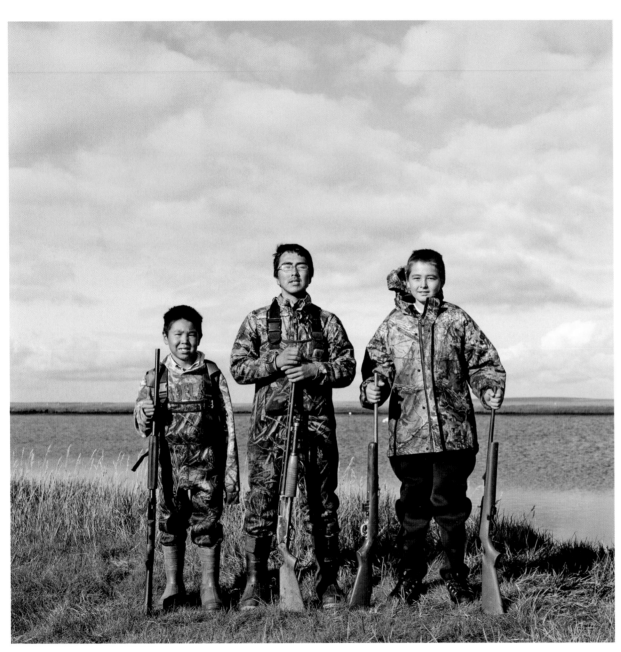

Charlie Katchatag, Taylor Kulukhon and Keenan Jackson, Iñupiaq

"We are just getting back from duck hunting. We didn't get anything today, but I got 11 this year."
—Taylor Kulukhon

"I caught one the first time I went out with my new shotgun; it's a 20-gauge. We are going to go change our clothes and then go clean our guns now."
—Charlie Katchatag

"Our favorite way to eat duck is duck soup. First we pluck it, gut it, skin it, and save the gizzard and clean it. You can roast it, too, but duck soup is our favorite."
—Charlie Katchatag

Travis Savetilik,
Iñupiaq

"I went upriver with a couple people, and at 10:06 p.m. in the evening, when we were headed back downriver, we saw a moose at Punuk [a landmark along the river]. It's up towards the hills, not that far. We saw the moose, and Trevor stopped. And I aimed and shot a couple times and dropped it. This is my first one this season. One will be good enough. Now we just need to focus on beluga."

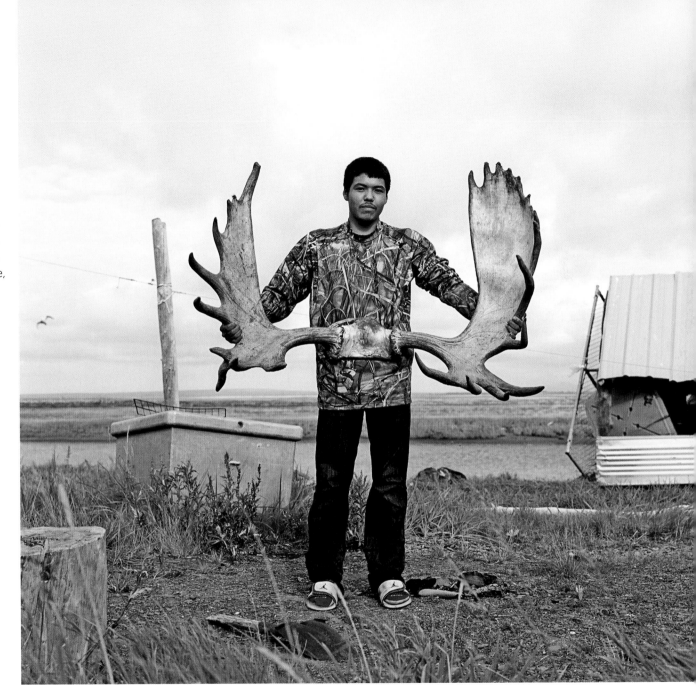

Eugene Asicksik, Iñupiaq

"In 2008, I realized we were number 39 on the 'new school list' for the State of Alaska. So I wrote a letter to Governor Sean Parnell, and he put us in his budget. When we got it all done, I wrote a letter to the school district to have the school named after my brother, who was the first Native principal in this region, and then the kitchen is named after my mother-in-law. The school is sitting on solid concrete so it could take a pounding. Shaktoolik was identified and listed as one of the five communities that are eroding away by Senator [Ted] Stevens [former U.S. Senator of Alaska]. We have been on that list for 15 plus years, so there was some hesitation to spend funds on the school.

We are now a community that is staying and defending. I worked and got the berm [sea wall] built in 2014. There was storm in 2013, and basically what it did—I call it cresting—it pushed everything [drift wood/debris] on top of the land we are currently living on. We didn't anticipate that big of a storm. We started pushing the logs off the crest and back down and went over it with a CAT. Then, we started filling it in and made the berm wider and higher. This year we added a little more to the berm. We trucked our gravel in for the berm, from the mouth of the Shaktoolik River. It hasn't been tested. I am anticipating that we will have a storm this year. It will just buy us time."

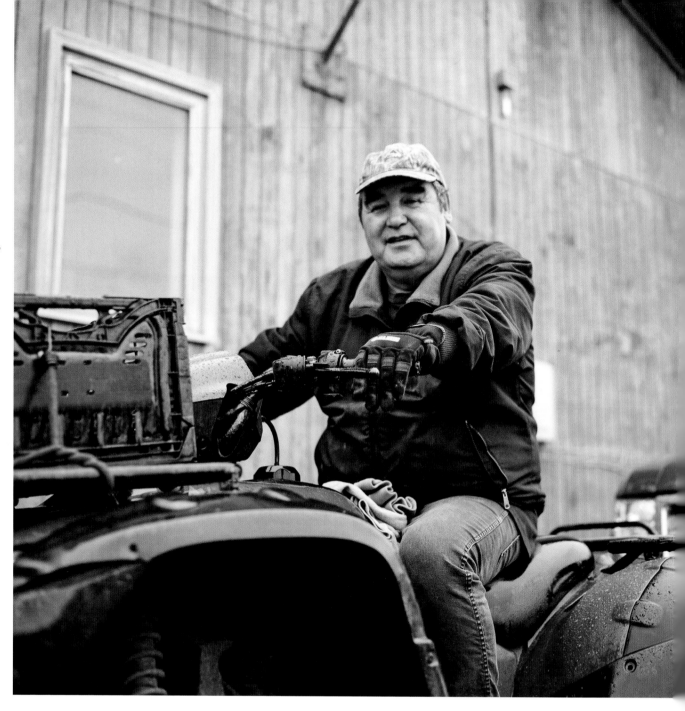

Edgar Jackson and Helen Jackson, Iñupiaq

"We have lived here all our lives. We came from the old site here. The village moved here in 1972 or '73. It's three miles down south. We have seen a lot of storms during our lifetimes. The worst one was down at the old village site in 1969 or '70. No one used to get scared back then, though. There was wood that washed up outside our doorway. I was the mayor at that time and I was 23 years old.

During the flood years, we have no means of escape right now. We could stay floating on a boat for a while, but we would drift away. It's a tricky situation here. There is no place to run and it's scary. The reason why we moved three miles up here is because the water is shallower up here, and the waves break farther out there."—Edgar Jackson

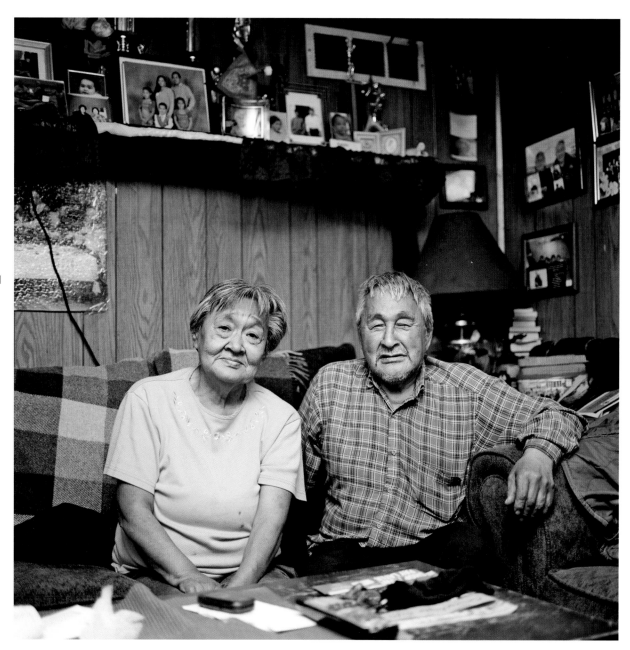

SHISHMAREF

Shishmaref, traditionally known as Kigiqtaq, is a coastal Iñupiaq village with a population of approximately 600. Shishmaref faces an immediate threat to life and property due to beach front erosion and has been identified as a village that needs to be relocated. The village is located on a barrier island, just north of Bering Strait and five miles from the mainland. Shishmaref is 126 miles northwest of Nome and 100 miles southwest of Kotzebue. The village was traditionally a seasonally occupied area that transitioned to permanent settlement in the early 1900s when a school and church were built.

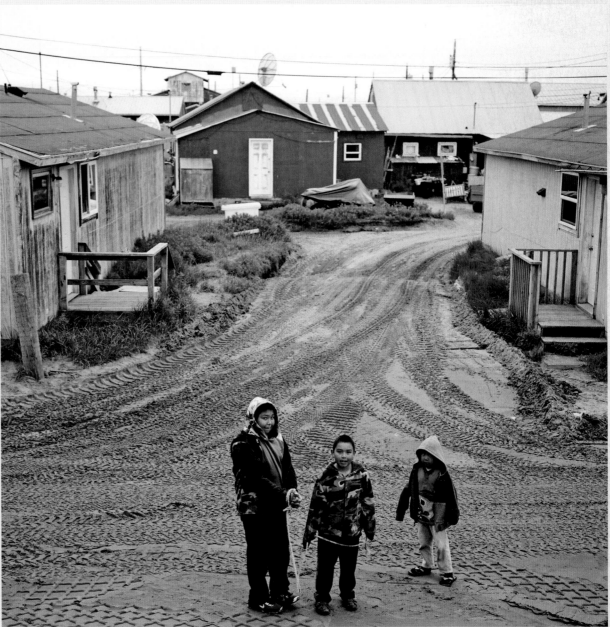

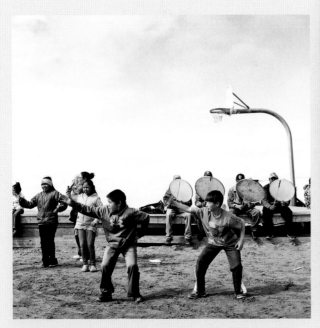

Youth performing a traditional Iñupiaq dance at a community picnic in Shishmaref, Alaska. 2016.

Kids playing in Shishmaref, Alaska. 2016.

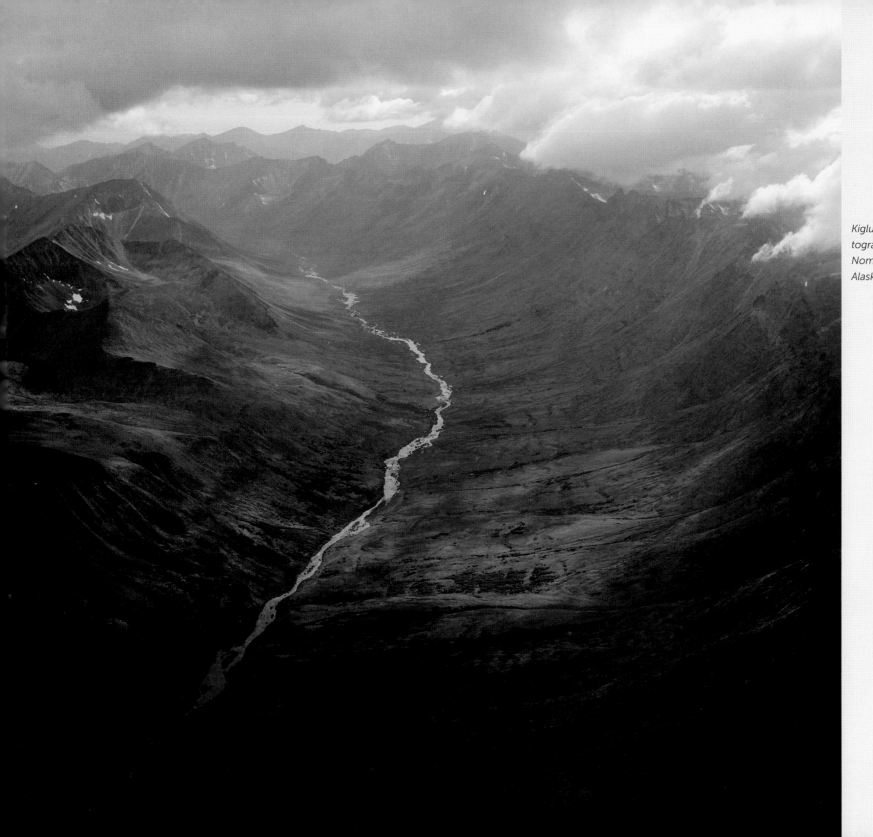

Kigluaik Mountains pho-
tographed flying between
Nome and Shishmaref,
Alaska. 2016.

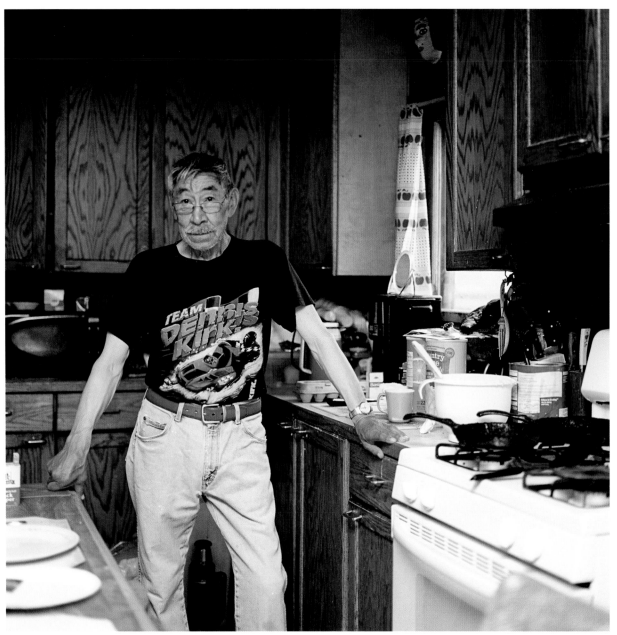

Clifford Weyiouanna, Iñupiaq

"This sourdough. My mom and dad started it. Before my wife died of cancer, we got some dough from them and this dough we have here is almost 100 [years old]. Everyday and every night I mix it, add water and flour. I never know who is going to be hungry in the morning. Whenever me and Flo go camping, that damn thing goes with us, even in the winter on snow go.

There are some families here in Shishmaref that, when their dough gets funny, they come get starter from me, and they mix it with theirs. When my dough gets really big I freeze some of it. Now our dough is even in Michigan. Some hunters who visited liked this sourdough so much they asked if they could take some starter.

When Flo and I go camping, we like fish in the morning. Our parents didn't make bacon but we always had fish, and Flo and I enjoy having fish and hot cakes in the morning."

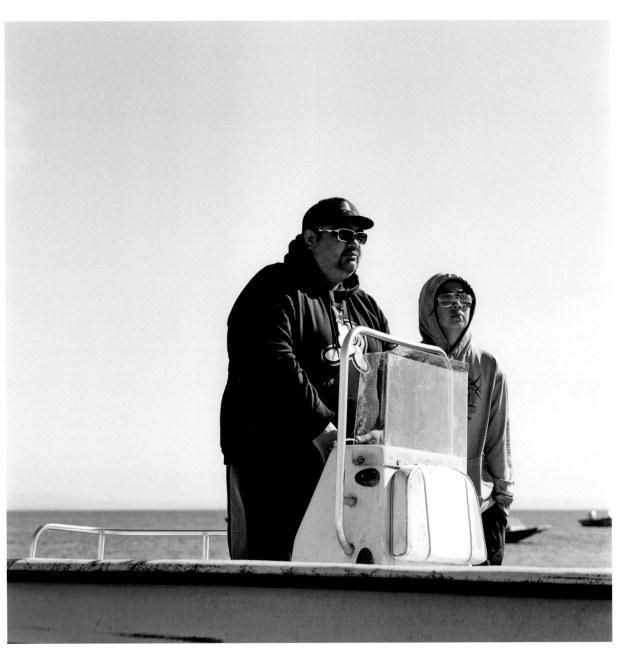

Dennis Davis, Iñupiaq

"Shishmaref is so off the radar. With my drone work, there is so much I can do with it. I can do search and rescue. I can check the ice in the spring, because the climate is changing. In the spring I can send it out three miles and see if the ice is rotten or not and safe to go on. Or after big storms, I can survey the land and see how much land we have actually lost from each storm.

Nobody knows down in the States what's going on in Shishmaref, and we are Americans, you know? I thought it would be my job to show the world what's actually happening here. It shouldn't be just because there is only 800 people here that we aren't going to get help.

I am interested in the real image. If a house fell in the ocean, I would put my drone up in the air and put it up on YouTube. Social media is the best thing. I can post a picture and hit 100,000 people. The first image I posted on Facebook from my first drone, it reached over 100,000 people—that's nuts. All in all, I am just trying to make a movement or a change to open people's eyes, because you don't get news companies out here unless something really drastic is happening. By then, it is too late. I want people to see that these are actual people dealing with climate change."

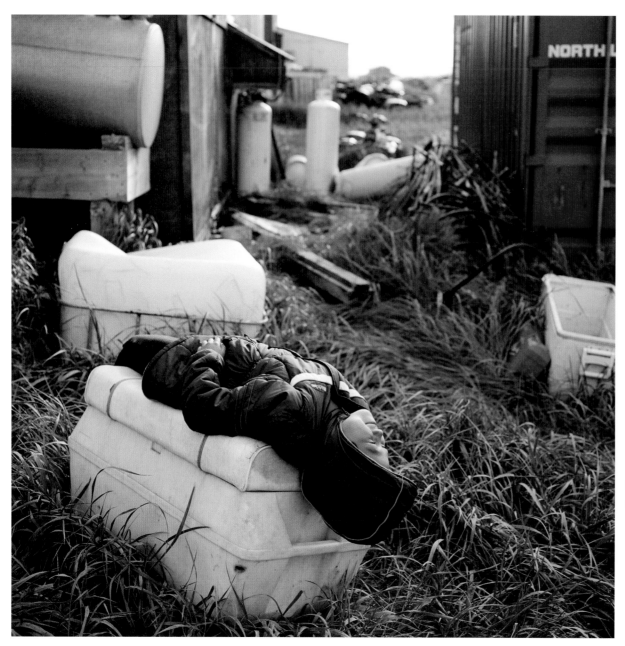

Makayla Nayokpuk, Iñupiaq

Makayla Nayokpuk watching her dad, Dennis Davis, operate his drone in Shishmaref, Alaska. 2016.

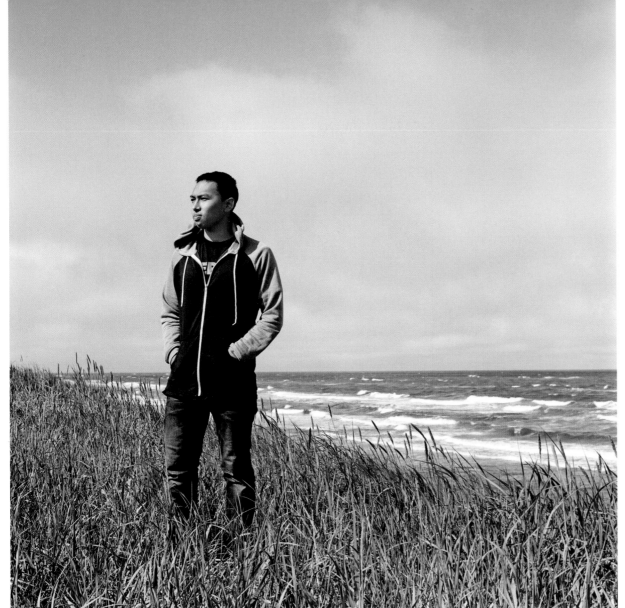

Esau Sinnok,
Iñupiaq

"I am from the island of Shishmaref. I am Iñupiaq Eski-mo. My dad is from Brevig, and my mom is from Shish-maref. I grew up in Shishmaref, Nome, and Fairbanks. My uncle Boy came back here to Shishmaref to go hunting for my papa and grandma. He loved to hunt. He would go hunting whenever he had the chance, but he passed away in 2007. He fell through the ice coming back from geese hunting. Ever since then, there hasn't been a day that goes by that I don't think of him. He is the main reason I am in the environmental movement. I do it in honor of him. I traveled all this summer across the nation—DC, West Virginia, Miami, and California. That was with the Sierra Club and United States Climate Action Network. I am one of the 22 selected Arctic Youth Ambassadors.

Right now, I am currently studying at the University of Alaska Fairbanks, majoring in Tribal Management. I want to come back to Shishmaref and run as tribal council president or mayor of Shishmaref."

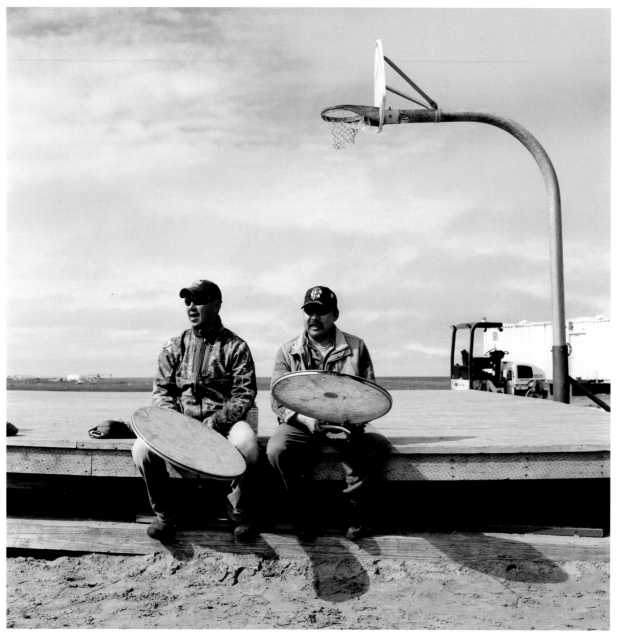

John Kokeok and Jonathan Weyiouanna, Iñupiaq

"I had all these recordings of dance groups from the '90s on old VHS tapes. I don't know who recorded them on those old VHS tapes. I started watching them and getting into it. When Carter [his son] was two years old, I would go home on my lunch break, and he would be watching his cartoons. I got tired of them and started putting in those tapes and he would watch them. Then soon, everyday when I got home from work, I would ask him, 'what do you want to watch?' and he would want to watch those tapes. He is ten now.

Our dance group in town kind of faded away, [when the] elders passed away. Mary, Kate's sister [and John's sister in law], came back to town. She is a teacher too [like my wife Kate]. She got [the Shishmaref Dance Group] back together and that's when I joined. I am a part of the Shishmaref Drummers. We have all these young kids now, I think they will take over eventually. There are about ten to 12 kids in our group now."
—John Kokeok

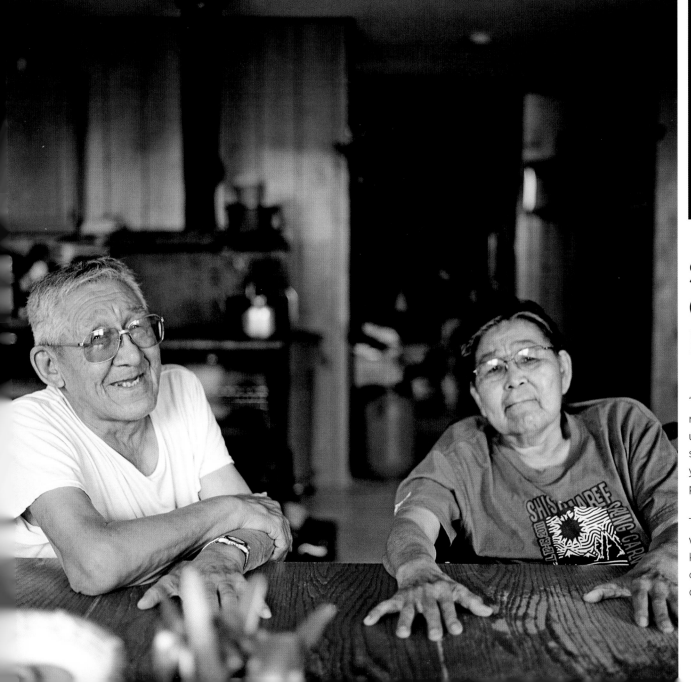

Shelton Kokeok and Clara Kokeok, Iñupiaq

"Shishmaref is always popular for Eskimo food—except no maktak! We are not a whaling community. We go for ugruks (bearded seal), walrus, spotted seals, common seals, and caribou. Less caribou in the last ten to 12 years. They have started migrating back to some other place.

There used to be lots of beach way out there. Even when people used to walk out there, they used to look kind of small. When we build this house, there were other houses across the street. One of the houses went down."—Shelton Kokeok

141

Donna Barr,
Iñupiaq

"In May of 2009, we went to a suicide prevention con-
ference in Nome. There was an elder with us and two
youth. After we got trained on suicide prevention, we
decided to hold a community picnic with efforts to cel-
ebrate life using our Native traditions and culture. This is
our eighth picnic. We always planned it for the third Sat-
urday in July, when the fish is fresh. It's an all-volunteer
event. Our goal of the event is to eat food together, play
Eskimo games, and celebrate our history as a Native
people. It's a strength when we build our identities with
our Native culture. We utilize our elder's knowledge and
advice."

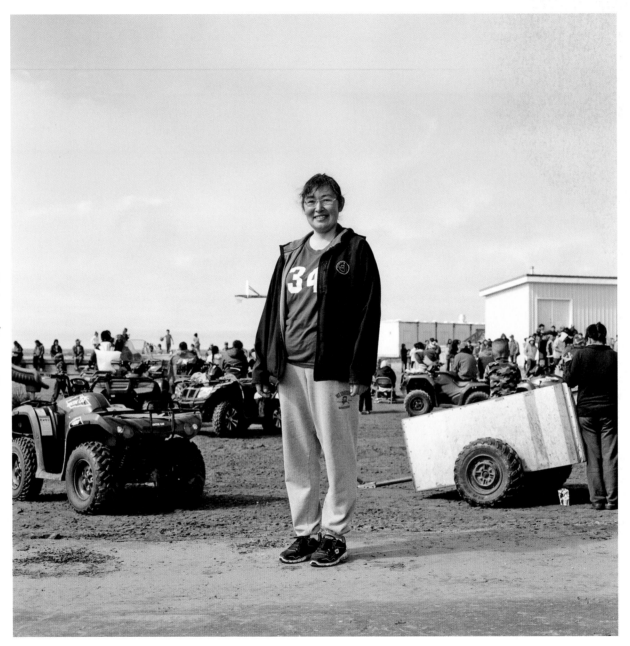

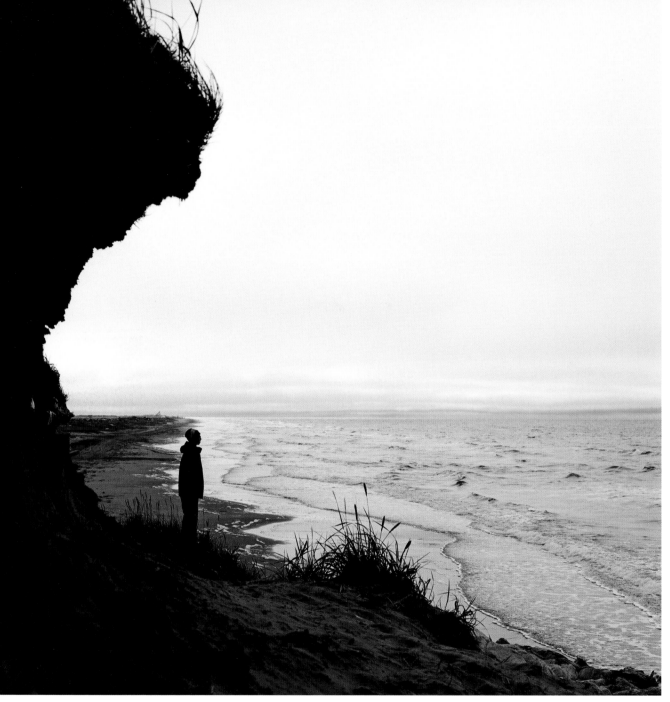

Lynden Weyiouanna, Iñupiaq

"I will be 18 tomorrow and every year I see the land slowly decreasing. People call it climate change; others call it 'big bologna.' In real life, if they actually came up here and lived with us for a few years, they would see what we are talking about and what we are going through, year by year. Berries and animals are coming quicker than usual. It's a big change for us. Prices have even gone up in town. I am not even that old, you know? Things have changed in a short amount of time."

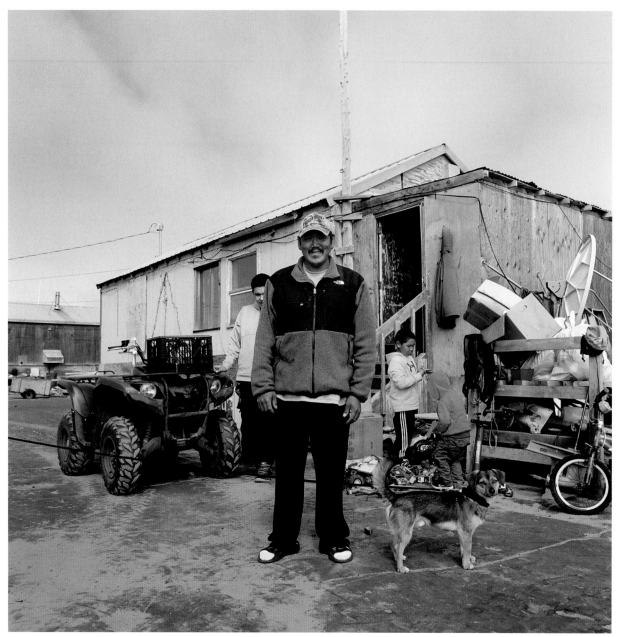

Norman Kokeok, Iñupiaq

"I have lived here in Shishmaref my whole life. I was born at my parent's house. I love doing subsistence hunting. I am getting excited for berry picking. My family will all go out berry picking for salmonberries. I do a lot of hunting in the spring; that's the funniest time of the year for me. Right now we can go out for berries and caribou. Last spring was good. My girlfriend's side of the family has enough ugruks [bearded seal] for seal oil, and my parents have enough ugruk for seal oil. It was a good hunt this year. I am starting to teach my son how to hunt. He is seven now. He was five when he shot his first seal. He will probably be a better hunter than me when he gets older."

Rylan Moses,
Iñupiaq

Rylan Moses eating fresh fruit at a community picnic in Shishmaref, Alaska. 2016.

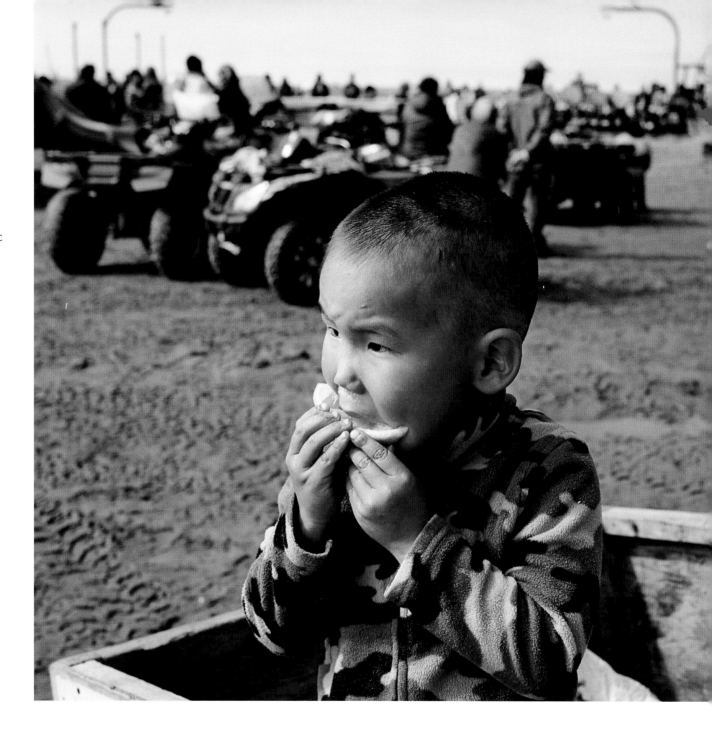

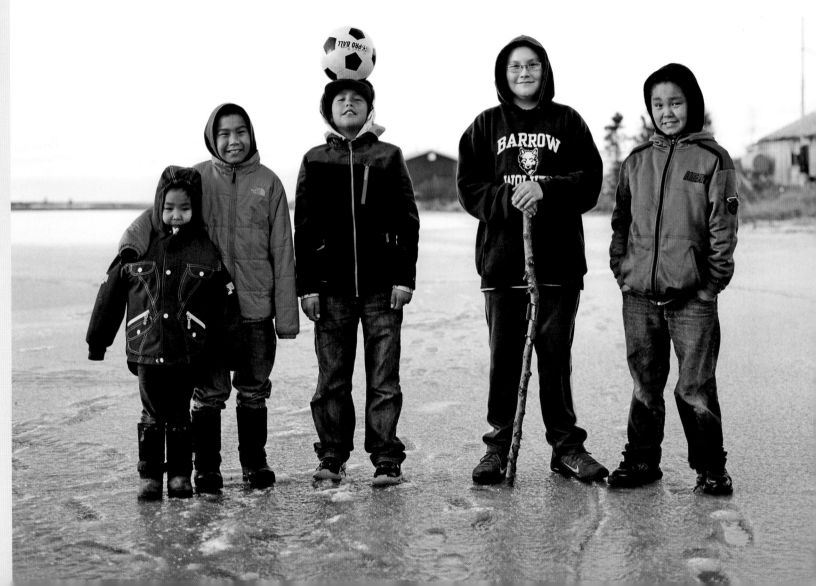

Dominic Cleveland, Dennis Cleveland, Keon Barr, Donovan Barr, and Julie Cleveland playing soccer on a frozen pond in Shungnak, Alaska. 2015.

Kids playing on a pond in Shungnak, Alaska. 2015.

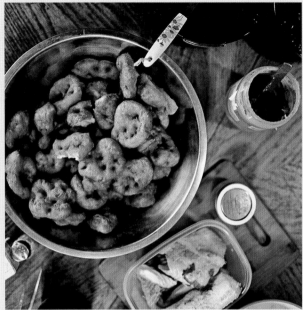

Homemade donuts in the home of Caroline Tickett and Warren Douglas in Shungnak, Alaska. 2015.

SHUNGNAK

Shungnak, traditionally known as Issingnak, is an inland Iñupiaq village with a population of approximately 260. Shungnak is located on a bluff rising above the west bank of the Kobuk River, about ten miles downstream from the village of Kobuk and 150 air miles east of Kotzebue within the Northwest Arctic Borough. Residents of Kobuk migrated downstream along the winding Kobuk River to escape massive flooding and established Shungnak in the 1920s. The new village was originally named Kochuk, but its name was later changed to a derivative of the Iñupiaq word for jade, a gemstone found extensively in the surrounding hills.

Edna Commack, Iñupiaq

"My birthday is April 22, 1922. I still go to church with my cane, but I forget I have it sometimes and carry it! I walk a lot. When I get tired of staying in, I take a walk. My mom lived to be 104.

I was born in Qualla [fish camp above Kobuk, Alaska]. I used to always go with the dog team up to that white house up there, the Collins' house. But when the snow was too deep they would pick me up in their snow jeep. I used to work up there; clean the floor, wash the clothes. They were FAA [Federal Aviation Administration] and they had the landing field and plane."

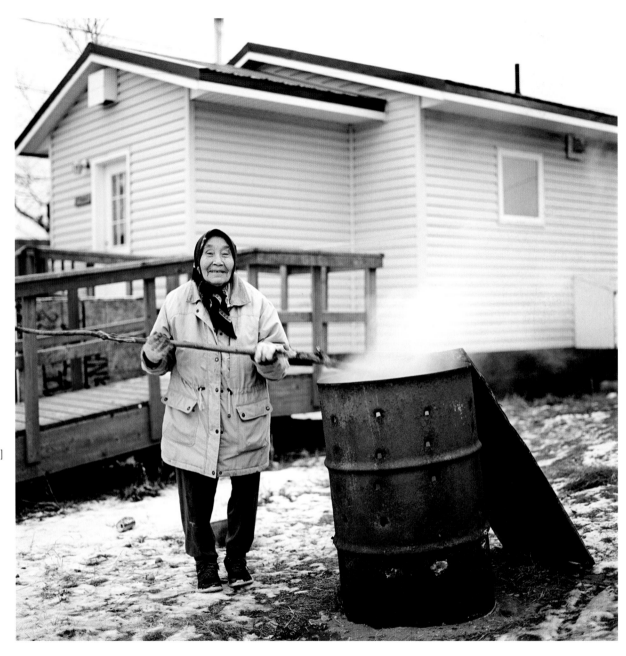

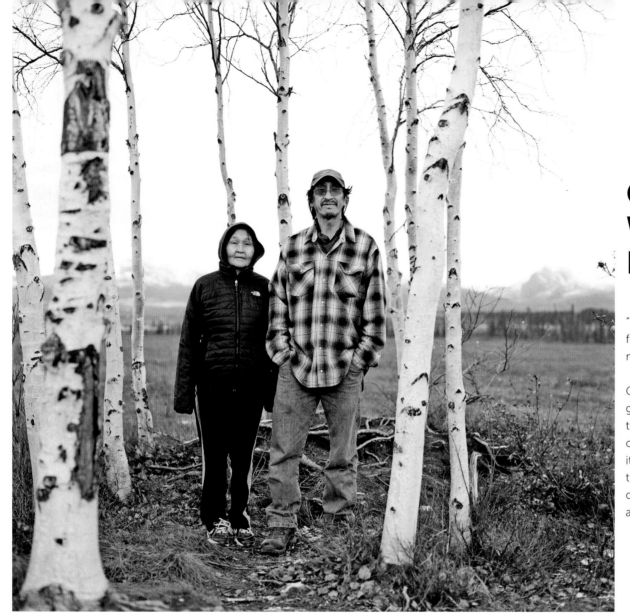

Caroline Tickett and Warren Douglas, Iñupiaq

"We met on the Kobuk River. She's from Kobuk. I am from Shungnak. Just like our elders, that's how they all met—camp to camp, hunting and fishing.

Our favorite part about living here is the hunting and gathering. It's what keeps us here. Our food is out there—it's up to us to pick it up. Our least favorite [part of living here] is the alcohol and drugs. Kids are doing it at a younger age. The big game hunters are diverting the caribou migrations. We grew up with caribou all over. They would come up right over these mountains, and now they have just disappeared."—Warren Douglas

Jerrilyn Cleveland, Iñupiaq

"My favorite part about living in Shungnak is probably all of the good food, the hunting, and all of the fish and caribou we get. I help my sister cut meat, we go pick berries, and I help them fish and hang fish. My favorite is probably caribou—that's the best. It's best to dry it and dehydrate the meat. It makes a really good jerky."

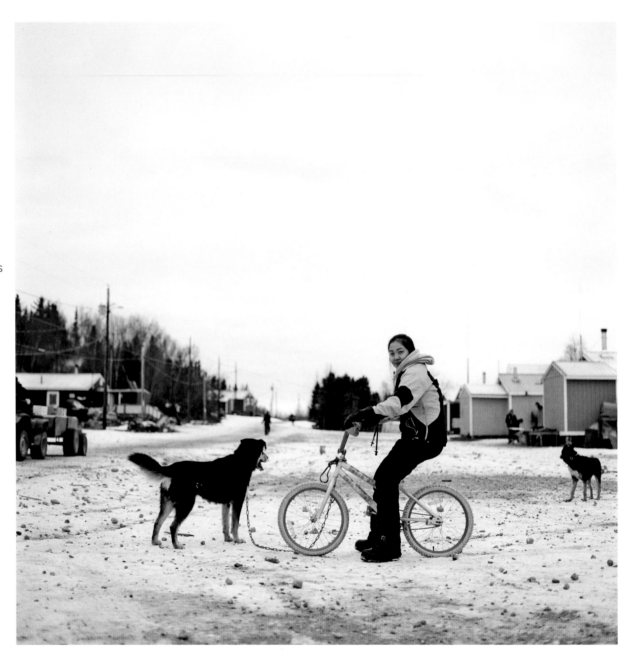

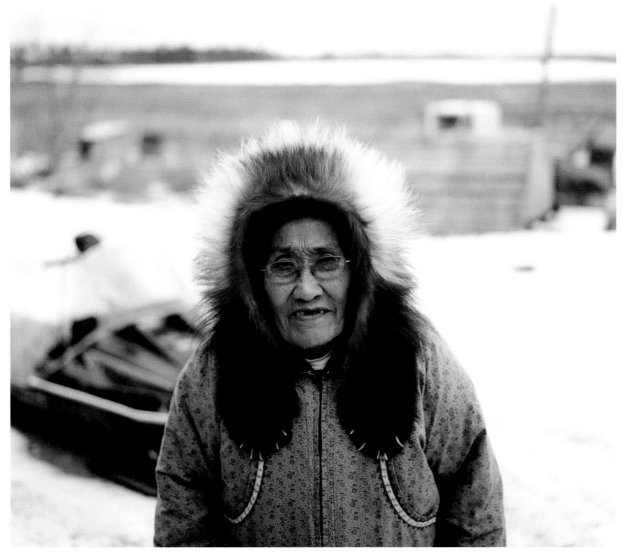

Mildred Black, Iñupiaq

"I like this village. We started living at fish camp year-round when I was six years old. We needed food and there was no work. We were raised in camp until I was 17 years old. When I was 17, they sent me to school. It was during the winter, so I was there for six months, then the next year for three months. Then we went back to camp.

At camp, my siblings and I learned how to make muk-luks, fish, pick berries, hunt, and trap. Mom taught us how to make baskets, sew, and make nets.

When I was 12 years old, I went to the school to visit. I spent the day there. Everybody was speaking English, and I didn't know how to speak English. I never learned. I started speaking to them in Iñupiaq, and they complained about me to the teacher, and then the teacher wrote down my name. When we all got ready to go out to play, the teacher said, 'Mildred, you talked Eskimo in school.' He gave me a sheet of paper and a pencil, and he told me to write, 'I will not talk Eskimo in school anymore' 100 times. So, I wrote, 'I will not talk Eskimo in school anymore' 100 times. After I finished, I gave that paper to him, I went out, and never went back to school."

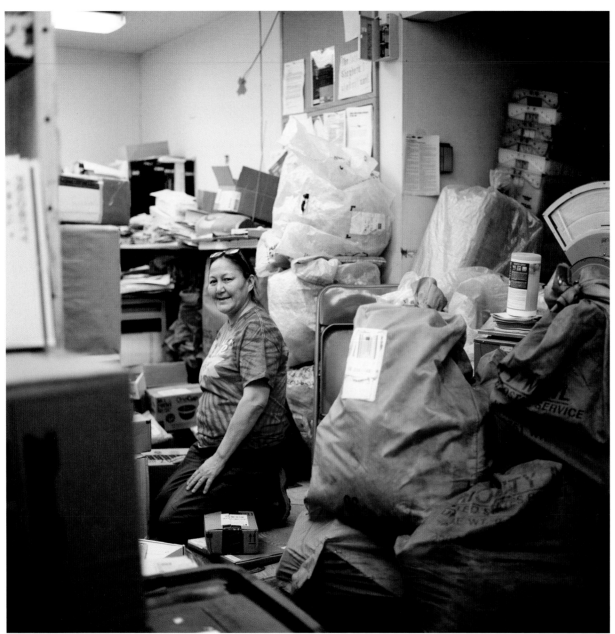

Linda Lee,
Iñupiaq

"The post office was closed for a week and a half. I am the former postmaster. I am here volunteering to sort out all this backed up mail while the post office is in limbo. If you know anyone at the post office in Anchorage, tell them to send help here."

Melvin Lee,
Iñupiaq

"I have been working as a carpenter most my life. I would travel to Kobuk and Ambler, doing mostly casket making. We make our own caskets.

I have got five daughters and two adopted boys. There are 14 of us living in there [points to his house]—three families. We are short of houses [in the village]. The last time they built homes here, they only built five. Because of the freight costs, we don't get barges up here, only once in a great while. Everything has to be shipped in by airplane. It's expensive living up here. But, we make do. The people are nice, and whatever you ask for, it's right here in town. You don't have to go nowhere. I like it right here."

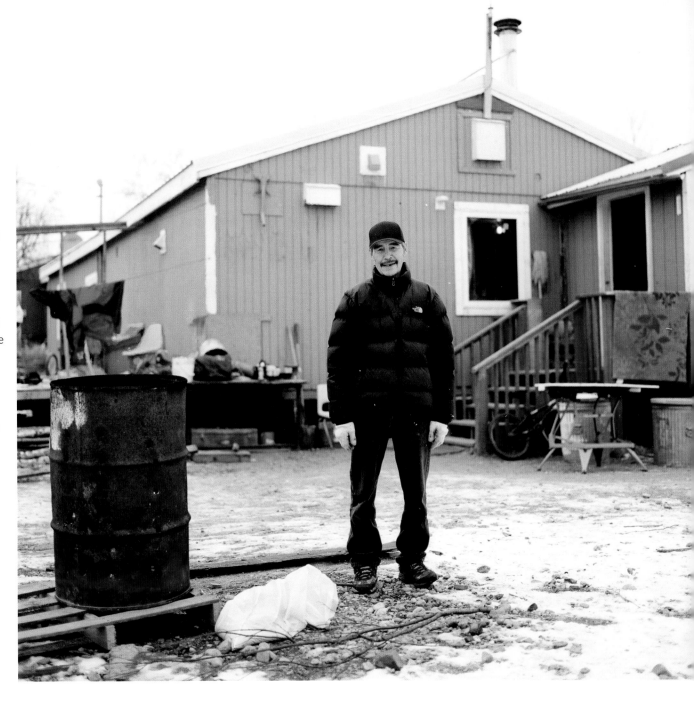

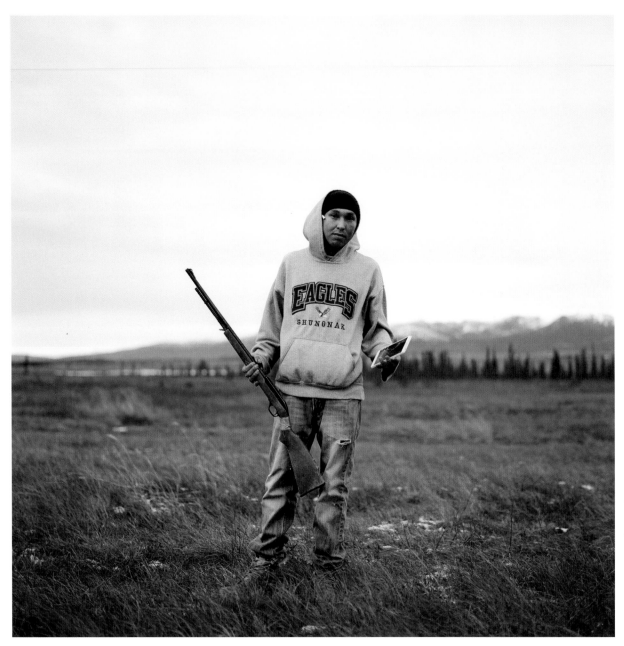

Paul Tickett,
Iñupiaq

"Technology is helping in one way. I mean, you can go to college on the internet now. And in another way, it's hurting, because it's keeping the young people from their culture, from fishing and camp."

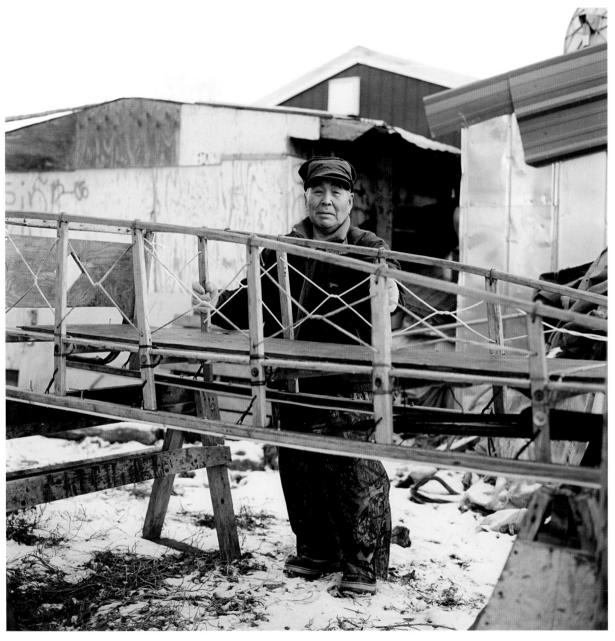

Oscar Griest Sr., Iñupiaq

"These are my dad's old sleds. The runners are bent, so I am taking it apart to rebuild it. I have been building sleds for quite a while. My dad taught me; he would watch me and when I would make a mistake, he would straighten me out, which was good, you know. He would watch and tell me, 'you're not doing it right, right there' and either I would take it apart or just keep on building. I would try not to get mad. Then I had to do it right, which is good. The airfare is getting pretty high here and the gas. So, it's better off to get some dogs I think, and a lot cheaper. We have seven of our own kids and we adopted five more girls. We have a big family."

TELLER

Teller is a coastal Iñupiaq village with a population of approximately 230. It's located in the Bering Strait Region on a spit between Port Clarence and Grantley Harbor, 72 miles northwest of Nome, on the Seward Peninsula. During the early 1900s, Teller was a major regional trading center, attracting Iñupiat from Diomede, Wales, Mary's Igloo, and King Island. Many residents of Teller were originally from Mary's Igloo.

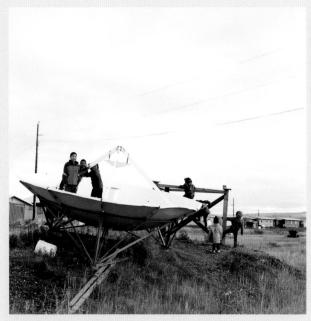

Kids playing in a non-operational satellite dish near the coast of Teller, Alaska. 2015.

Teller, Alaska. 2015.

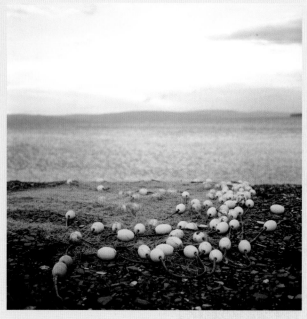

Fish nets on the beach in the fall of 2015 in Teller, Alaska.

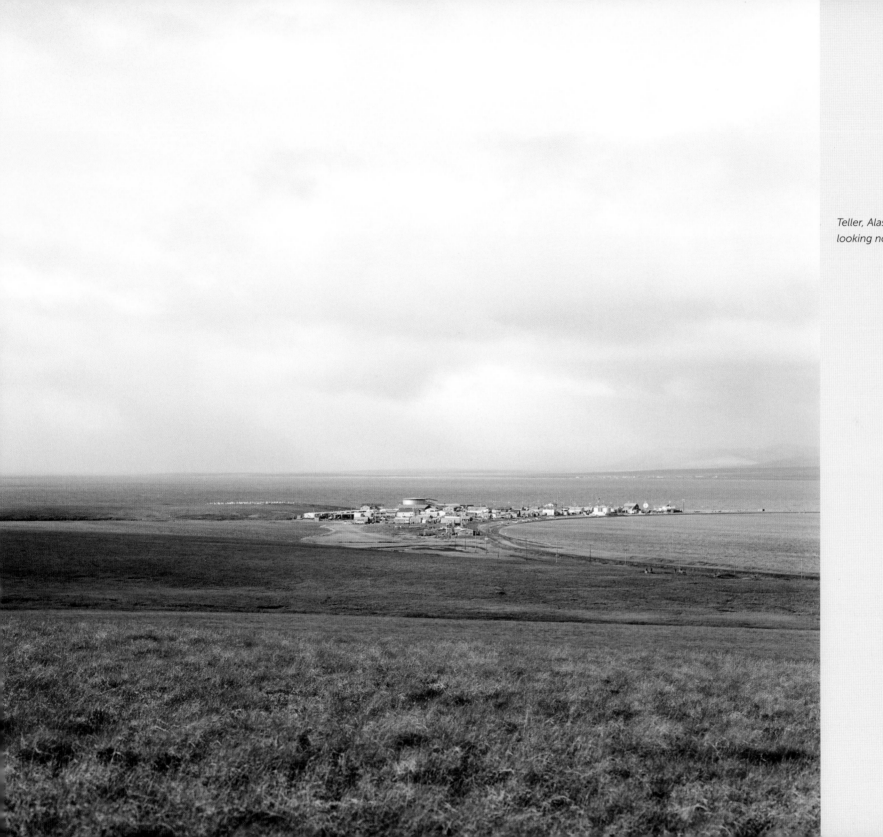

Teller, Alaska from the airport looking northwest. 2015.

Benjie "Seghlili" Iknokinok, St. Lawrence Island Yupik

"I am from Gambell and am in Teller for the Culture Festival. This is my second year. There is a lot more people this year. It is wonderful. I met some new old friends, got to hang out with Point Hope, and my sisters were with the Nome St. Lawrence Island group. It was like a reunion.

I haven't been drumming for too long, but I have been dancing since I could walk. I started performing in front of crowds when I was seven years old. I lived in Savoonga for a little bit, and when I was there, we tried to remake what used to be the Savoonga Comedy Group. We made our own rendition. It was nothing like the original though. The original was 'unique.' The original comedy group was elder ladies, and when we tried to do it, it was a mixed generation of ladies and some guys. We tried, we made some people laugh. Tough crowd!"

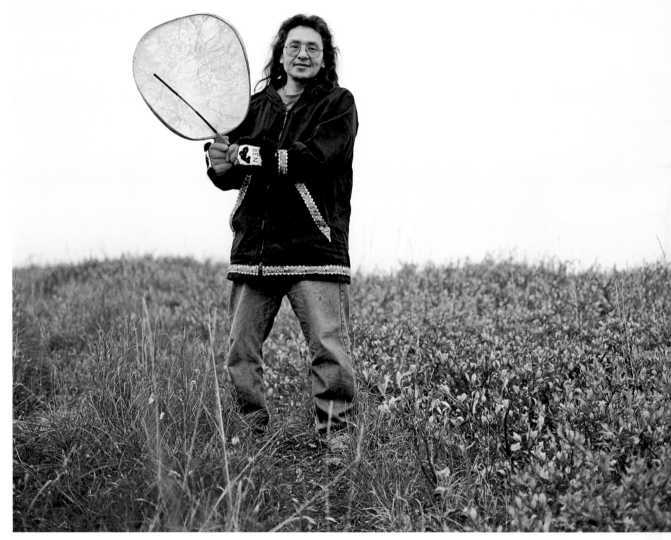

Marvin Okleasik, Iñupiaq

"My dad won the first Iditarod [dog sled race] in 1967. He said he wished we named me after him."

Cora Ablowaluk, Iñupiaq

"I am the tribal coordinator. I am a volunteer for the Teller Culture Festival. We have been working on the Festival for 12 years. It took a whole year just to get it started. We organize, we shop, we cook—everything! It's one of the biggest events we have here in Teller. We have seven villages here—eight including Teller. The first year we had two festivals: One at the end of September because the Russian group couldn't make it after getting weathered in. But we had paid so much money for them to come that we had to reschedule for a week or two later. So the first year we had two festivals within two weeks, and everyone that came the first time, came back the second time to see the Russian group. Our goal is just to keep it going."

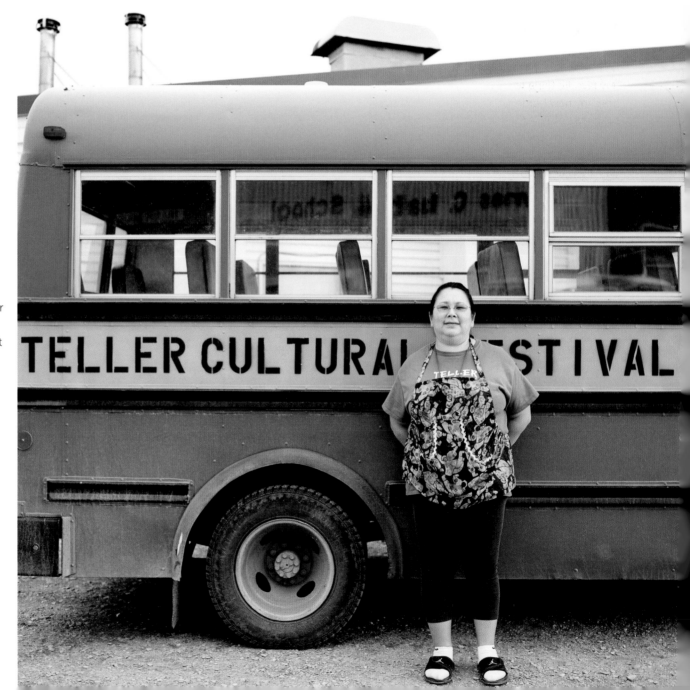

Daniel Komok, Iñupiaq

"My favorite thing to do is to walk everyday. I walk from my new home up over there, which is two miles southeast of Teller. I walk up and down everyday. I enjoy walking and it's good for my heart. I moved to my house in '74/75 after the flood. I own my house. I paid it off nine years ago from Bering Straits [Housing Authority]. I had them hold all my dividends until my house was paid off."

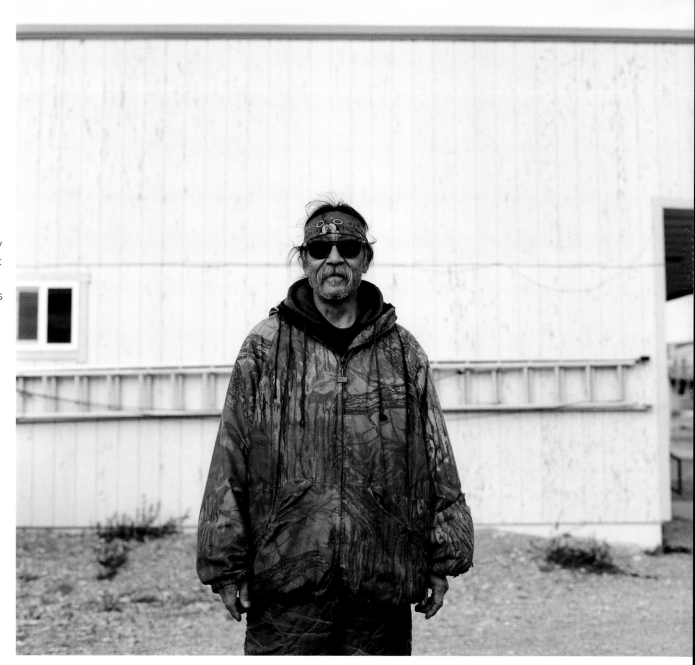

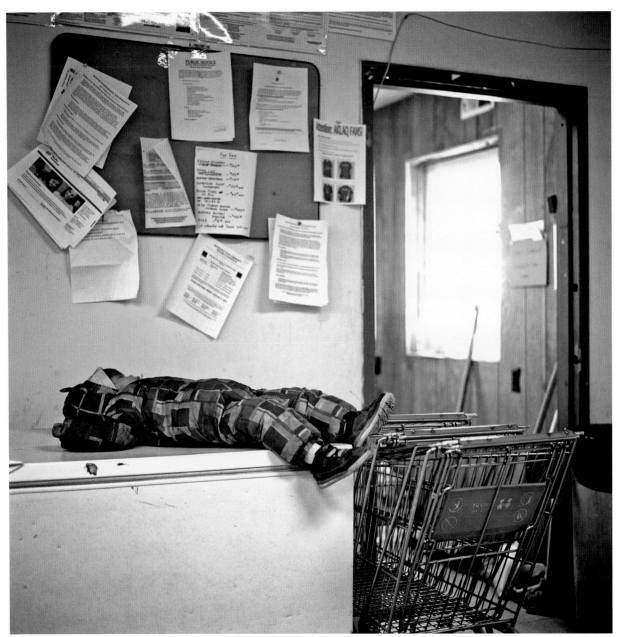

Derek Menadelook, Iñupiaq

"He passed out on the way. We live two miles up, at 'New Site.'"—Roger Menadelook, father of Derek Menadelook, photographed here.

Grace Ongtowasruk, Iñupiaq

"I am a senior at Teller School. After I graduate I want to get into UAF [University of Alaska Fairbanks] and get into human services and psychology. It's scary. I think what I am going to miss most is my little siblings, because I am the oldest. I will also miss going upriver to fish camp and reindeer corralling, it's a lot of fun and goes on all night."

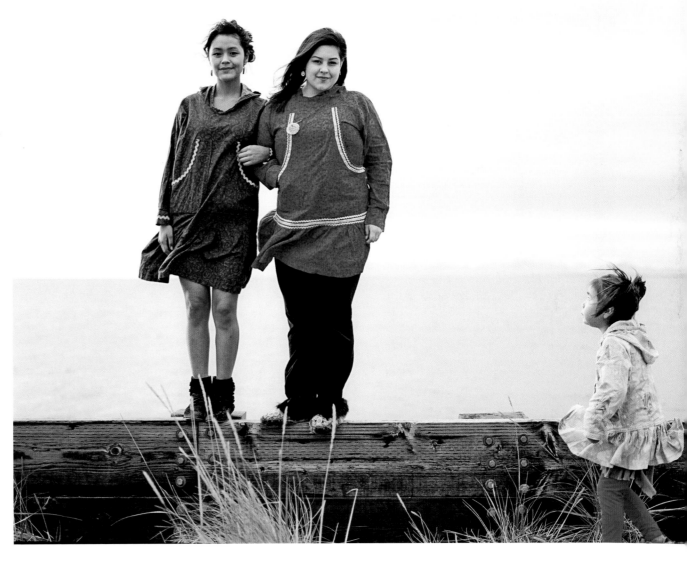

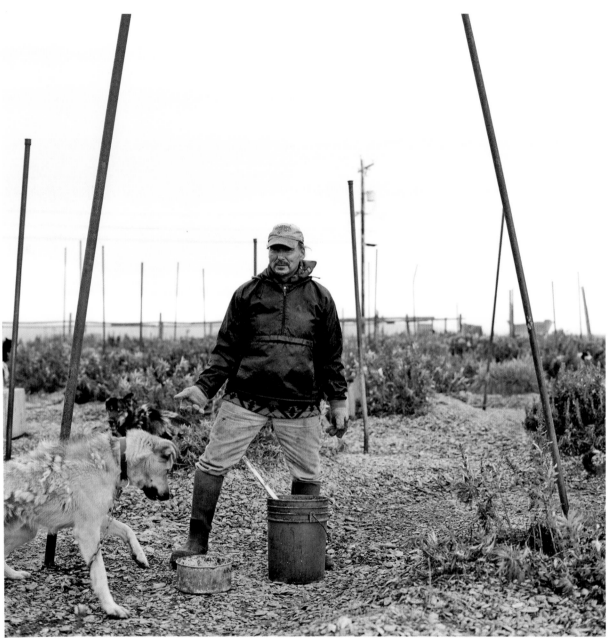

Joe Garnie, Iñupiaq

"I was born and raised right here. I was born [near] King Salmon Creek.

I have had dogs all my life. I only had four years of my life during high school when I didn't run dogs. The day I got back from high school, I started up my own kennel—my folks only had one dog at the time.

We went to these boarding schools—I went to one in Oklahoma—and when I left, everyone had dogs. In my absence they had invented the snow machine, and most everyone had gone snow machines.

I have run the Iditarod [sled dog race] 17 times and numerous other races. I raced my first Iditarod in 1978/79. I haven't run the Iditarod in 12 years or longer—it's been awhile. I use these dogs for hunting and fishing, hauling firewood, the whole nine yards. These are real dogs here."

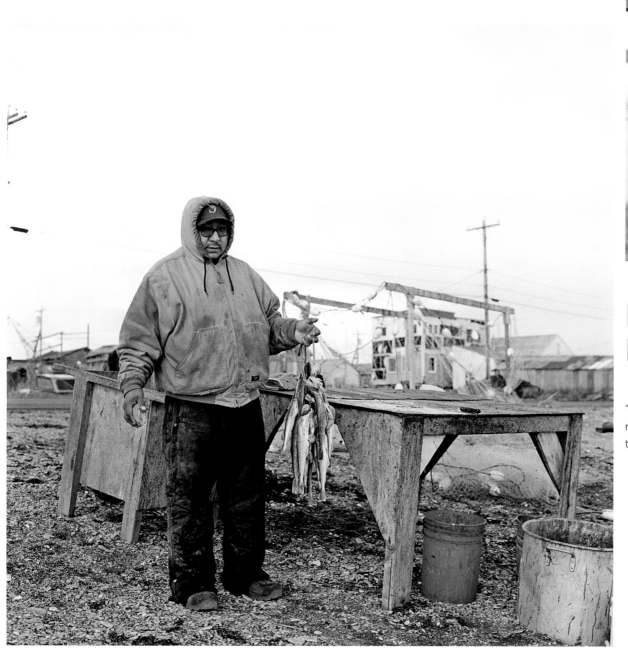

Nick Topkok,
Iñupiaq

"Hardly anyone does this anymore. In the fall time they run thick, and right now they are really healthy. We eat them half dried and frozen. I grew up eating this food."

Julia Lee,
Iñupiaq

"Our reindeer herd was passed down from generation to generation. The first owners passed on, then it went to my aunt from her husband and when she passed on it went to our mother, and when she passed on it went to us children. We were born into it, but have been hands on for nearly 14 years now.

We are at a standstill right now with the herd. My brother has been missing for five years and it's hard to get a death certificate when it's a missing person. I am waiting to get a court date set up, but they said it can be a long process, even after someone has been missing for five years."

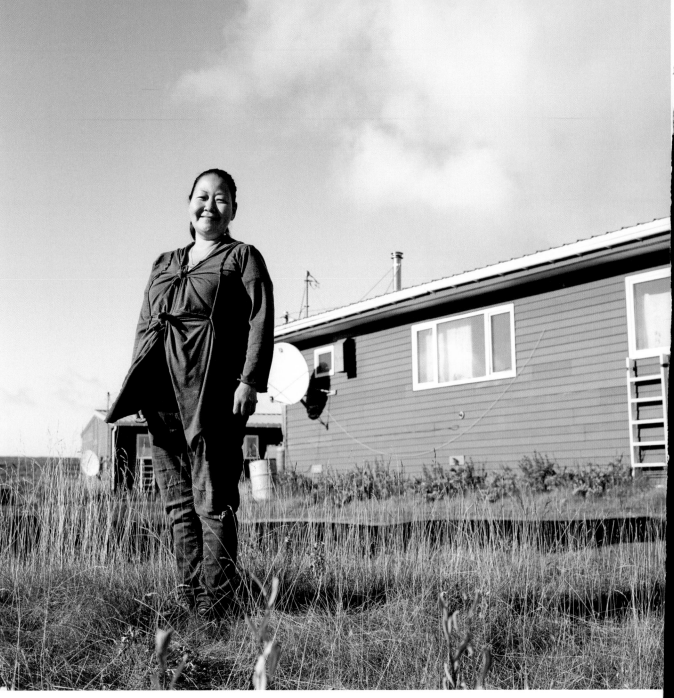

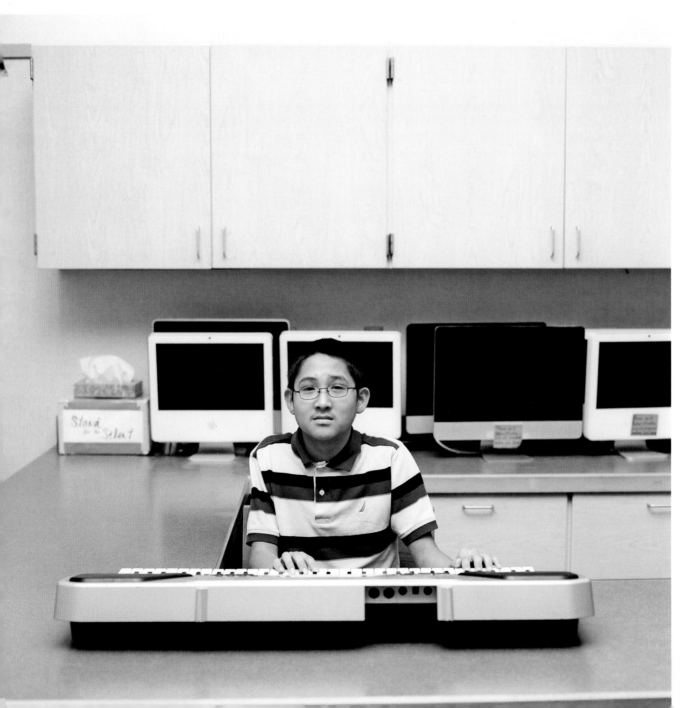

Kevin Bell,
Iñupiaq

"I used the computer to learn to play piano. My favorite song to play is *Back On Track* by Geometry Dash."

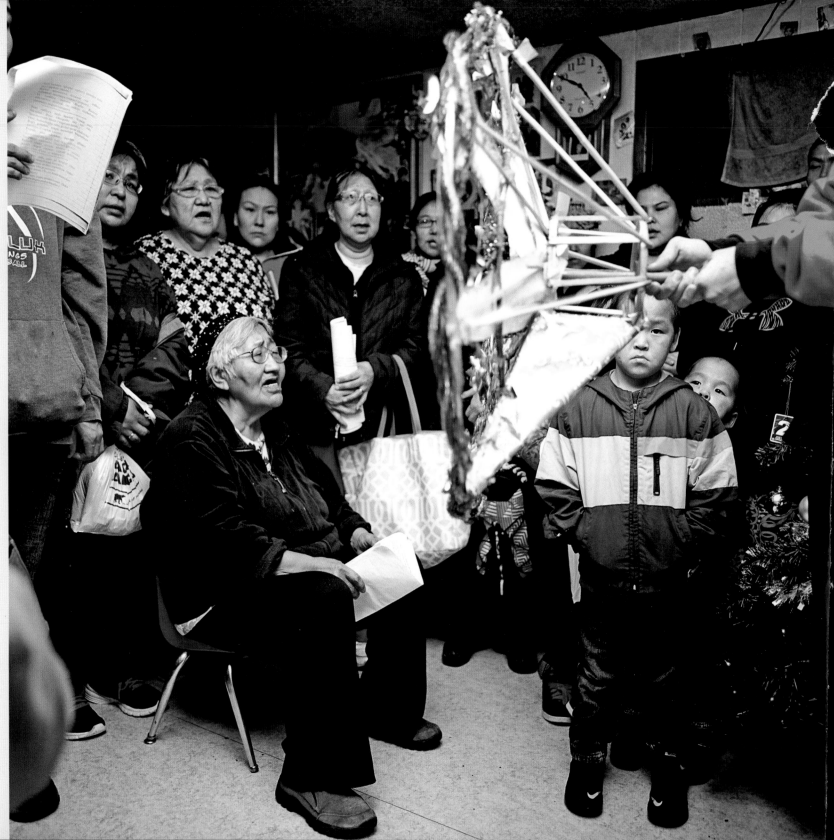

Dora Napoka, who helps arrange Slaviq in Tuluksak, said this about why only men or boys can hold or touch the star: "Women can't touch it, because Mother Mary and all women menstruate and part of menstruating is close to sinning. A long time ago, before my time, women couldn't even go into the church, or make sign of the cross or kiss the icon, because they didn't have adequate stuff [tampons/pads] to use. Until modern time. A long time ago, my sisters had to use the grass that's out there with a piece of linen, you would put the grass in there and wrap the linen around. That was their pad. That's why we don't touch it. If we do, it has to be blessed with holy water, and when we bless it, we bless it in the name of the Father, the Son and the Holy Spirit. There are rituals we have to follow, keeps us disciplined."

TULUKSAK

Tuluksak, traditionally known as Tul'yagmyut, is an inland Yup'ik village with a population of approximately 400. Tul'yagmyut is the Yup'ik word meaning "related to loon." The village is located in the Yukon-Kuskokwim region, a short distance away from the Kuskokwim River and sits along the bank of the Tuluksak River, about 34 miles northeast of Bethel.

The Tuluksak Pool Hall. Tuluksak, Alaska. 2016.

The frozen Tuluksak River, a tributary to the Kuskokwim River, serves as an ice road in the winter. The village of Tuluksak, Alaska is located at the mouth of the river.

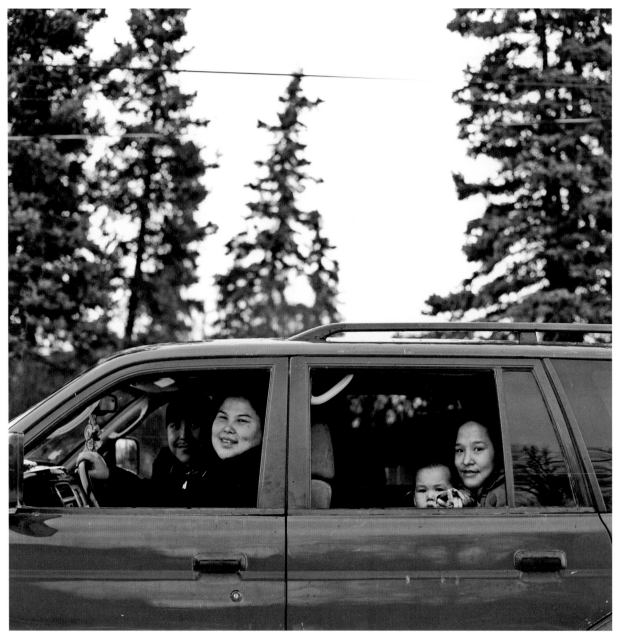

Anastasia Jones and Sonny Jones Sr. (passenger seat), Yup'ik

"We are headed to Slaviq. We sing and pass out candies in peoples' homes. It's a Russian Orthodox tradition. We aren't Russian Orthodox, we are just joining in. It's been going on here as long as we can remember. Slaviq started today and we will be celebrating for about a week."
—Anastasia Jones

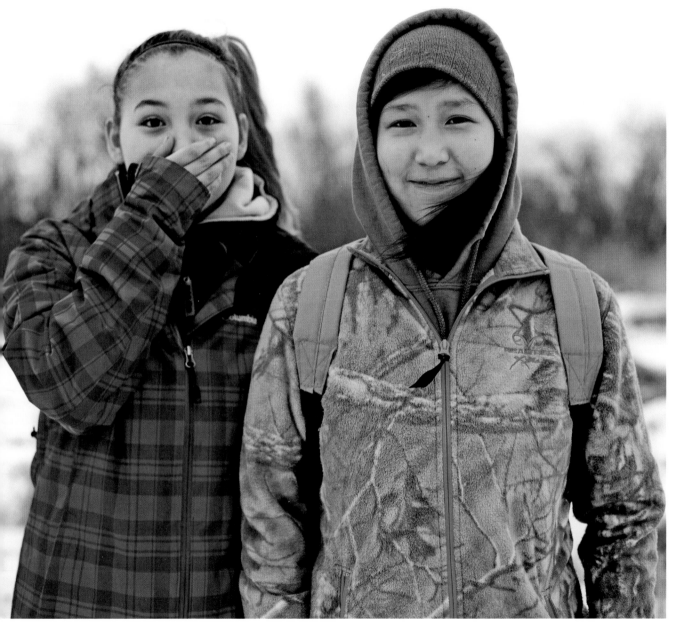

Coreen Napoka (left) and Amber Allain, Yup'ik

"We are both 14. After high school we want to join the Army and be based in Bethel. My Apa [grandfather in Yup'ik] and my dad were both in the Army. We come from a military family. We would miss our parents most."
—Amber Allain

Tommy Owen, Yup'ik

"I was just out jigging for pikes. Nothing today. I was fishing on the Kuskokwim [River]. It's right on the other side of this river [Tuluksak River] about a mile away. I walk everyday about four to five miles a day. I go down here, I go downriver, about an hour and a half walk. I like walking. People come by on snow machines and offer me a ride home and I say, 'No, I will walk home.'

It's a little different this year, only a little bit of snow, and last year we got nothing. There should be more snow. I have been fishing on the Kuskokwim River almost every year of my life. Most of my catch I give away to dog mushers in town. The Kuskokwim 300 [dog sled race] is going to be pretty soon."

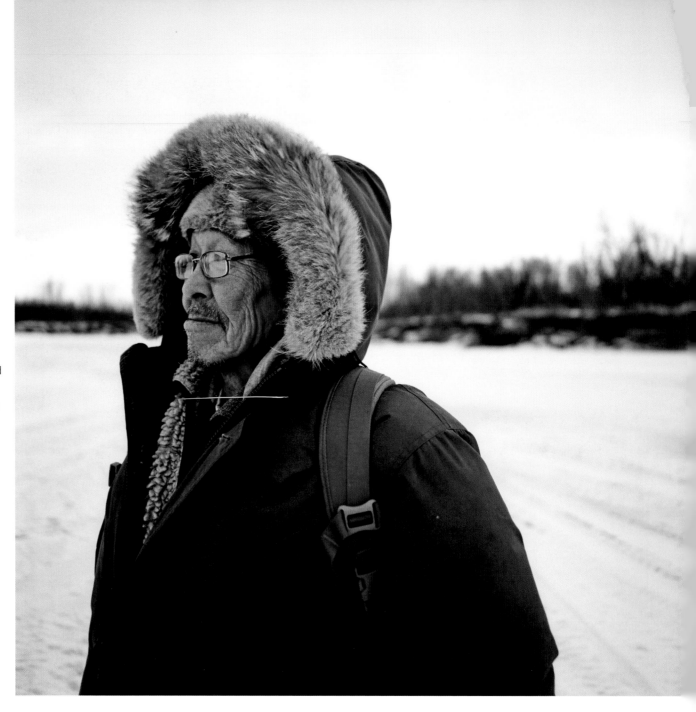

Dora Napoka,
Yup'ik

"I am originally from Russian Mission, Yukon [River]. A long time ago, when I was a little girl growing up, we would go to church around six until midnight, then we would start up the 'Slaviq' songs and all the stars would line up. The big stars were for the adults and the small stars were for the children. We don't have that in this village because we are so small and there are just a few [Russian] Orthodox here so we just use one, and we all fit in one house. But we make sure we get to every house."

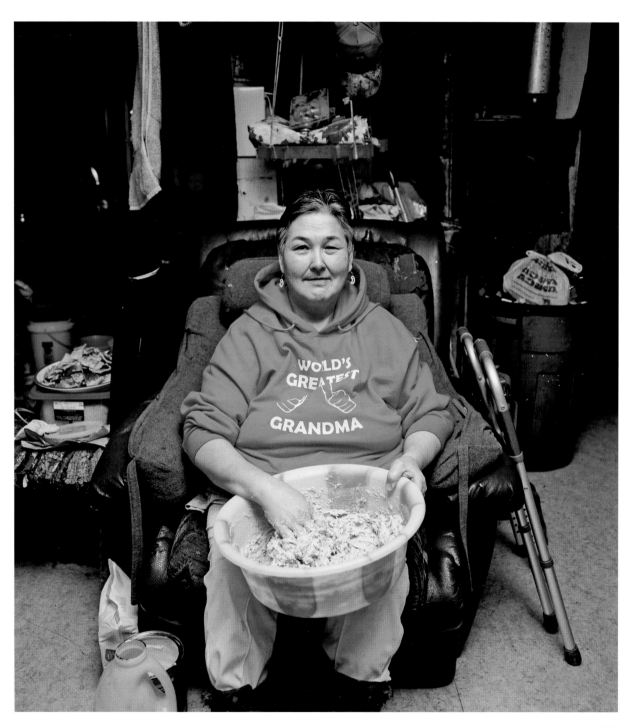

Lott G. Lott, Yup'ik

"I have been working here at the pool hall for close to eight years, since it first opened in 2008. My favorite thing to do here is go fishing and take my sister picking berries in the summertime around August and September. I can't wait for the birds to fly too, so we can start hunting ducks, geese, snow geese, and swans."

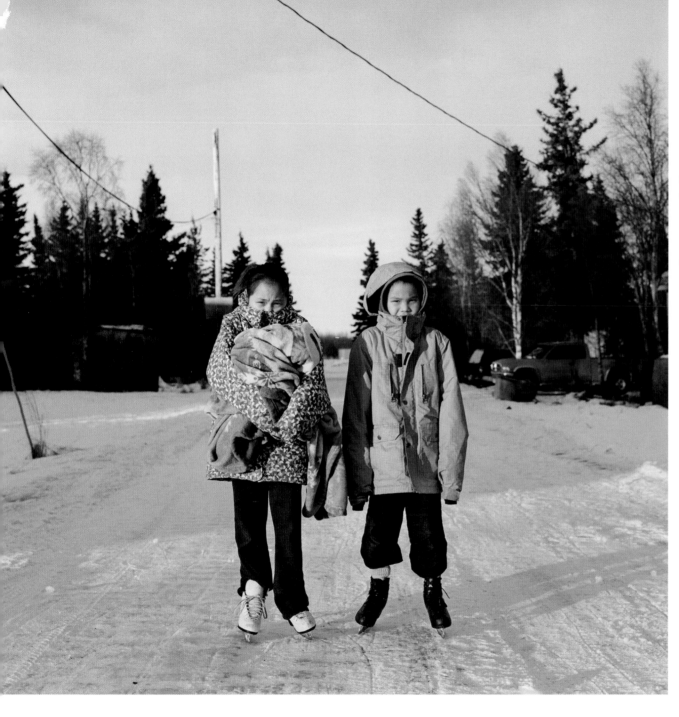

Mason Gregory and Carissa Alexie, Yup'ik

"We are skating home."

Myron Andrew, Harry Williams and Triston Peter, Yup'ik

Myron Andrew (17, left), Harry Williams (16, center), Triston Peter (16, right) hanging out and playing pool at the Tuluksak pool hall.

After high school, all three boys plan to attend the University of Alaska in Fairbanks or Anchorage after graduating.

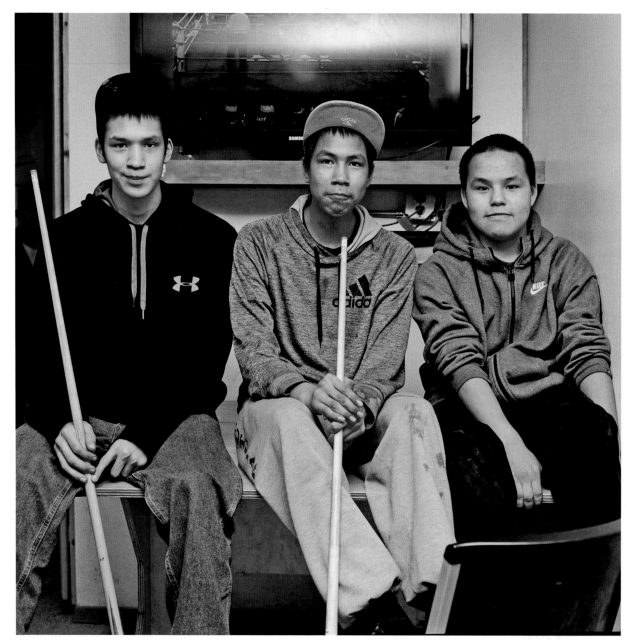

Teams compete in the 31st annual Robert Putto Charles Memorial Valentines Tournament in White Mountain, Alaska. 2016.

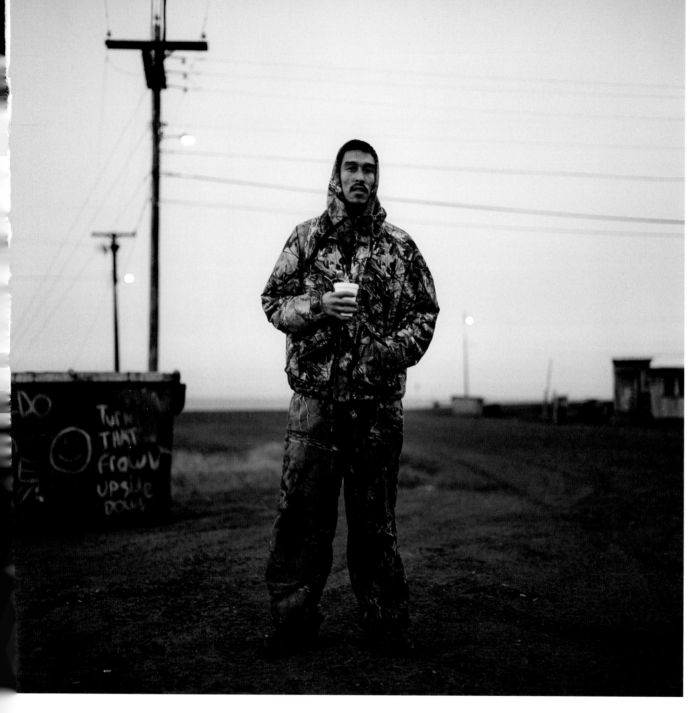

Michael Agnasagga, Iñupiaq

"I shot a polar bear, and it made it on the news. It's still being viewed all over the world. It's all over YouTube. We got a [bowhead] whale, and while we were cutting it on the ice, the polar bear came. One guy posted the video, and when I saw the video I knew it was going to make news.

I am on the Ice Berg 11 Crew [a local whaling crew]. We go by Ice Bergs; it goes from Ice Berg 1 to 15, but the only ones that go whaling now are 2, 5, 6, 12, 14, and 15. It's fall whaling [season] right now. It's too warm right now though. There's big swells out there. They have to go out about 30 to 40 miles away from town.

We almost died back in 2002. The forecast said it was going to be nice, and I had just got a white bearded seal. It was on the ice and all you could see were these black eyes looking at you. The moment we threw the body [of the seal] in the boat, we could feel the wind and the storm come. And there were the biggest waves ever; they were bigger than the boat. I was a little boy, crying. I was 13, my cousin was ten, and my grandpa and dad were there. We had a long 15-mile boat ride. My cousin didn't go in the ocean until he was in his 20s after that."

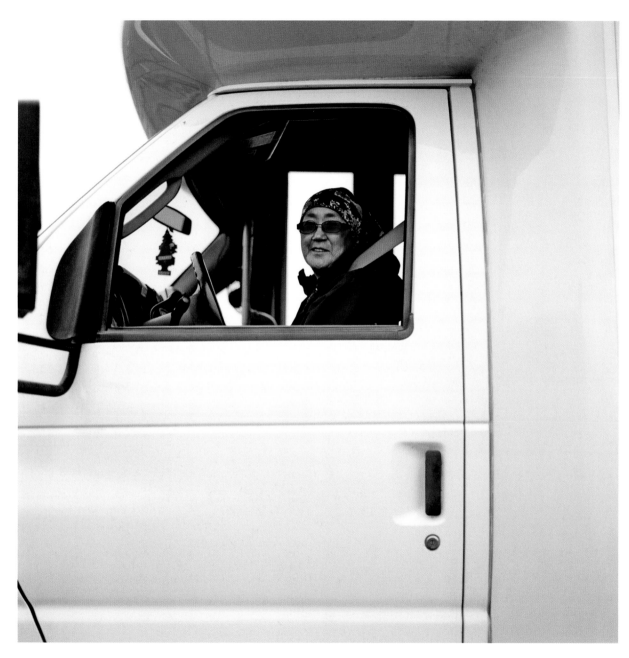

Isabel Nashookpuk, Iñupiaq

"I am the Senior Van Para Driver through the North Slope Borough Health Department. I give the seniors rides, and some of them are my uncles and aunties! I also deliver 'Meals on Wheels' through the school for the seniors. I have been doing it for 12 years, and I enjoy it. I am born and raised here. It's my hometown."

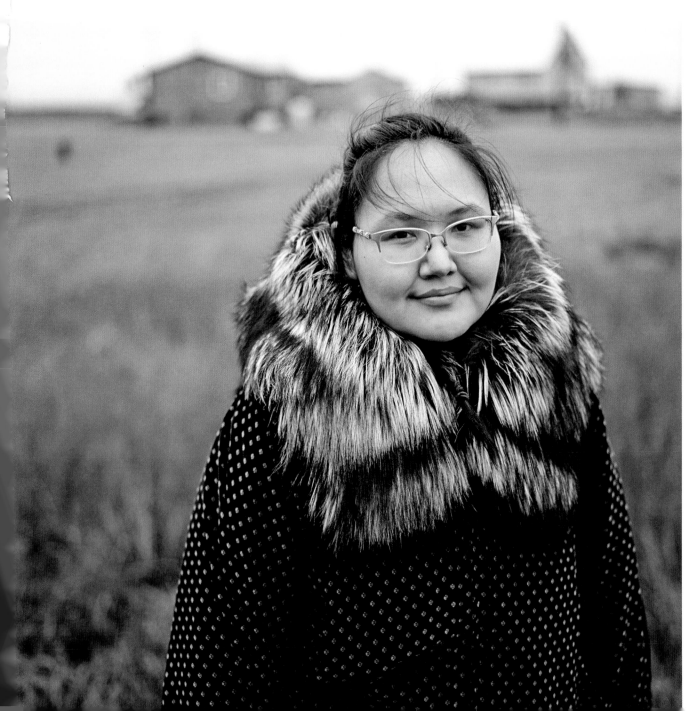

Christine Kagak, Iñupiaq

"I was born in Barrow and raised in Wainwright. I went to high school at Mount Edgecumbe [boarding/high school] for all four years, and I lived there until last year. It's a lot warmer down there than here. It took me a year to get used to the weather up here all over again. I enjoyed it down there, but I was away from family most of the time and only got to see them once a year for Christmas break. Once in a while they would get to come down and see me, but it's pretty expensive to travel down there. I got used to living down in Sitka though because there's people from the North Slope living down there too.

My Aaka [grandma] and them always sent me Iñupiaq food at least once a week. All of us North Slope people would get together and eat Iñupiaq food."

Frederick Rexford, Iñupiaq

"I am originally from Barrow. I moved here 24 years ago and have been living here, hunting, ever since. I didn't know anything about hunting when I lived in Barrow. I was too much into trouble. Moving here really changed my life around.

The first time I went hunting was for walrus. It was with my grandfather and uncle. They were showing us what to do. A walrus jumped on the ice and my grandfather wanted to show us [how] not to be scared and got the oar from the boat to let us kids follow beside him. He pushed the walrus on the whiskers in the face. It attacked him a little and he pushed it some more, and then it jumped in the water. We loaded up the boat with all the meat, and the boat gets low, slow and slow. And we make it home to feed everyone. The whole community is happy when we come back and get on the radio. Everyone comes and gets their bags full of meat.

Right now, we are trying to catch a whale with our last strike [the community quota for bowhead whales]. If we catch the whale, we will send some maktak [bowhead whale skin and blubber] to Gambel because they gave us their strike. I am part of the whaling crew Ice Berg 10. We got two whales this year."

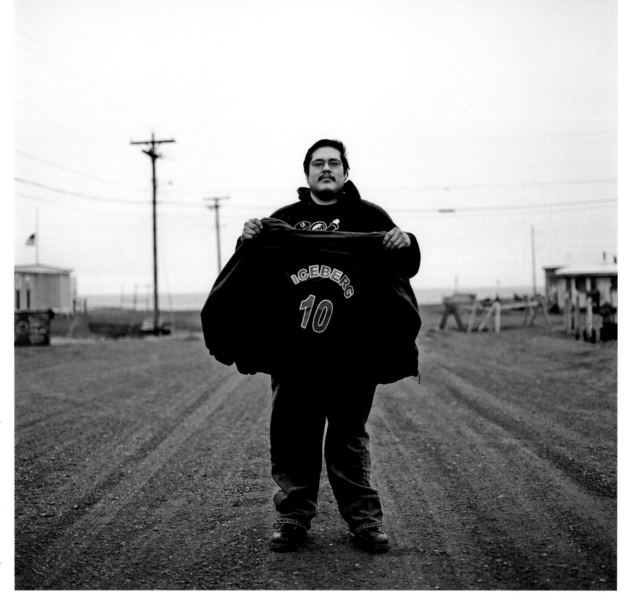

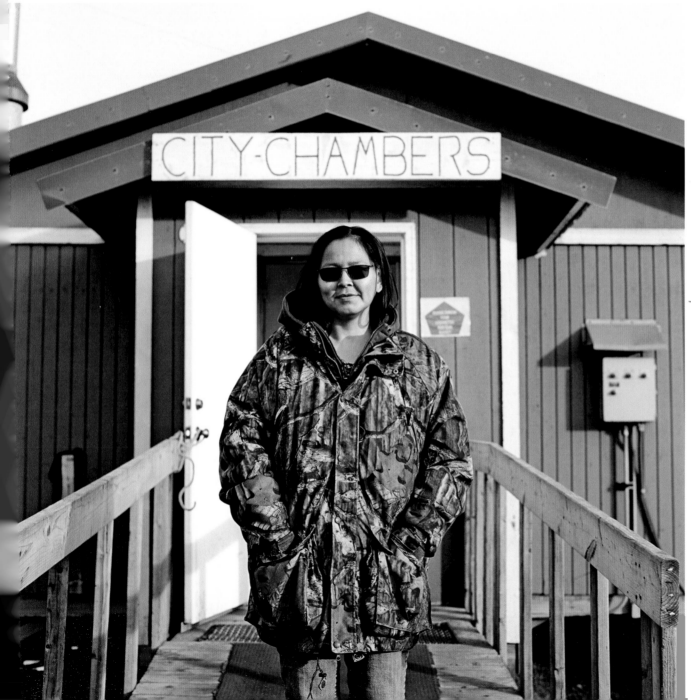

Cheryl Panik,
Iñupiaq

"I am the accountant here at the city. It's pretty good here in Wainwright. There is an ocean in the front and a river in the back—the land, the animals. I go out hunting every summer. I go hunting for caribou, ducks, and geese. My favorite is tuttu [caribou]. My friend and I caught nine this summer. You have to go out about 35 miles on four-wheelers. We can do it in about 18 to 20 hours per trip. It's pretty good living out here."

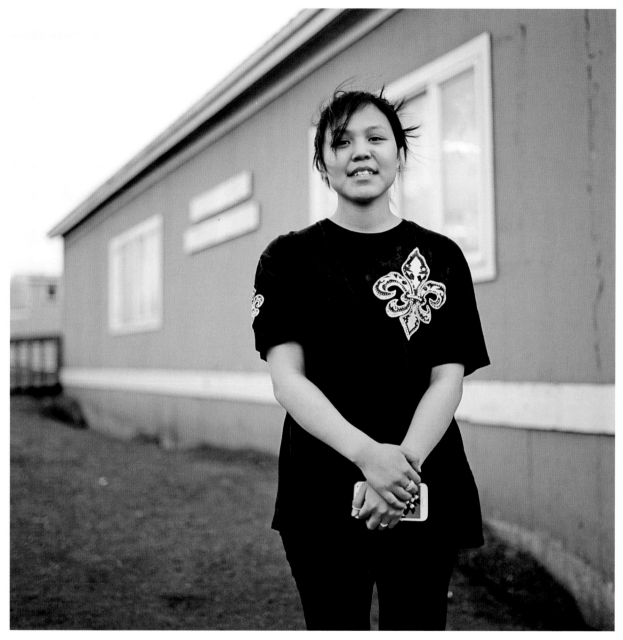

Amy R. Okpeaha, Iñupiaq

"I was born and raised in Barrow. I came here because my adoptive mom used to live here and her mom lives here. All my siblings and both my parents still live in Barrow.

I am a youth program director at the community center. We play a lot of games. We play a lot of Iñupiaq games, like stick pull and all the other kinds of games. I think the biggest thing is, we stay open so the kids can stay out of trouble."

WAINWRIGHT

Wainwright, traditionally known as Ulġuniq, is a coastal Iñupiaq village with a population of approximately 550. Wainwright is located along an eroded coastal bluff on the west side of a narrow peninsula, which separates Wainwright Inlet from the Chukchi Sea. Wainwright is located in the North Slope Borough. The village was traditionally a well-populated area that transitioned to a permanent settlement in the early 1900s when a school was built and other services were introduced.

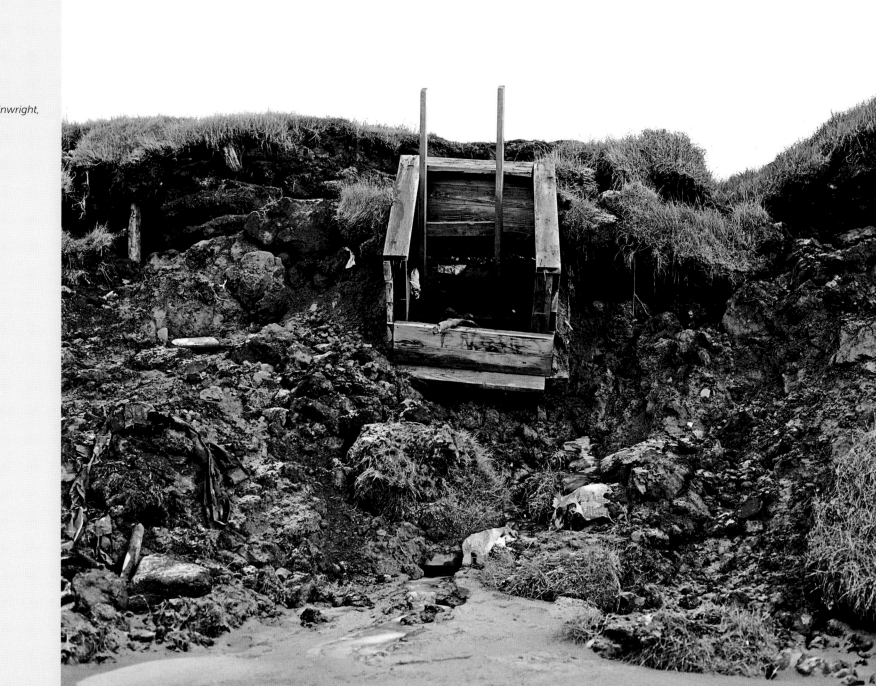

Two ice cellars in Wainwright, Alaska. 2016.

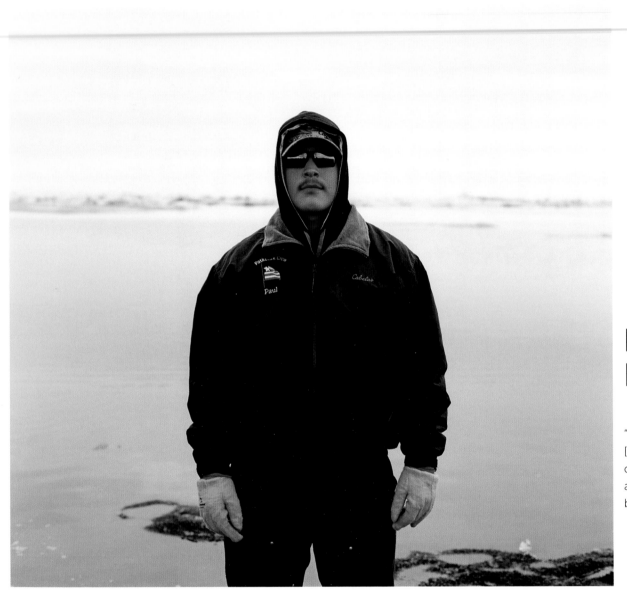

Paul Patkotak, Iñupiaq

"I am a part of the Patkotak whaling crew. I have been [bowhead] whaling with them since I was eight years old. I am the harpooner on the crew. I love going out and coming back with the whale and feeding everybody. I am 16 [years old]."

Nicole Kanayurak, Iñupiaq

"There is a lot going on in the Arctic right now with development and conservation. There is a lot of attention on the Arctic and climate change. Right now I am working at the [North Slope Borough] Department of Wildlife Management. I work on polar bear co-management. It's co-management between Alaska Natives and the [U.S] Fish and Wildlife Service. I contact different communities that hunt polar bears, and I keep up with the status of the polar bear co-management agreement and bilateral agreement with Russia, United States, and Canada on the harvest and conservation of polar bears. Its purpose is to continue the harvest of the polar bears, and there's a conservation component and management under the Marine Mammal Protection Act."

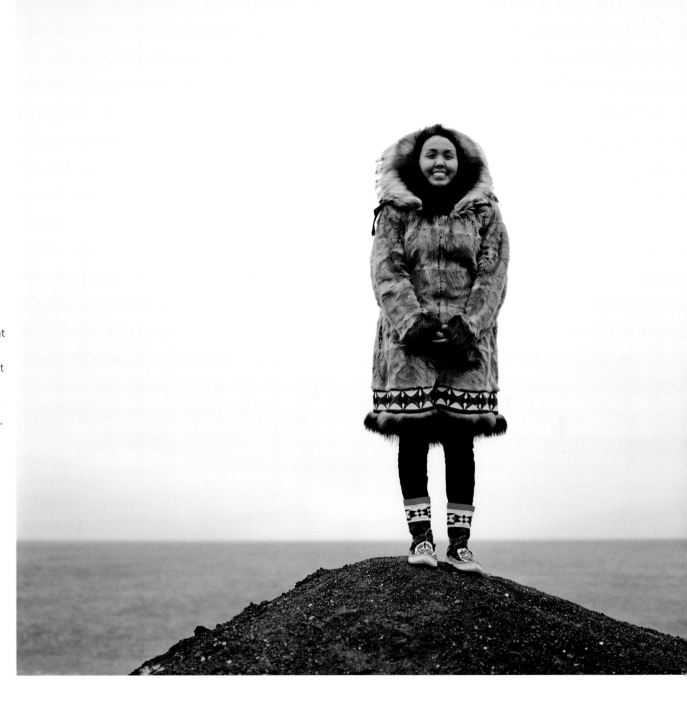

Joni Edwardsen, Iñupiaq

"I started learning to sew from my grandmother, sitting next to her, watching her. I would follow her to arts and craft sales. I started taking my things along that I had created, which led to an official business. I have been making the work since I was a little girl.

I sell mostly sealskin items. Lots of jewelry, earrings, sealskin cuffs, bracelets, bowties. I am working on a pattern for men's ties. I do a lot of things—mukluks, everything. I am from Barrow, born and raised here."

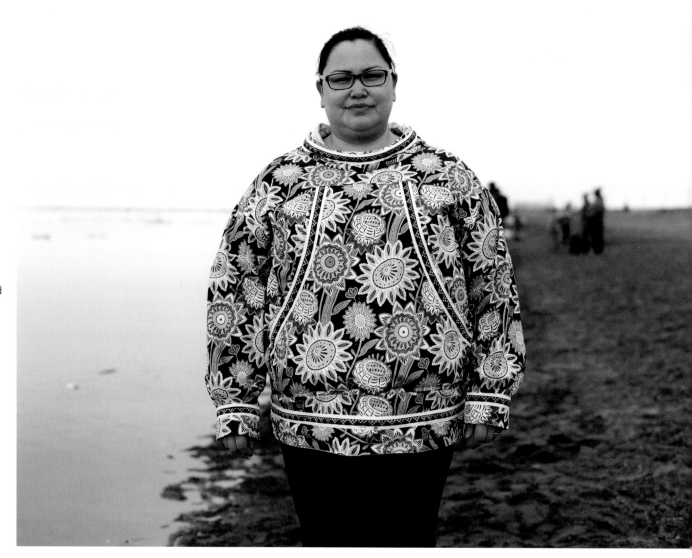

Harry Patkotak and Mary Patkotak, Iñupiaq

HP: "We just got married in March. We joined the crew this year. I took a job in Barrow in February for the North Slope Borough in risk management as an Assistant Disaster Coordinator. I am originally from Wainwright.

We went to go see my uncle when they were giving out candy. It's tradition for them to give out candy at the beginning of the whaling season for the kids."

MP: "Whatever the whaling captain's wife needs done or asks us, we will do. We have a lot of fun cutting and serving and preparing for Nalukataq. Last night my kids and I made a whole bunch of cream cheese frosting and someone else made 400 cupcakes and we had fun last night decorating the cupcakes.

I really love being married to Harry, because he is a hunter and a whaler. My favorite thing in the world is when he sharpens his knife and cuts maktak for me, it really makes me feel special and loved. Ever since we have been together, he has gotten me into eating a lot more walrus than I used to, and beluga. It's so good to be married to a hunter and a whaler."

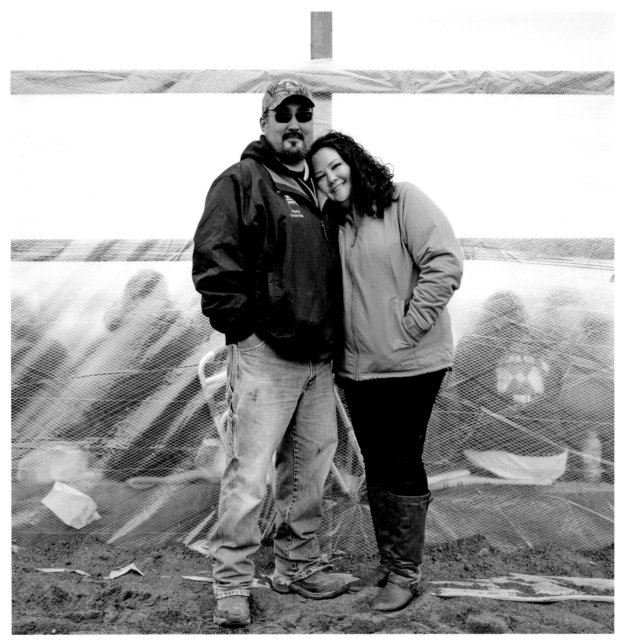

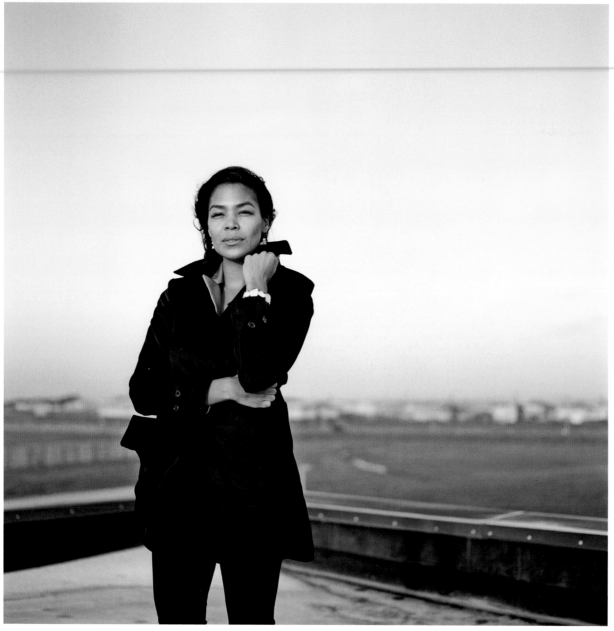

Angela Nasuk Cox, Iñupiaq

"I am just a Barrow kid. I grew up here. It has always been home to me. It seems no matter how far I have gone, no matter where I have gone, I have always come back.

I went to school here until my junior year, then I went to Anchorage and did my last two years of high school there. My dad wanted me to experience the transition of leaving home so I could be successful in college. That was hard for me. But it did what I think it was supposed to do. Right after I finished my graduate degree I came right back. I still have like 50 pairs of high heels in storage.

My dad was born in South Korea. It was during the war; he was orphaned and adopted by a family in Anchorage. They adopted many children; they had nine. They raised children from every background. My dad came up in the late 1970s to work in the gas field. That's where he met my mom and the rest is history.

People often ask me if I will ever leave Barrow or if I am going to stay here forever. The truth is, I don't know. But even with all my traveling and living away from home, I haven't ever been anywhere else where you feel like you are surrounded by so much love."

Crawford Patkotak, Iñupiaq

"I have been the whaling captain of the Patkotak Crew since 2008. The whaling captain's ship was passed down to me and my wife from my dad, Simeon Patkotak Sr. My mom and dad ran the Patkotak crew. They started it in 1966. So, for 42 years they kept the whaling crew going before they passed it down.

Our crew ranges from 30 to 40 people and a core crew of about 12 to 15 that are involved with the hunt itself. Once a hunt is harvested, that's when everyone comes out of the woodworks—family, friends, new recruits.

It's important to note, this is a part of our rich culture and tradition that has been ongoing for thousands of years, and when we are hunting a huge animal as the whale, it takes people working together and being able to harvest a whale and being able to feed the whole community. It's not a one-man show, it's not a one-crew show. It really brings our community together, to work together. We take that same principle of working together into everything else we do. Knowing that if we work together, we achieve more. It's about feeding the people, feeding the community. Nobody goes hungry and everybody is fed."

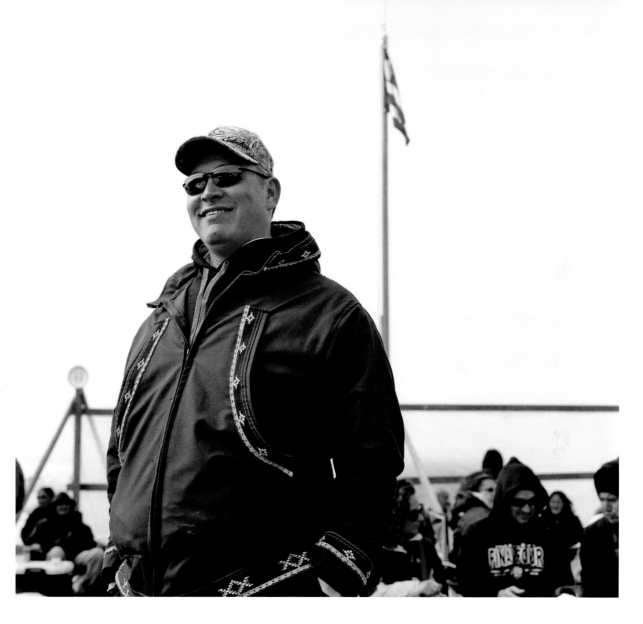

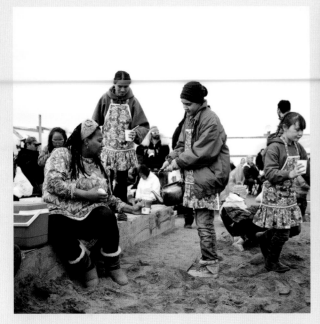

Hot water and tea being served at Nalukataq, a traditional community celebration of a successful spring bowhead whaling season. Utqiaġvik, Alaska. 2016.

Bowhead whale skin and blubber, also known as maktak in Iñupiaq, being shared at Nalukataq, a traditional community celebration of a successful spring bowhead whaling season.

UTQIAĠVIK

Utqiaġvik, formerly known as Barrow, is the northern-most community in the United States with a population of approximately 4,500, located on the coast of the Arctic Ocean. It has been home to Iñupiat for more than 1,500 years. The city's official name, Utqiaġvik, refers to "a place for gathering wild roots." An important archaeological and anthropological site discovered in Utqiaġvik is the Birnick site, which contains dwelling mounds of a culture believed to have existed between 500 to 900 A.D. Utqiaġvik is a vital hub for the North Slope Borough with eight villages who rely on Utqiaġvik as a primary transportation center, for administering region-wide health care, shopping, and other areas.

Seagulls in Utqiaġvik, Alaska, enjoying what's left of a bowhead whale caught by the Pamiilaq whaling crew in October 2016.

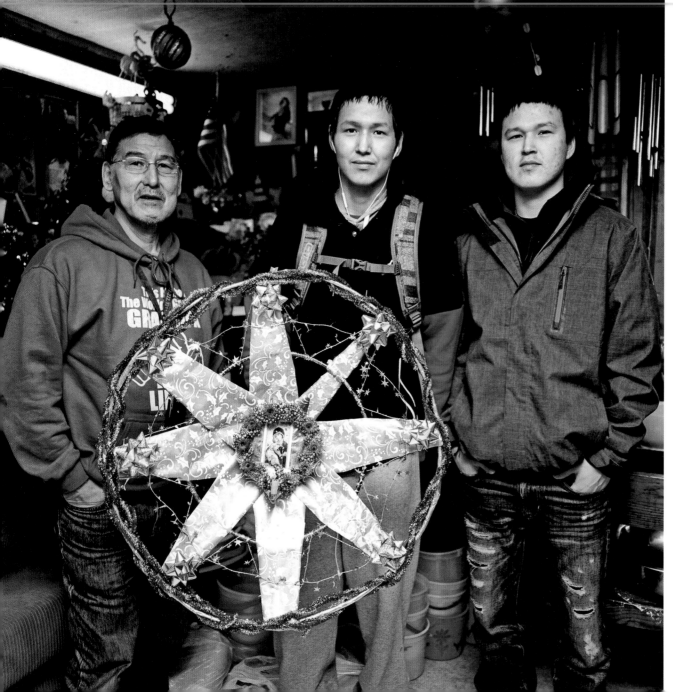

Peter Napoka (left) with brothers Andrew (middle) and Jeffrey Hawk (right), Yup'ik

"I am not Russian Orthodox, but my wife Dora is. A guy from Kalskag showed me how to make the star. He said that you have to use driftwood and cut it up straight. He was supposed to make it, but I ended up making it. I need to make another one a little bit bigger."—Peter Napoka

WHITE MOUNTAIN

White Mountain is an inland Iñupiaq village with a population of approximately 200. The village is located on the west bank of the Fish River, near the head of Golovin Lagoon, on the Seward Peninsula. It is 63 miles east of Nome and is located in the Bering Strait region. White Mountain settled at a seasonal Iñupiaq fish camp, Nutchirviq, where the bountiful resources of the Fish and Niukluk Rivers sustained the people.

White Mountain, Alaska, photographed from the top of White Mountain. 2016.

The top of White Mountain or Natchirsvik which means "a place to see." White Mountain, Alaska. 2016.

Adrian Nassuk,
Iñupiaq

"I come from Koyuk, Alaska. We all know each other down there, that's the village life. I am living in Koyuk, but I am trying to start over in Nome, looking for work. It's hard; life is a struggle, good or bad. I even came down here with no money. I drove down in two hours with a four-wheeler [all-terrain vehicle]. I am glad for my friends. For the future, I would like to see a better me, not trying to be better than anybody else. I don't live in yesterday. Forget about yesterday, live for today because tomorrow is never promised."

Joseph M. Simon, Iñupiaq

"I am born and raised in White Mountain, for 35 years. I work at the store [White Mountain Native Store], going on four years now, and sometimes I help my dad with the airlines.

My niece said one cool thing about White Mountain, 'It doesn't take a mom and a dad to raise a child, the whole village helps raise the child.' We all help each other; everybody is close to one another."

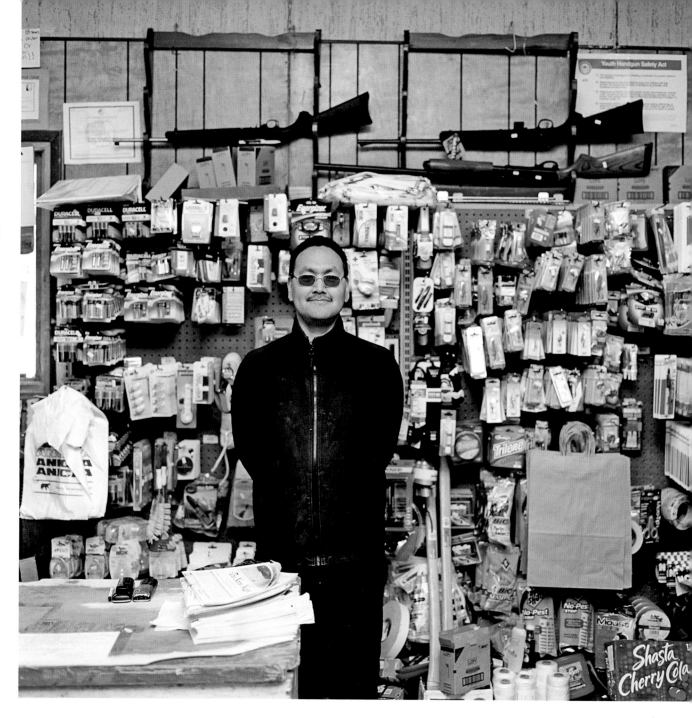

Irving Ashenfelter and Mary D. Charles, Iñupiaq

"Jim Richards started the basketball tournament. It was originally the White Mountain Valentines Tournament. I started back in 1988. I took over it, and have been running it. My son Irving started getting more involved about four years ago. I am slowly stepping out. I have a lady's team staying at my house. I was telling them, back before people flew in, you could see 20 to 25 snow machine lights coming into town, that was fun."
—Irving Ashenfelter

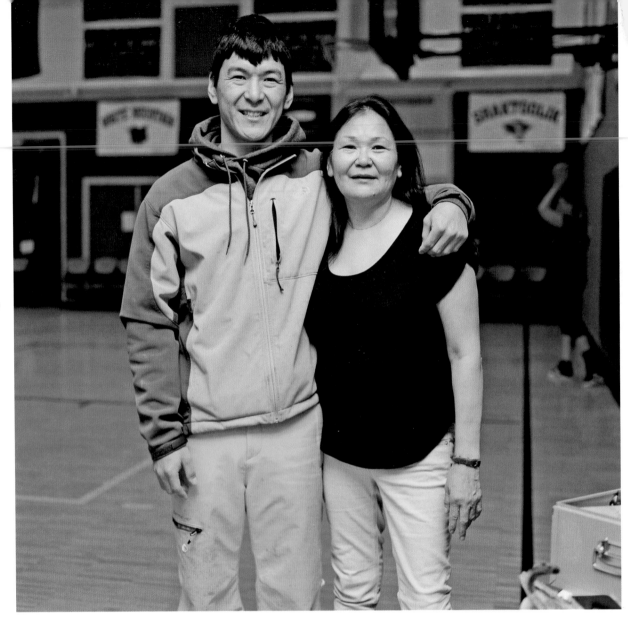

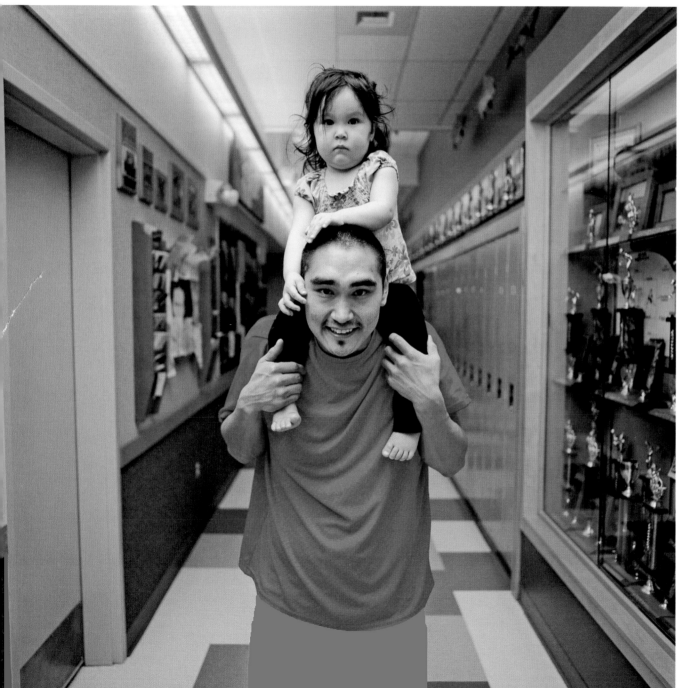

Derek Moses and his daughter Jaeda, Iñupiaq

"We are from Elim. We are here for the basketball tournament. I am playing in the tournament.

I commercial fish in the summer, starting in June and until the first week of September. We commercial gill net in pacific skiffs. We sell to NSEDC [Norton Sound Economic Development Corporation] and there is a fish buying plant there in Elim. I am thinking about getting my own [commercial fishing] permit. Right now I am fishing with my dad. I have been doing it a while—it's in my blood."

Karl T. Ashenfelter, Iñupiaq

"I am three-quarters Eskimo and a quarter, I guess, German. There are so many things different here since I was a child. You don't really notice it until you get older. Our diet was more traditional. We ate a lot of fish—there was no hamburger and there was bacon and canned ham and the rest of it was Native food. We lived off the country. Most of our meat was reindeer, ptarmigan, fish—whatever was around and there was more of it.

The biggest change, I would say, is the climate. It affects the fish reserve and the crab. Now there is hardly any. Skip jacks used to come up every fall. They used to catch them by the net and now there is hardly any. Each year when they come in, it used to be on a specific day, July 4th—now it's anytime. I think it has to do with the water temperature. I see more algae in the river and it's warmer.

Our diet used to be a lot healthier. It's even common now that these kids are tall and lanky. Us, we have short legs, long back, not too tall. What you see is what you get. I would say this: I think we were a lot stronger, and the Eskimos before us were even stronger. They had to live off the land and do everything by hand. There were no motors, they had dogs and they had to feed the dogs everyday, chop wood, haul water. You took a bath once every two weeks. There would be five of us that had to take a bath in the same water, and by the time the fifth person came around it was kind of murky."

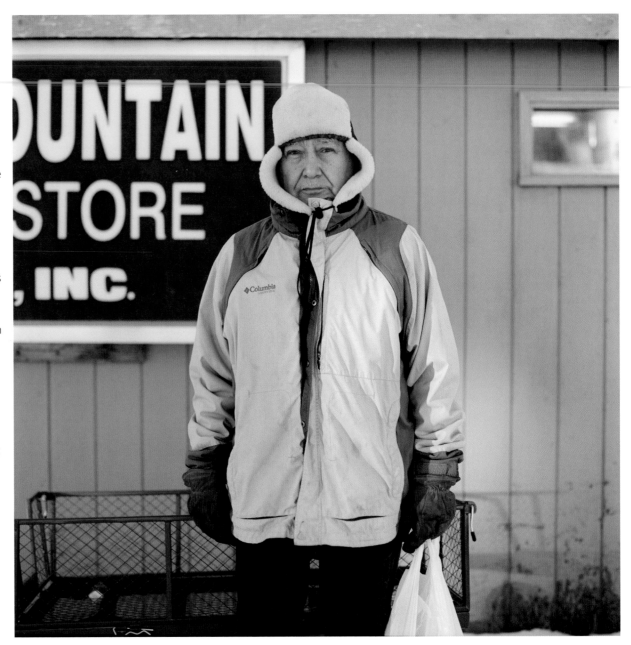

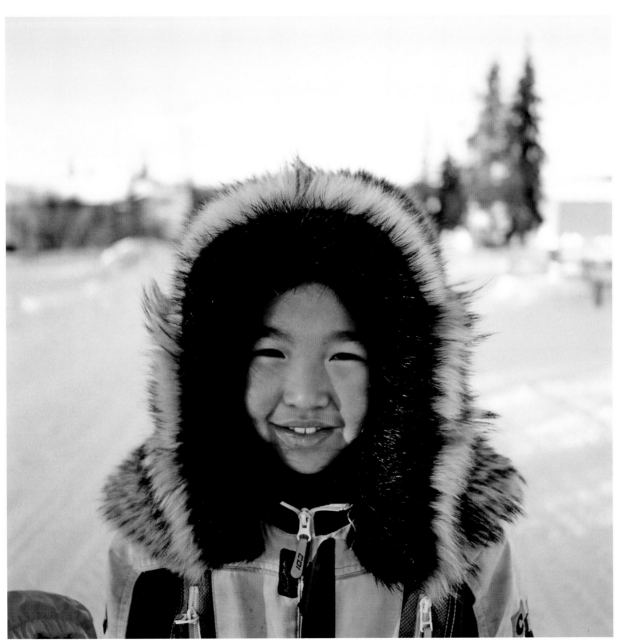

Naomi Oxereok, Iñupiaq

"My mom made my ruff [wolf and beaver fur around the hood of her coat] for me."

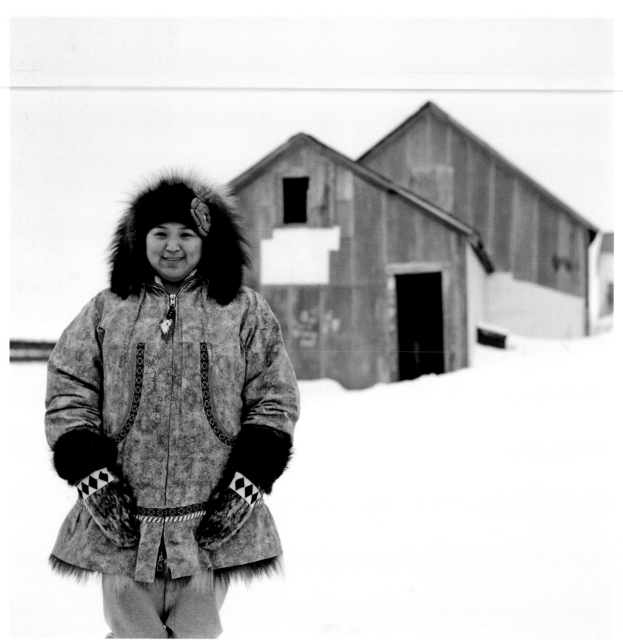

Renee Olanna,
Iñupiaq

"We came to White Mountain for the basketball tourna-
ment. We live in Brevig [Mission], Alaska. We drove here
[by snow machine]. It's about 200 miles. It takes about
four hours to get there from here. We will probably stop
in Nome, and see how the weather is at home, keep
going if it's good. If they say it isn't good, we will proba-
bly overnight in Nome. We have work tomorrow. I am a
health aid in Brevig. We had fun at the games. It's good
to see people from all over."

Sally Agloinga, Iñupiaq

"It was nice growing up here. We have good water in front of us and protection for our village with the mountains. That hill up there [White Mountain] used to be a watch out. That's why they call the hill 'Natchirsvik,' or 'a place to see.' This is my look out right here. I like to watch people. 'Hey, VPSO [Village Public Safety Officer]! They are fighting over there!' There used to be a house right here [across the street], but it burned down. Now I have a good view. I can look all over."

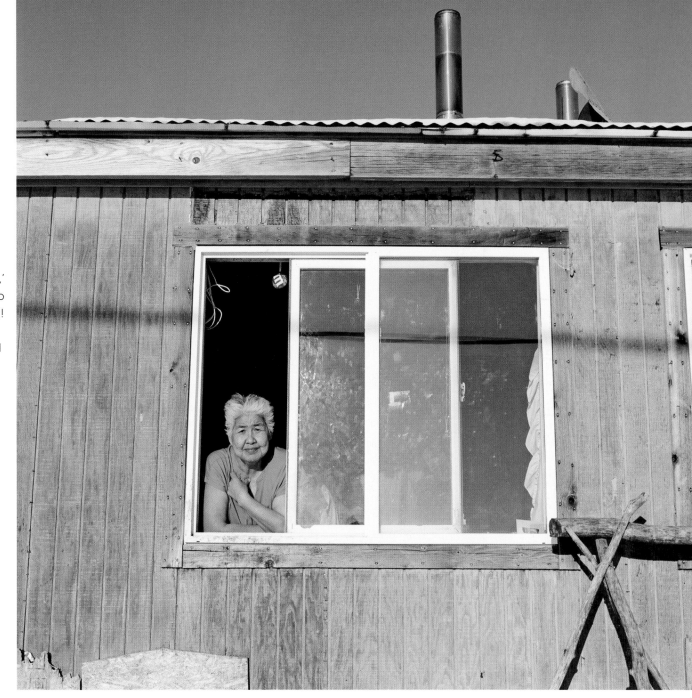

Tara Richards and her daughter Shailene, Iñupiaq

"My daughter is one and a half. This is our first time here. I am an admin[istrative] specialist at the hospital in Nome. We came to watch the basketball tournament. We live in Nome. My husband is originally from here."

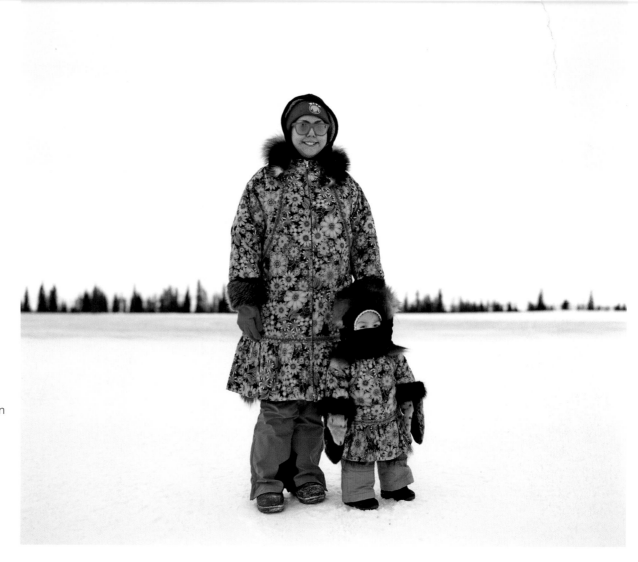

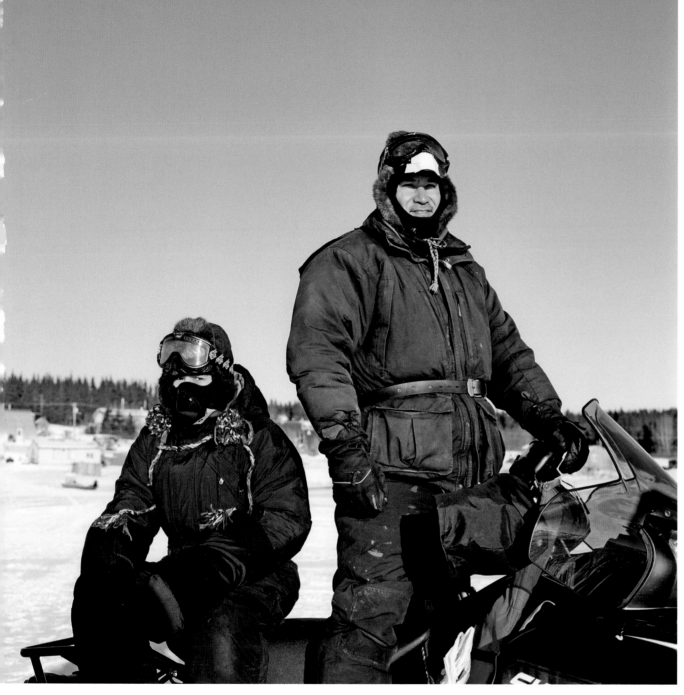

Ted Moore and his son Micah, Iñupiaq

"We live in Nome now. We are going down to Elim. We have a cabin down there. We are going to spend the night and try to go get caribou, then head back to Nome tomorrow or the next day. There are caribou there, probably 35 to 40 miles out of Elim, closer to Koyuk. We do this about three times a year. We are hoping to get two. It will last us all year, we get moose in the fall, too."

About the photographer

Brian Adams is an editorial and commercial photographer based in Anchorage, Alaska specializing in environmental portraiture and medium-format photography. His work has been featured in both national and international publications, and his work documenting Alaska Native villages has been showcased in galleries across the United States.

Brian Adams would like to thank his wife, Ash, and two children, Elliott and Ellis, for their love and support as well as Julie Decker and the Anchorage Museum, Katie Orlinsky and Matt Eich for their input and support during the early stages of I AM INUIT, and Kelly Eningowuk of the Inuit Circumpolar Council of Alaska for seeing the need for the I AM INUIT project and making it possible.

About the Anchorage Museum

The Anchorage Museum connects people, expands perspectives, and encourages global dialogue about the North and its distinct environment. It is recognized as a leading center for scholarship, engagement, and investigation of Alaska and the North.

Julie Decker is Director/CEO of the Anchorage Museum. She has also served as Chief Curator for the Anchorage Museum and has organized and curated numerous major exhibitions and authored numerous publications on the art and architecture of the North.

About the Inuit Circumpolar Council-Alaska

The Inuit Circumpolar Council-Alaska exists to be the unified voice and collective spirit of Alaskan Inuit, to promote, protect and advance Inuit culture and society.

The Deutsche Nationalbibliothek lists this publication in the
Deutsche Nationalbibliografie; detailed bibliographic data are
available on the Internet at http://dnb.dnb.de

ISBN 978-3-7165-1839-7
© 2018 Benteli, imprint of Braun Publishing AG, Salenstein
www.benteli.ch

1st edition 2018

Proofreading: Sophie Steybe, Nele Kröger
Graphic concept: Michaela Prinz (Prinz+Partner), Berlin
Reproduction: Bild1Druck GmbH, Berlin
© Photos: Brian Adams
© Text: Julie Decker, Kelly Eningowuk, Jaqueline Cleveland,
and Vernae Angnaboogok